ROY G. BIV

―――――

AN EXCEEDINGLY
SURPRISING BOOK
ABOUT COLOR

―――――

JUDE STEWART

BLOOMSBURY
NEW YORK · LONDON · NEW DELHI · SYDNEY

Bloomsbury USA, 1385 Broadway, New York, NY 10018

Bloomsbury Publishing Plc, 50 Bedford Square, London WC1B 3DP

Bloomsbury Publishing, New York, London, New Delhi, Sydney

All papers used by Bloomsbury Publishing are natural, recyclable products made from wood grown in well-managed forests. The manufacturing processes conform to the environmental regulations of the country of origin.

Library of Congress Cataloging-in-Publication data has been applied for.

A CIP catalogue record for this book is available from the British Library.

US ISBN: 978-1-60819-613-5

UK ISBN: 978-1-40883-551-7

First published in the USA and Great Britain in 2013

1 3 5 7 9 10 8 6 4 2

Designed by

OMG
The Oliver Munday (group)

Printed in China by C&C Offset Printing Co Ltd.

FOR SETH

CONTENTS

INTROD

UCTION

WHY A BOOK ABOUT COLOR?

> It came back to me, I read it many years ago: 'Color no es colorido,'
> 'color is not colored,' a sentence attributed to Goya. Through the
> window I see the olive trees I planted around the house. When I
> paint I sometimes use a pigment designated as olive green (PR101,
> PY42, PG7). It doesn't match the color of the trees. The two dogs
> are lying on the floor and they also look outside. It seems that they
> see the world in black and white. I wonder if it is the same world.
> —Pedro Cabrita Reis

Color is a daily mystery we all swim in. In the cartoon strip of everyday life, panel after panel is crammed with colored objects, every blank outline shaded in: pencils, subways, umbrellas, ties, cherries, leaves, smoke. Color is so ubiquitous, it's invisible—until suddenly, it's not.

Babies don't see colors, exactly; they see what enchants them. A fire truck rolls by: It wails! It shines! It squirts! A kid takes it in as a shining whole. Only an adult can isolate the salient ingredient in the truck's charm: its colors, juicy red with silver chrome.

Learning colors as a kid means trading enchantment for knowledge. Each object you can label as red shrinks the vast category of RED down to something tamer. The colors become like a series of buckets, into which we drop successive objects. RED: First in are apples, cherries, fire trucks, stop signs. Later on we add lobsters, little Corvettes, valentines, short wavelengths of light, fire, wrong answers on quizzes, Christ's salvation, Communists, voting Texans, Chinese celebrations, African funerals, blood, alarms.

As the buckets fill, it gets trickier to answer the question, What does the color red mean? Red daubs the Communist worker, but also the elitist lobster. Red means angry—when it doesn't mean loving, courageous, vital, or dead. Only twenty-six countries (out of 194 total) *don't* include red in their national flags; when clashing on a battlefield, two opposing nations each draw their courage to fight from the same color. What *doesn't* the color red mean? Calm, chilly, boring, innocent: Only a few ideas spring to mind. If red could mean almost anything, does it simply mean nothing? That idea rankles, too.

Remember the 1980s self-help book *Color Me Beautiful?* Its pages were crammed with hopeful ladies transformed by wearing the "right" colors for their skin tone. Its first before-and-after shot packed a wallop. Drape her in pink and she's dewy and glowing. Drape her in orange, though, and she turns sallow and shrunken. Amazing: as if color could suck out her soul, or breathe it back in. Once I hastily painted a living room yellow, pooh-poohing the manufacturer's dopey name for the shade, Little Angel. The oppressive cheerfulness of that room clamped down on you like a migraine. Red rooms make people working in them more accurate and cautious, and blue turns them more creatively loose—so claims a 2009 study (among others) in the journal *Science*. (Cognitive psychologists seem to love pitting red against blue and measuring the psychological effects of each.) More than half the world channels their God through blue: Jews contemplating the infinite, embodied in blue-fringed shawls; Muslims in blue mosques; Buddhists fingering turquoise beads as they pray, all thinking blue, blue, more blue.

Picture these in your mind's eye, like a Pantone slide show: a blackened tomato. The word YELLOW written in blue type. A fresh, unsullied watercolor set. The leafy greens of Ireland and Islam. Chunks of lapis lazuli and Indian yellow rocks, to be ground down into pigments. A plain red rectangle, also known as Alphonse Allais's painting *Apoplectic Cardinals Harvesting Tomatoes by the Red Sea*. Your football team's colors. Your country's colors. The colors of your enemy. The color that comforts. All these colors hold power to stir or repel you, to sway your thinking. Artist David Batchelor devoted an entire slim volume, *Chromophobia*, to explaining the subtle superstition against color in Western thought, a fear that relegates color to the status of "other." Think of a Wall Street businessman, dressed in grays and blacks and whites. Bright color seems tacky, childish, atavistic, hysterical, queer, uncontrollably sexual, antirational. The point is, color *means* something.

It's no surprise that there's been lots of arguing over color—centuries' worth of it. Philosophers have turned to color as a perfect medium to pin down the limits of sensation: Is the red I see the same as the red you see? How can we know for sure? It helps in exploring the problem of other minds, the gap between language and its object, even the knowability of the world. "Is it a familiar fact to me that I see?" asks philosopher Ludwig Wittgenstein in his book *Remarks on Color* (1950–51). He marvels at color's intractability, at impossible colors like reddish green, at the improbability of black mirrors and brown traffic lights. Political activists wield color to mobilize revolutions; artists alternately binge and purge on color. Even at the workaday level, colors swing in and out of fashion with vicious regularity. A dusty-pink-and-turquoise color scheme

RED AGAINST BLUE:
For more on Red Versus Blue and each color's cognitive impacts, see p. 35.

BLUE-FRINGED SHAWLS:
The story of the lost blue p. 87.

IRELAND:
Brits, Scots, and the Irish harbor numerous superstitions against the color green as unlucky. See pp. 73–74.

ISLAM:
See p. 78.

LAPIS LAZULI:
A semiprecious blue stone ground up into an eye-poppingly expensive paint. See p. 89.

INDIAN YELLOW:
A yellow paint made from the distilled urine of mango-leaf-chewing cows. Yes, really. See p. 66.

REDDISH GREEN:
Wittgenstein loved pondering reddish green as the perfect example of a color one could never see. That's until biophysicists at the Wright-Patterson Air Force Base came along. See p. 127.

BROWN TRAFFIC LIGHTS:
Brown is actually a low-intensity shade of orange, not too visible on a foggy winter's night. See p. 127.

ROY
G.
BIV

INTRO

BLOOD:
For fast facts on the color
red's most enduring as-
sociation, see p. 27.

x

screams 1980s corporate chic, just as MacBook white with clear, strong lollipop shades locates us in our own era. Meanwhile, the full spectrum asserts itself practically every day: Children fight over 128 colors of crayons and stain their fingers with Easter egg dye, face paint, hair dye, or henna; every morning confronts each of us with the open closet door, where we figure out what to wear, a decision that boils down to choosing the perfect color.

When you write a book about color, you realize one thing in a hurry: You can bring color and words into closer proximity, on the page or on a canvas, but you can't make them fully merge. There is no decoder ring, no Rosetta Stone. Almost by definition, you can't finally transform one into the other, even though colors and words are available in infinite supply.

So what does a satisfying (and finite!) book about an infinite topic look like? More to the point, how can reading a book deepen your understanding of the colors you see every day? "Habitualization devours works, clothes, furniture, one's wife, and the fear of war," wrote art critic Viktor Shklovsky in 1917. "Art exists [so] that one may recover the sensation of life."

Color is absolutely everywhere. This book means to invigorate you back to really seeing it, as a kid sees a red fire truck. *ROY G. BIV*'s aim is simple: to tantalize and inform your eye, to reveal with sudden clarity the universe of meanings inside the colors you see daily.

HOW TO READ THIS BOOK

ROY G. BIV is bursting with actual color—the illustrations you see sprinkled throughout the book. These visuals are intentionally abstract: color in its purest form. Free of any context, color is gorgeous, suggestive, but never specific. So how do you decode it?

"The 'pure' red of which certain abstractionists speak does not exist," announced American painter Robert Motherwell flatly in 1944. "Any red is rooted in <u>blood</u>, glass, wine, hunters' caps and a thousand other concrete phenomena. Otherwise we would have no feeling toward red and its relations."

What stories lurk within each color's depths, both familiar and strange? Those answers—at least, some of them—lie in the text. To explain the book's title: *ROY G. BIV* is a zippy, *Jetsons*-sounding mnemonic for the order of colors as they appear in the rainbow. (That'd be Red Orange Yellow Green Blue Indigo Violet.) I collapsed indigo and violet into a single chapter for <u>reasons explained later</u>. I also inserted a chapter each for non-spectrum colors with rich cultural significance: pink, brown, gray, black, and white.

The next question was, how to fill each chapter? You could list every possible meaning of the color red, but what good is that? White equals mourning in many parts of Asia. Fine, but why? You're going to forget that as soon as you learn it, unless there is a good story to tell about it. You have to <u>see white as, say, a northern Russian mourner might</u>, even if it's just briefly. And that's what I've tried to accomplish here. Another point of order: While I tried to explain many big-picture color questions—<u>Why is the sky blue? Why is pink for girls and blue for boys? Why do prisoners wear orange?</u>—I did so only if I could also tell a bang-up good story, one that would swim suddenly into focus the next time you encountered that color.

I kept these rules of thumb in mind, but otherwise my selection is willfully subjective. In the end, I wanted to tell you my favorite stories about colors. During my research, each of these anecdotes caught my attention and held it; each changed my conception of color permanently. I hope these brief entries contain that spark of amazement, the jab of alertness you feel at seeing something familiar in an entirely new way.

Chapter One primes you with basics: what color actually is, the history of dyes and pigments, a crash course in color theory, and linguists' (crazy) take on color terms. Then we plunge into the rainbow, with each chapter devoted to a single color. Each color opens with an infographic "map," a bird's-eye view of the terrain the chapter will traverse. As you'll see, the entries themselves draw on the widest possible range of disciplines, aiming for cross-cultural angles where possible. The goal: to decode colors' meanings, fluttering the veil between color and words while never fully lifting it.

Of course, what colors we see are random and fleeting and rarely chosen by us. This book lets you relish the freedom of self-navigation. While you can read the entries sequentially, the text of *ROY G. BIV* is crisscrossed with bright escape hatches in the form of cross-references. Say you're reading about <u>why flamingos are pink</u>, including an unlikely true tale of gray flamingos falling from a Siberian winter sky (to the joy of

REASONS EXPLAINED LATER: Why did Newton stretch the actual number of colors in the rainbow from six to seven? See p. 96.

SEE WHITE AS, SAY, A NORTHERN RUSSIAN MOURNER MIGHT: See p. 7.

WHY IS THE SKY BLUE? See p. 86.

WHY IS PINK FOR GIRLS AND BLUE FOR BOYS? See p. 16.

WHY DO PRISONERS WEAR ORANGE? See p. 47.

WHY FLAMINGOS ARE PINK: See p. 15.

THE MIRACULOUS
BLUE BLOOD OF
HORSESHOE CRABS:
See p. 88.

WHY PENCILS ARE
COLORED YELLOW:
See p. 65.

NERDY FELICITY:
An alternate title for this
book might be *A Bunch of
Nerdy Felicities About Col-
or.* A few of the nerdiest:
a groan-inducing "purple
prose" contest (p. 101), the
rediscovery of the lost blue
coloring tekhelet (p. 87),
mildly torturing redheads
as scientific inquiry (p. 35),
and various fictional colors
invented by sci-fi writers
(pp. 128, 129).

RA NBOW:
Gay-pride activists share
the rainbow flag symbol
with some unlikely compa-
triots. See p. 136.

xii

villagers below). Within that entry you'll be invited to follow several cross-references. Crustaceans takes you to an entry on the miraculous blue blood of horseshoe crabs. Siberia takes you to entries on why pencils are colored yellow (hint: graphite lodes discovered on the Siberian-Chinese border). Hop from one entry to another, like sprawling lily pads, to pursue a theme that intrigues you, or, if you choose, you can read each chapter's entries straight through.

I hope *ROY G. BIV* hits you as a reader on two levels. Of course, I hope to charm the pants off you with color's speed, variety, and wit, with hilarious digressions, a loopy yet lovely format, the strange felicity of the entries.

But I also hope you feel an emotional undertow, as though you're traveling to the mysterious heart of something true, or isolating the properties of a new element. I wanted to write a book rife with that deep sense of "Aha!" that you get when you finally unravel something that has puzzled you since childhood. Even if we can never completely understand it, I hope this book reveals color in the widest sense of the word.

COLOR: A POINTILLISTIC HISTORY AND USER'S GUIDE

WHAT IS COLOR?

There's a nerdy felicity to typing some impossibly big question like "What is color?" into a library database and getting a perfectly matched title in response: *The Physics and Chemistry of Color: The Fifteen Causes of Color* by Kurt Nassau (1983).

Nassau divides the ways something can be colored into physical and chemical causes. Physical coloration is epitomized in the rainbow: the result of a pinball action of light *refracting* between water droplets and *scattering* to separate the rainbow's bands of color.

Another manifestation of physical color: pearlescence and iridescence. Inside pearly-colored materials are obstructive flakes that produce *interference* with the light rays striking them, combined with *selective absorption* of light, followed by *diffusion*. All of these (except selective absorption) can be classified as physical reactions versus chemical: That is, color results from changes happening at a level above the molecular.

Now for chemical color. Imagine the classic color example: A tomato sits redly on a kitchen counter. White light containing all the colors strikes its rounded cheek; only red wavelengths are reflected, giving us the vivid mental image of a red tomato. But why does the red light bounce off, while the rest is absorbed? How does an object reject light?

In his book *Bright Earth: Art and the Invention of Color*, science writer Philip Ball explains selective absorption of color by comparison to a piano wire. Ball writes: "The light may be absorbed if it can boost the electrons [inside the tomato] from one energy state to another, just as the piano wire's energy is increased when it is stimulated into resonant vibration by sound waves . . . Only rays of certain frequencies have the right energy to stimulate these color-inducing 'electronic transitions.'"

If you say so, Mr. Ball. Bottom line: Color is a shivering, glorious, active thing, a sympathy of poles founded on an exact kind of wavelength repulsion. Color is cagey, only partially knowable; it resists us even as it beckons. Thus the foundation of its perverse charm.

A CRASH COURSE IN MATERIAL COLOR

Nowadays color is astonishingly cheap and fungible. Those inviting mounds of T-shirts at H&M—canary yellow, taupe, blackberry purple—all sport the same (low) price. In preindustrial times, taupe would've been relegated to the discount rack, purple featured in costly splendor upfront. (Yellow's price tag would have added or subtracted zeroes based on its brightness: strong, uniform colors cost the earth; muddy or pale colors commanded lower prices.) "We have seen too much pure, bright color at Woolworth's to find it intrinsically transporting," complained Aldous Huxley in his 1956 book *Heaven and Hell*. "The fine point of seldom pleasure has been blunted. What was once a needle of visionary delight has now become a piece of disregarded linoleum."

GENTLEMEN: I SENT YOU BY THIS SAME POST A LITTLE FRENCH BOX OF—SO CALLED—'SAFE' COLOURS. WE HAVE VARIOUS SCARES HERE ABOUT SCARLET-PINK—GIROFLÉE—AND CARNATION-DARNATION FEVERS; AND I'VE JUST GIVEN THIS DOZEN OF MORTAL SINS TO A YOUNG CONVALESCENT OF SIX. WILL YOU KINDLY ANALYSE THE TEMPTATIONS AND SEE IF THEY'RE—NOT WORSE THAN APPLES AND CURRANTS—IF ONLY MILDLY LICKED?

—John Ruskin, letter to colormaker Winsor & Newton, 1889

IN THE CHALKY WORLD OF DULUX [PAINT] AND THE COLOUR CHART, YOU REMEMBER COLOUR WAS ONCE BRIGHT AND PRECIOUS . . . IF THE SCARLET WHORE OF BABYLON WAS PAINTED WITH THESE HOUSE PAINTS YOU WOULD NOT NOTICE HER, BUT IN A BOOK OF HOURS SHE WOULD FLAME LIKE THE SUNSET.

—Derek Jarman, *Chroma*

How did we get here? In 1856, William Perkin was trying to synthesize artificial quinine to treat malaria when he stumbled on a brilliant, durable purple dye he dubbed mauveine. Mauve was the first artificial dye and a breakthrough in industrial chemistry. It also rendered Perkin stonkingly rich: Queen Victoria wore mauve to her daughter's wedding in 1858 and "mauve measles" broke out all 'round London-town. Fast-forward mere decades and you get synthesized, cheap, miraculously bright colors in every shade. Much like computers, textiles were the preindustrial era's site of technological innovation: a history of advances spelled out in bright bolts of cloth.

This radically abbreviated history of material color starts with the question: What are pigments and dyes? François Delamare and Bernard Guineau explain in their 2000 book *Colour: Making and Using Dyes and Pigments*: "Pigments are pure colors in powder form, which must be suspended in a medium in which they are insoluble (such as oil) in order to make paint." Easy peasy: Most natural colors are ground-up colored rocks, suspended in a wet, clear medium.

Dyes, by contrast, "are *soluble* color compounds suspended in a medium," per Delamare and Guineau. In her book *Indigo*, Jenny Balfour-Paul expands on this idea: "Some natural dyestuffs are 'substantive' or 'direct,' meaning that with heat they will fix directly to a fibre with which they have an affinity. However, most natural dyestuffs belong to a group known as 'adjective,' which require an intermediate chemical substance called a mordant to make them fast." So: A *pigment* is naturally colorful, solid stuff that must be made spreadably liquid as a paint. A *dye* is a coloring solution chemically affixed to the textile fibers it's coloring. Dyes often need mordants—like alum or potash—to nudge the color to "bite" into the cloth.

Bonus round: What could a "lake" color be? A lake combines both a dye and a pigment, a water-soluble dye affixed to some organic, colorless powder. With lakes, first you chemically dye some dust; then you suspend that pigment in a clear, spreadable liquid.

Natural dye-making was skilled crap work—often literally. A thirteenth-century B.C. Egyptian papyrus, designed to steer promising students away from dye-making, described the profession thusly: "The lot of the dyer at home is worse than any woman's . . . When he does not produce enough in a day, he is beaten like a lotus in the pond . . . the dyer's finger smells like rotten fish. His eyes are wrecked by fatigue." Stale urine provided a cheap, plentiful reducing agent for woad and indigo dyeing. Scottish house-

MAUVE:
For more on Perkin's discovery and its implications, see p. 98.

QUEEN VICTORIA:
The Great Queen V also set the fashion for white wedding dresses. See p. 4.

LAKE:
Even odder is the original meaning of "pink," a complicated pseudo-lake pigment. For more on yellow pinks, brown pinks, and (eventually) rose pink, see p. 15.

WOAD AND INDIGO DYEING:
See p. 85.

ROY
G.
BIV

INTRO

IMPERIAL PURPLE:
See p. 96.

INDIAN YELLOW:
See p. 66.

WHITE LEAD
PIGMENTS:
See p. 29.

GROANINGLY
HIGH PROFIT
CALCULATIONS:
Big moneymakers of
natural colors include
cochineal red dyes (p.
28), ultramarine blue (p.
89), Tyrian purple (p.
96), arsenic-laced yellows
(p. 66), and Scheele's
green (p. 75). Hard to
market, disgusting browns
like mommia and Isabella
brown are discussed on
p. 55-56.

NAZI:
For more on where the
Nazi brownshirts got their
color, see p. 55.

NEW "SUPERBLACKS":
See p. 117.

GRAY GOO:
See p. 110.

WHAT COLORS WERE
THE DINOSAURS?:
See p. 136.

SYNESTHETES:
See p. 132.

ALIEN-COLORED
PLANT LIFE:
See p. 77.

THE AVERAGE COLOR
OF THE UNIVERSE:
See p. 135-136.

wives and Pompeian dyers alike kept urine vats handy for donors. Phoenicians stashed the imperial purple dye works outside of town to aerate their smells. Touching indigo plants causes superstitious Indians to lose their caste; the traditional remedy required consuming all five products of the sacred cow: milk, ghee, curds, urine, and excrement. Crystallized urine from cows chewing poisonous mango leaves supposedly is the chief ingredient in Indian Yellow. Manure also figured prominently in color-making: For example, steaming-hot cow flops powered the production of white lead pigments. To make pinewood red dye in eighteenth-century France, one recipe advises building a double-stacked boiler of horse manure, sprinkling it with horse urine, and allowing the mixture to rot. And so on.

Like the mercantile-class Rodney Dangerfield, dye-makers fought for respect. Medieval dyers' guilds ensured customers of quality ingredients and proven processes whose resulting colors wouldn't curdle or fade—"go fugitive"—over time. Consider that colonial traders classified dyestuffs and pigments as "spices," and the mind reels with groaningly high profit calculations. Around the mid-eighteenth century, color-making migrated in Europe to the grocer-chemist's shop. Using ingredients sourced globally, *marchands de couleur* whipped up medicines, ground culinary spices, and doled out art-ists' colors variously, their mortars and pestles smeared with rainbows.

Even after synthetic color labs wiped out the grocer-chemist color man (and his global supply chain), the demand for color proved a boon to industrial chemistry. Around World War I, German pharmaceutical companies—BASF, Bayer, Hoechst and Afga—merged into one massive firm, IG Farben, and succeeded in cornering color-making in the early twentieth century. (IG Farben was also implicated in the twentieth century's atrocities: *Arbeit Macht Frei*," "Work Makes You Free," started as an anti-union motto festooning IG Farben's Buna rubber factory gates. It eventually scrolled above Nazi concentration camps' gates where Zyklon B, an IG Farben product, gassed the Jews.)

Color runs like a brilliant ribbon through scientific advances still. Synthetic color dyes the genome and cancer cells targeted for chemo blasts. Carbon nanotubes bring us new "superblacks" and the threat of annihilation via gray goo. To pursue the seemingly frivolous question, What colors were the dinosaurs?, grant money has avalanched forth. Cognitive psychology dogs synesthetes like paparazzi for myriad insights into brain function. We peer through telescopes looking for alien-colored plant life and calculate, with less than half-joking intent, the average color of the universe. For good or for ill, color persists as a minor B-plot to the big drama of history.

A CHEAT SHEET OF COLOR THEORY

Color theory's most prominent thinkers constitute a hit parade of (mostly) gentlemen with grandiloquent names, innovative mustachery, and a vast junk drawer of color gadgetry. How to do justice to eighteenth-century entomologists Ignaz Schiffermüller, Moses Harris, and Jacob Christian Schäffer, whose charts recorded the colors witnessed in their bug-chasing zeal? What of the more pragmatic color-mixing systems for painters by Philip Otto Runge and Ogden Rood? How about Johann Wolfgang von Goethe's 1810 classic *Theory of Colours?* Intended as a corrective to the science underpinning Newton's *Opticks* (1704), Goethe imagined darkness not just as absence of light but as its own active force; the battle of Light vs. Dark supposedly threw off observable sparks of color. This wrongheaded conviction led the inventor of *Weltliteratur* and the Italian tour to spend weekends breathing on glass panes, prodding chocolate-froth bubbles, and flapping his arms in daylight, then jotting down how colors changed in each observation.

In 1824 Michel-Eugène Chevreul joined Gobelin Dye Works in Paris with a mission to perk up the dull-looking dyes filling display cases. Chevreul turned the tables on the question: The dullness *wasn't* the fault of bad dyes, but rather caused by complementary colors weaved too closely together. Viewed from a distance, these colors blended into optical grayness. Chevreul went on to pen two monster classics of nineteenth-century color theory, handing the baton in 1900 to Albert Henry Munsell. Munsell's 3D cylindrical color model quantifies colors' relationships nicely, even as its unloveliness is to older color wheels what a textbook of porn mechanics is to actual sex. Bauhaus masters Josef Albers and Johannes Itten contributed their own Extremely Good Textbooks to the study of color contrasts and perception. Whether pinning down scientific truths, optimizing artists' mastery, illuminating God's mind, or measuring color to brew more purified beer, our most prominent color theorists deserve their own books—and have gotten them.

What facts from color theory do you need to know to read this book? Very few. Below is a cheat sheet:

What are the "true" primary colors?
There are actually three answers to that: red, blue, and yellow for paints and pigments; cyan-magenta-yellow-black for processing printing; and red-green-blue for colored light.

BUG-CHASING ZEAL:
Bugs and creepy-crawlies figure largely in the story of cochineal red (p. 28) and Tyrian purple (p. 96). The fictional color *squant* is characterized by a scent lovely to earthworms. See p. 129.

PORN MECHANICS:
Japanese "pink films" work around strict obscenity laws. See p. 19.

PERCEPTION:
Avionics scientists have figured out strangely low-tech ways to overcome our eyes' normal limitations of color perception. See p. 127.

BREW MORE PURIFIED BEER: See p. 52.

If the rainbow contains all colors, why can't you mix paints to produce white?
Because paints are the wrong type of color. *Additive* colors are made of actual light
sources (like sunbeams), while *subtractive* colors are reflected colors, those built from
pigments that reflect (but don't generate) light. Additive mixing of colored light tends
toward lightness (like your full-spectrum lamplight), while mixing pigments subtrac-
tively tends to darken the resulting color.

Why isn't brown in the rainbow?
Because brown is actually a low-intensity orange. See p. 50.

How do collaborative teams talk about color—and ensure everybody means the same shade?
Today we use three different color-numbering systems, depending on the audience and
purpose: Pantone numbers and CMYK values for printed matter; hex and RGB values
for the Web; and CIELAB and CIECAM02 color models for science and industry.

CMYK printing counts as subtractive mixing, by printing a color image in successive layers of Cyan, Magenta, Yellow, and blacK /grayscale. CMYK straddles the traditional color divisions of the rainbow: Cyan contains both blue and green, magenta both red and purple, et cetera. Shockingly, CMYK technology was invented in 1722 by Jacob Christoph Le Blon. Although Le Blon's process was too finicky for large-scale production, and the printing dyes of the day were not yet equal to the task, CMYK was a big idea that endured.

CMYK is great for color printing, but papers are only one colored material; clothes, lamps, crockery, armchairs, and cars all are colored, too. Pantone Matching System (PMS) numbers ensure that a product's color stays consistent from the original concept to the injected-plastic molding or dyed textiles of the product itself; to printed paper catalogues or its on-screen rendition on the company's Web site.

Which brings us to RGB and hex values. James Clerk Maxwell invented RGB in 1861 and took the first colored photograph based on it. His subject? A Scottish tartan ribbon. Under RGB, each color gets a six-digit code representing how much red, green, and blue respectively should be additively mixed to render it accurately in lights. RGB light mixing still animates Web monitors, televisions, and the countless little glowing screens we use today. RGB values work in tandem with hexadecimal color-coding system coloring the Internet. A nice manifestation of how hex values work can be found at thecolourclock.co.uk. The site renders the six-digit time as a continually shifting hexidecimal color value.

THE SPLINTERED RAINBOW

The rainbow we think we know gets filtered through foreign languages into wholly different shades. To Russians, for example, dark blue (, sínij) and sky blue (, golubój) look as different as red and orange to us.

Hungarians differentiate between living and inanimate reds, with an added wrinkle of sophistication: *Piros* describes simple, emotionally uncomplicated objects fit for children, while *vörös*, a darker shade of red, is reserved for reds with a deeper emotional resonance. Stop signs, clowns' noses, Slushees: *piros*. The Red Army, wine, blushing in anger or shame: *vörös*.

SKY BLUE:
Why is the sky blue, anyhow? See p. 86.

SHAME:
For the various colors of shame, from Hindu to Hebrew, see p. 8.

ROY
G.
BIV

INTRO

GREEN LEAVES:
On the non-inevitability of green plants (and a primordial plant past that's downright plummy in hue), see p. 102.

APPLES:
Adam may've fallen for a tempting orange from Eve. Or was it a pomegranate? See p. 38.

Lots of languages conflate blue and green, among them Vietnamese, Zulu, Korean, Thai, and Kurdish. Gaelic distinguishes between *glas*, plant green, and *uaithne*, any artificial green, even if the shades look identical. Inchworms and celery are *glas*; pale-green cardigans and Mountain Dew are *uaithne*.

Japanese and Chinese also blur their blues and greens, but the rules are murkier. The Chinese character 青 (rendered as *qīng* in Mandarin and *ao* in Japanese) spans both blue and green. The Japanese always use the word *midori* for green leaves, from the verb *midoru* (to be in leaf or flower), but they also use the Anglo-Japanese word *guriin* in slightly unpredictable ways. Traffic lights they call *aoi*, or blue, even though theirs glow exactly as green as Western ones. Green apples and shiso leaves, the delectably spicy leaves adorning sushi platters, are also *aoi*.

Modern Japanese is just as confusing as the bewildering color world of Latin, first described by Aulus Gellius in the second century A.D. and pondered at length by Umberto Eco in a 1985 essay. That Tower of Chromatic Babel featured such head-scratching terms as *caerulus*, the color of "skies, the eyes of Minerva, watermelons and cucumbers . . . [and] rye bread."

THE BERLIN-KAY COLOR ORDER

In 1969 linguists Brent Berlin and Paul Kay surveyed speakers of twenty wildly different languages and noticed a law binding all of them. As languages develop differing names for colors, those names always enter a language in the same order: black, white, red, green or yellow, then blue, then brown. Only in the final stage does this strict pattern loosen: The last step introduces purple, pink, orange, or gray, in no particular order.

If a language isn't very color-inclined, it may have only three words for different colors—but those three words will always be black, white, and red. If a language makes finer color distinctions, it always names yellow or green next. The Berlin-Kay color order holds true for all languages, and, while disputed in its details, hasn't been disproved in forty years.

COLOR IS LIKE SEX. IT'S MYSTERIOUS. IT'S UNKNOWABLE. IT NEVER LOOKS THE SAME TWICE. NO TWO PEOPLE SEE THE SAME THING. NO TWO PEOPLE FEEL THE SAME THING. I ONCE WENT TO CHINA ON A CRUISE SHIP. EIGHT HUNDRED OF US GOT OFF THE SHIP WEARING WHITE, BECAUSE IT FEELS FESTIVE AND SHIPPY AND SAYS, "I'M ON A CRUISE." IN CHINA WHITE IS THE COLOR OF MOURNING. WE LOOKED INSANE.

—Stephen Drucker, editor in chief,
House Beautiful

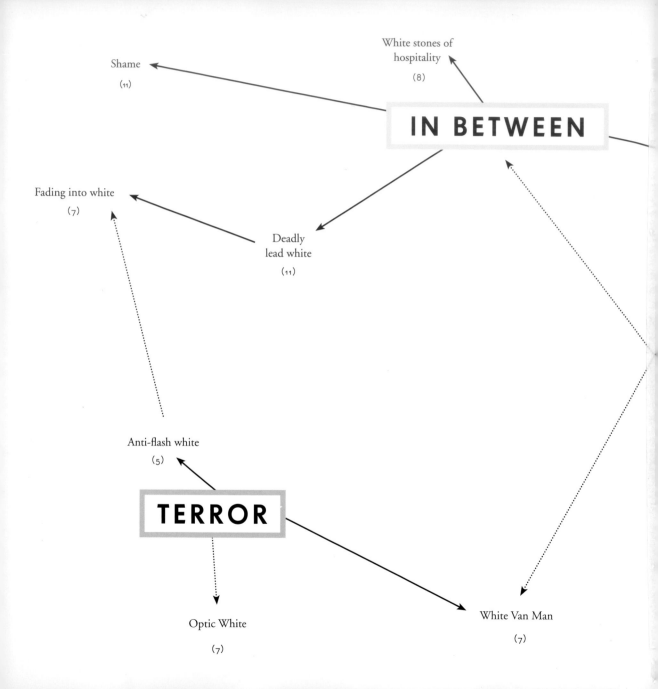

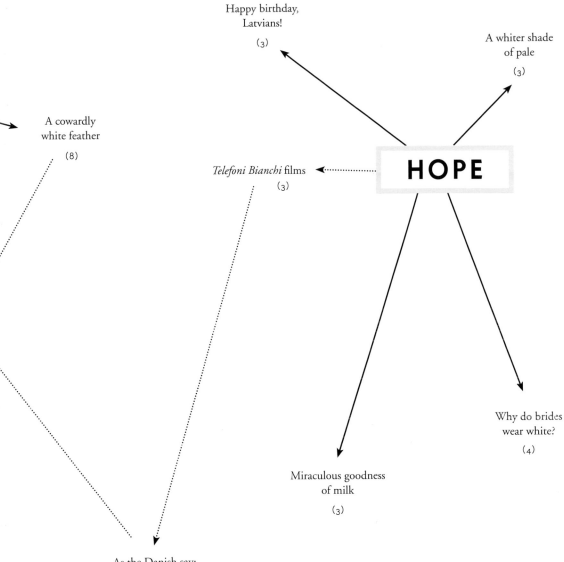

Happy birthday,
Latvians!

(3)

A whiter shade
of pale

(3)

A cowardly
white feather

(8)

Telefoni Bianchi films

(3)

HOPE

Why do brides
wear white?

(4)

Miraculous goodness
of milk

(3)

As the Danish say:
"Shoot a white stick at that."

(4)

White has a tendency to make things visible. With white, you can see more of a nuance; you can see more.

—Robert Ryman, minimalist artist of mostly white paintings

HOPE

A WHITER SHADE OF PALE

Names plucked at random from Benjamin Moore's 140 shades of white paint reveal the worlds inside white: Cloud Cover. Opaline. Niveous. Albescent. French Canvas. Old Prairie. Halo. Pompeii. Mayonnaise. Ivory Tusk. Desolate. Minced Onion. White Down. Berber White. Celery Salt. Temporal Spirit. Ice Formations. Man on the Moon.

MIRACULOUS GOODNESS OF MILK

Dairy farmers, rabbis, mullahs, and moms worldwide agree: milk is indeed tops for goodness, purity, and wholesomeness. The Koran blesses it thusly: "Here is the description of the garden promised to those who believe in God. There will be rivers of milk whose taste never changes." The Talmud groups milk with wine, honey, and dew as one of the four sacred substances. Most beautifully, perhaps, is the Muslim-Egyptian habit of evoking milk to describe a lovely day.

HAPPY BIRTHDAY, LATVIANS!

On birthdays, Latvians gather round their klingeris (a pretzel-shaped coffee cake preceded by a hearty dinner of pig snout and washed down with Riga Black Balsam herbal liqueur) and sing their birthday wish:

"Have Many White Days" (*Daudz baltu dieni u*):

Have many white days
And let fortune follow
So grand, so stately—live on!

TELEFONI BIANCHI FILMS

Pre–World War II Italian *Telefoni Bianchi* (white telephone) films painted a giddy picture of the upper classes in high-toned elegance, dashing through nightclubs, pent-

MILK:
Confucius and his cohort were similarly wild about jade. For a tour of jade's ten virtues, see p. 80.

GARDEN PROMISED:
Muhammad and Islam are clear on the color of paradise: green like the elusive gardens of the desert. To plumb Muslim holy green, see p. 78.

PIG SNOUT:
To decode the expression "blue pigs" and other blues of obscenity and vice, see p. 87. For unnatural flowers shaped like pigs' tails and other color mad affectations of an exhausted duke, see p. 119.

ROY
G.
BIV

WHITE

houses, and yachts to answer the slim white telephone proffered on a silver tray, just a rotary-dial sweep away from God.

A TRUE LONG SHOT

Any hopeless gesture in Danish will elicit a shrug and a colorless write-off: "You can shoot a white stick after that." (*Skyde en hvid pil efter.*) The saying's origins are obscure, but the likeliest stick appears in the Danish fable of Esben and the Witch. Esben's twelve brothers ride into the world on white steeds, while Esben the runt gets only a stripped white stick.

Working as stablemen for the king, the brothers are plagued by the foul Sir Red, who fills the king's ear with false reports of the brothers' access to gold-plated doves, a dazzling boar, and a supersonic lamp and coverlet set. Naturally the king demands these items, the brothers wring their hammy fists in despair, and Esben sets to work redeeming his brothers' honor via magical means. Esben murmurs a charm over his magical white stick—"Fly quick, my little stick, and carry me across the stream"—upon which he's delivered to a witch's house, conveniently stocked with everything he seeks. He steals each talisman in a series of increasingly hair-raising raids, feats met with relative ingratitude by the strapping brothers.

Lest hearts melt too easily for poor Esben, note that by fable's end, Esben has offed all thirteen of the witch's daughters and survived a heavenly-sounding torture of being fattened for slaughter on sweet milk and nuts.

WHY DO BRIDES (USUALLY) WEAR WHITE?

Queen Victoria first popularized the white wedding dress in Euro circles at her 1840 marriage to her first cousin Prince Albert of Saxe-Coburg. The couple married for love, an accidental by-product of a carefully strategic alliance. Bedizened in white Honiton lace on her wedding day, her face wreathed in orange blossoms, the young queen bride shone in pure white. In contrast to the brilliantly colored trappings and jewels royals usually wore, Victoria and Albert chose a willfully blanker canvas to mark the start of their union.

The populace rushed to imitate Victoria's whim. As early as 1849, *Godey's Lady's Book*—the *Good Housekeeping* of nineteenth-century America—issued its blessing: "Custom has decided, from the earliest ages, that white is the most fitting hue [for brides], whatever may be the material. It is an emblem of the purity and innocence of girlhood, and the unsullied heart she now yields to the chosen one."

A popular folk saying confirms the rightness of white for brides, along with adjudicating the rest of the rainbow for the occasion:

Married in White, you have chosen right,
Married in Blue, your love will always be true,
Married in Pearl, you will live in a whirl,
Married in Brown, you'll never live in town,
Married in Red, you will wish yourself dead,
Married in Yellow, ashamed of your fellow,
Married in Green, ashamed to be seen,
Married in Pink, your spirit will sink,
Married in Grey, you will go far away,
Married in Black, you will wish yourself back.

The purity of white cuts both ways. For the contemporary French, a "white wedding" indicates a marriage in name only, an unconsummated, administrative matter cut off from the actual community. (Much like the modern sham-marriages of Chinese closeted gays.) Similarly, when the Italians "go in white" (*andare in bianco*), they mean they've failed to score—in love or sex.

TERROR

ANTI-FLASH WHITE

A white paint with uncommon superpowers. In the 1950s and '60s, British and U.S. military coated their nuclear bombers in anti-flash white to deflect thermal radiation from a nuclear explosion, protecting both the plane and its occupants.

VICTORIA'S WHIM:
Also responsible for the craze for mauve fashions in 1858. See p. 98.

"WHITE IS THE MOST FITTING HUE":
In 1918 *Ladies' Home Journal* similarly ruled that baby boys should be dressed in pink, and baby girls in blue. See p. 16.

MARRIED IN YELLOW:
Hindi brides would beg to differ. See p. 60.

MARRIED IN GREEN, ASHAMED TO BE SEEN:
For the Scottish superstition against green wedding dresses, see p. 73.

SEX:
Aroused male characters in Japanese anime may be indulging in *pinku eiga*, Japanese porn films (p. 19). Ndembu brides in Zambia symbolize their sexuality with red marriage chicks (see p. 32).

UNCOMMON SUPERPOWERS:
Tetrachromats are women with amped-up color vision—see p. 134. To learn how aeronautic scientists made "forbidden colors" finally visible, see p. 127.

NUCLEAR EXPLOSION:
Another way the planet could go kaput is by "gray goo" miniature-robots. Stop laughing—this is science. See p. 110.

ROY
G.
BIV

WHITE

IT WAS THE WHITENESS OF THE WHALE THAT ABOVE ALL THINGS APPALLED ME . . . WHITENESS IS NOT SO MUCH A COLOR AS THE VISIBLE ABSENCE OF COLOR; AND AT THE SAME TIME THE CONCRETE OF ALL COLORS; IS IT FOR THESE REASONS THAT THERE IS SUCH A DUMB BLANKNESS, FULL OF MEANING, IN A WIDE LANDSCAPE OF SNOWS... ? AND WHEN WE CONSIDER THAT . . . ALL OTHER EARTHLY HUES— EVERY STATELY OR LOVELY EMBLAZONING—THE SWEET TINGES OF SUNSET SKIES AND WOODS; YEA, AND THE GILDED VELVETS OF BUTTERFLIES, AND THE BUTTERFLY CHEEKS OF YOUNG GIRLS; ALL THESE ARE BUT SUBTILE DECEITS, NOT ACTUALLY INHERENT IN SUBSTANCES, BUT ONLY LAID ON FROM WITHOUT; SO THAT ALL DEIFIED NATURE ABSOLUTELY PAINTS LIKE THE HARLOT, WHOSE ALLUREMENTS COVER NOTHING BUT THE CHARNEL-HOUSE WITHIN . . .

OF ALL THESE THINGS THE ALBINO WHALE WAS THE SYMBOL. WONDER YE THEN AT THE FIERY HUNT?

—Herman Melville, *Moby-Dick*, from chapter 42,
"The Whiteness of the Whale"

WHITE VAN MAN

The Oxford English Dictionary defines this British colloquialism as "a male driver of a (typically white) delivery or workman's van, esp. when regarded as an <u>aggressive or bad driver</u> . . . a social type, usually characterized as an ordinary working man with forthright views."

So invidious is the media image of WVM in England that the UK's Social Issues Research Centre commissioned a study in 1998 to probe the WVM's softer side on his own, perhaps <u>dirtily upholstered, turf</u>. To delve into the WVM's idea of snappy dressing, his fondness for pets (ponies, parrots, Airedales, and fish), and his occasional sing-alongs to opera tapes in his cab, read the report here: www.sirc.org/publik/white_van_man.html.

OPTIC WHITE

<u>Fictional colors</u> can vibrate with real power. In *The Invisible Man* by Ralph Ellison, the Liberty Paints factory specializes in Optic White, a shade whose blinding quality derives from its darker ingredients: It's made by mixing just a few black drops into a <u>foul brown pigment</u>. "Our white is so white," brags plant supervisor Mr. Kimbro, "you can paint a chunk a coal and you'd have to crack it open with a sledge hammer to prove it wasn't white clear through."

FADING INTO WHITE

The paleness presaging one's final decline makes white the color of death in many cultures. Ancient Indians rubbed leprosy-riddled skin until <u>bloody</u>, then pressed a paste of turmeric, colocynth, and indigo into the wound—the perfect balance of colors resembling healthy skin. More recently, the Dogon people of Mali compulsively dye plain white cotton <u>saffron</u>; the undyed white is too alarmingly like the void. Russians in northern provinces still stage theatrical parodies featuring a white-suited man in flour pancake, masked in white birch bark with huge chunks of white rutabaga stuck in his mouth for teeth. Perhaps most plaintively, mourning a Gypsy chief in years past involved following the body, borne in a white-painted cart, as it traced the chief's original migration in reverse.

AGGRESSIVE OR BAD DRIVER: Why are green cars considered unlucky? See p. 74.

DIRTILY UPHOLSTERED TURF: For more on ungentlemanly turf-rolling, see p. 73.

FICTIONAL COLORS: Let's get this straight: Imaginary colors are those lying outside of normal human color vision—see p. 127. Forbidden colors are color pairs you can't see simultaneously in the same space—usually. See p. 127. So fictional colors refers to the fanciful colors invented by science fiction writers (p. 128), philosophers (pp. 127 and 129), and the band Negativland (p. 129).

FOUL BROWN PIGMENT: Two nasty brown artists' pigments are mommia, made from dead mummy remains, and Isabella, named after a resolute, very dirty queen (p. 55).

BLOODY: Blood is bound up with the color red in practically all cultures. For fast hematological facts, see p. 27.

SAFFRON: an impossibly fragile purple flower used to stain fabrics and food yellow for centuries. Ingesting too much of it can kill you with excessive giggles— or so goes the lore. See p. 65-66.

ROY G. BIV

WHITE

CLOGS:
The clogs-inventing Dutch House of Orange liked to strategically drown their enemies with dike floods—and they were damn good at it. See p. 44.

WHITE STONE:
The Ka'aba of Mecca, the sacred black meteorite of Islam, fell to earth lily white but was gradually soiled by the blackness of human sin. See pp. 122-123.

FIGHTING GAME-COCK'S TAIL:
Slit a turkey's throat for the blood to mix into iconic American barn-red paint—see p. 33. For the tale of the red marriageable chicks of the Ndembu tribe of Zambia, see p. 32.

SUDAN:
The Sudanese notion of three kinds of black space manages to be both lovely and flatulent. See p. 117.

Spinning the globe over to Europe, the Western practice of wearing black for funerals is surprisingly recent: The switchover dates to the sixteenth century. The French queen Anne of Brittany (1477–1514) supposedly set the trend for wearing black while mourning. Her other nickname, the Duchess in Clogs, suggests her fashion sense wasn't always so spiffy.

IN-BETWEEN

THE WHITE STONE OF HOSPITALITY

Revelations 2:17 presents a white stone as a clean, if intriguingly vague, token of Christian rebirth: "To the one who conquers I will give some of the hidden manna. I will also give him a white stone. On the white stone is written a new name that no one knows except the person who receives it."

Brewer's Dictionary of Phrase and Fable (1898) expands on this enigmatic practice: "When the guest left, the host gave him a small white stone cut in two; on one half the host wrote his name, and on the other [that of] the guest; the host gave the guest the half containing his [host's] name, and vice versa. This was done that the guest at some future time might return the favour, if needed. Our text says, 'I will give him to eat of the hidden manna'—i.e. I will feed or entertain him well, and I will keep my friendship, sacred, inviolable, and known only to himself."

A COWARDLY WHITE FEATHER

If you spy a white feather in your fighting gamecock's tail, its blood—and its ire—may not be as pure as you'd like. Similarly, mailing a white feather to a British man not in uniform during wartime is a very pointed, if cravenly delivered, message. The 1902 British novel *The Four Feathers* by A.E.W. Mason encapsulates one such Brit's revenge: Go to the Sudan, kit yourself up as an Arab, fight a covert war on Old Blighty's behalf, hurry home, and hand each of those four feathers back to the low-slunk, very wrong bastards who gave them to you.

—Henry de Montherlant

I have ripped through the blue
lampshade of the constraints
of color. I have come out into the
white. Follow me, comrade aviators!
. . .

I have overcome the lining of the colored
sky, torn it down and, into the bag thus
formed, put color, tying it up with a knot. Swim!
The white free abyss, infinity, is before you.

—Kazimir Malevich, from his 1919 manifesto
"Non-Objective Art and Suprematism"

SHAME

In Hebrew, the color of shame whitens one's face (*hilbin panav barabim*), while in Hindi, shame blackens it (*Muh kaala kar deeya*).

DEADLY LEAD WHITE

Costly pigments and dyes often first emerged from their vats amid the acrid stink of urine and excrement. Lead-white paint provides a case in point. Produced according to Pliny's first-century recipe until Rembrandt's time, the pigment was made by workers who laid lead shavings over a bowl of vinegar until lead carbonate deposits formed, which were then powdered, flattened into pigment cakes, and dried in the sunshine. The Dutch "stack" process accelerated matters. Steaming vats of manure, placed in proximity to the lead and vinegar, "produced not only the heat to evaporate the acid but also the carbon dioxide to transform the substance from lead acetate to lead carbonate," as Victoria Finlay explains.

One night in the late 1800s, a watchman named Burrows spied a leaking fire flue and plugged it up with materials readily at hand: an old fire grate, stuffed with loose ore and coal shavings from the zinc refinery next door. Hours later, he passed by again—to a billowing cloud of zinc oxide fumes. Thus was born the American "direct" process of making zinc oxide: a faster, more productive, and cheaper process than the then-dominant French method. Zinc oxide's tendency to fluff up into thought-bubble-like tufts in the oven lent it other nicknames: "tutty" (for the Persian word *dud*, "smoke"), "zinc flowers," and "philosopher's wool."

URINE AND EXCREMENT:
The value of pee and poop alike to traditional color makers is a many-splendored, golden-shower thing. See pp. 56, 66.

THOUGHT-BUBBLE-LIKE TUFTS:
Other eureka moments in color history: William Perkin accidentally inventing mauve (and launching industrial chemistry as we know it), p. 98; Goethe, blowing his own mind with various color-perception experiments, p. xvii; astronomers wondering about the average color of the universe, pp. 135-136; anti-intelligence agents theorizing an attack of the dreaded "brown note," p. 57.

"PHILOSOPHER'S WOOL":
For Ludwig Wittgenstein's explanation of why there are no brown traffic lights, among other philosophical color-stumpers, see p. 127.

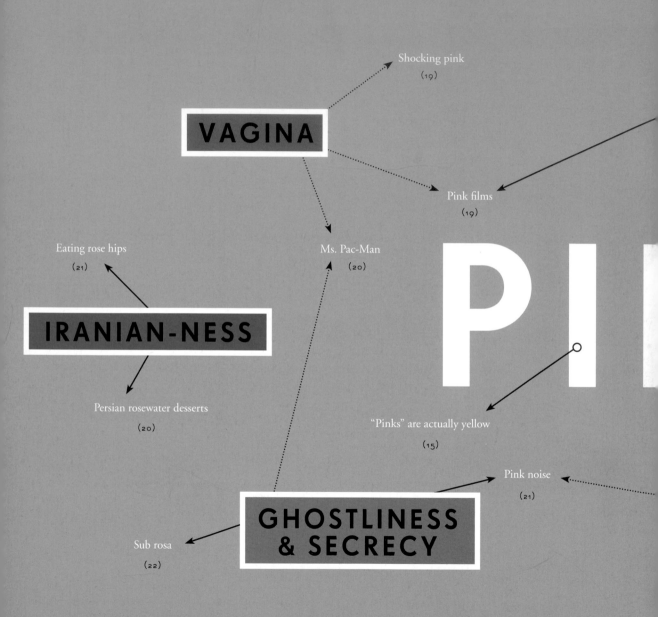

Shocking pink
(19)

VAGINA

Pink films
(19)

Eating rose hips
(21)

Ms. Pac-Man
(20)

IRANIAN-NESS

P I

Persian rosewater desserts
(20)

"Pinks" are actually yellow
(15)

Pink noise
(21)

GHOSTLINESS
& SECRECY

Sub rosa
(22)

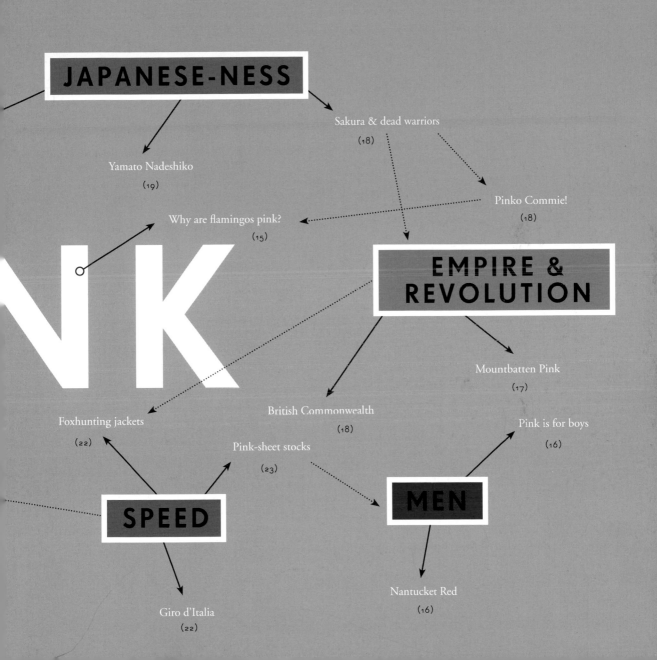

JAPANESE-NESS

Sakura & dead warriors
(18)

Yamato Nadeshiko
(19)

Pinko Commie!
(18)

Why are flamingos pink?
(15)

NK

EMPIRE & REVOLUTION

Mountbatten Pink
(17)

Foxhunting jackets
(22)

British Commonwealth
(18)

Pink is for boys
(16)

Pink-sheet stocks
(23)

SPEED

MEN

Giro d'Italia
(22)

Nantucket Red
(16)

I FELL OFF MY PINK CLOUD WITH A THUD.

—Elizabeth Taylor

"PINKS" ARE ACTUALLY YELLOW . . .

. . . when you're not referring to a green or brown pink, that is. To seventeenth-century chemists dabbling in artists' pigments, "pink" meant not a color but a type of pigment, what science historian Philip Ball calls a "pseudolake": an organic coloring agent bound to an inorganic, colorless substrate like crushed eggshell, alum, or chalk powder, which was then suspended in a spreadable, colorless liquid. Pinks differ from lakes in that the bond between colorant and substrate was physical, not chemical.

Seventeenth-century art historians, who could tell the difference, effused over the golden aura of yellow pinks (made with weld extract, broom, or unripe buckthorn berries), the verdant luster of green pinks, the rich mahogany of brown pinks, and finally blushing rose pink, made with brazilwood dye.

WHY ARE FLAMINGOS PINK?

Because they feed on carotenoid-rich crustaceans, from insect larvae to shrimp. Lesser flamingos in the pecking order grow more intensely pink from feeding exclusively on spirulina, a carotenoid-rich algae (which itself is green). Greater (i.e., socially dominant) flamingos are paler pink because they feed on animals that have already digested spirulina.

In his 2010 book *Travels in Siberia*, *New Yorker* writer Ian Frazier relates the following extraordinary tale. In January 2003 in the Siberian village of Verkhnemarkovo, amid swirling snows and crippling cold, a flamingo suddenly dropped from a white sky—miserable, dirty gray because of its pilfered diet, but alive and haughtily magnificent enough to capture the locals' attention. The villagers nursed the flamingo through the crushing winter, then transferred it to the zoo in nearby Krasnoyarsk.

Just a few years later a second frostbitten flamingo materialized, again uncannily landing within snowshoeing distance of the tropical winter garden in Severobaikalsk (whose director told Frazier this story). The villagers—no doubt enormously cheered up by this distraction—warmed the second flamingo back to health and later transported it to its friend in the nearby zoo. The first flamingo they named Phila, the second Phima.

LAKES:
For a crash course in traditional dyers and their lingo, see p. 15.

BRAZILWOOD DYE:
A madly popular, if fickle, reddish-pink dye. Lust for brazilwood drove the colonization (and naming) of Brazil. See p. 28.

CRUSTACEANS:
Another crustacean prominent in the color annals is the horseshoe crab, whose Smurfy blue blood makes a remarkably effective test for sepsis. See p. 88.

SIBERIA:
Yellow-painted pencils got that color thanks to a fortuitous discovery of graphite in Siberia—see p. 65.

ROY
G.
BIV

PINK

CRISP AGGRESSION
OF THE OFFICE:
For the secret semaphor-
ing of one gay financial
executive to another, see
pp. 108-109.

BABIES:
The Chinese celebrate
a new baby by throwing
a red-egg-and-ginger
party—see p. 33.

MEN

NANTUCKET RED

A trademarked shade of weathered red sold by Murray's Toggery Shop on Nantucket to unapologetically preppy men. You might think it was pink, but you'd be running afoul of Murray's to say so. It is not the color of Thomas Pink shirts signaling the elegant, crisp aggression of the office; not the color of pink polos dewed with sweat on the golf course; not a match to the rustling pink newsprint haunting the early-morning hours before the trading bell. Nantucket Red may be thoroughly relaxed, but it is decidedly not pink.

PINK IS FOR BOYS

The ironclad pink-is-for-girls, blue-is-for-boys rule took root only in the latter half of the twentieth century, according to Jo B. Paoletti, associate professor of American Studies at the University of Maryland and author of *Pink and Blue: Telling the Girls from the Boys in America*. Before then, babies were dressed in white or pale colors that could withstand frequent hot washings. Often parents chose colors according to their babies' complexions: Brown-eyed babies wore pink and blue-eyed ones wore blue.

 In the eighteenth and nineteenth centuries, the "French tradition" found pink an appropriately delicate shade for girls, while blue worked better for boys—but this rule was reversed (or ignored) in pockets of Belgium and the United Kingdom. In Catholic Germany, girls wore blue in homage to the Virgin Mary while little boys wore pink, a watered-down shade of traditionally masculine red.

In 1927, Wanamaker's in Philadelphia, Maison Blanche in New Orleans, and Marshall Field's in Chicago all hawked pink for girls while competing shopping emporia—Macy's and Franklin Simon of Manhattan, Bullock's of Los Angeles—positioned pink as a boy's color.

But the post–World War II period, exhausted with drab wartime hues, was saturated with brighter colors; pink was a standout that often (but not exclusively) got marketed to women. Noteworthy examples include the 1955 Dodge La Femme pink-and-white automobile (slogan: "By appointment to her majesty—the American woman") and the "Think Pink!" musical number in the 1957 film *Funny Face* starring Audrey Hepburn and Fred Astaire.

Paradoxically, Paoletti notes it was feminists' anti-pink backlash in the 1970s that cemented pink's association with the female—a backlash that continues in roiling waves. In 2008 sisters Abi and Emma Moore launched Pinkstinks.co.uk to protest the rampant "pinkification" of products geared to girls. Their Christmas 2009 boycott of a pink globe shone an unrosy spotlight on the pink ghettos lurking in toy stores. Neuroscientist Lise Eliot's 2009 book *Pink Brain, Blue Brain* offered an alternate spin: While pinkifying toys can be detrimental if it limits the suggested scope of girls' learning, little girls' love of pink can also be harnessed for educational good. For example, pink Legos could lull girls into practicing their spatial-relations skills, a cognitive area where girls are often lacking.

In any event, pink as a color isn't poisonous—only the politics the color can imply.

EMPIRE AND REVOLUTION

MOUNTBATTEN PINK

Technically a dirty mauve, Mountbatten pink was a shade of naval camouflage paint promoted by Admiral Louis Mountbatten for the British Royal Navy's use during World War II. The admiral colored his entire flotilla of destroyers this shade, intended to match the sky just before dawn or at dusk. Mountbatten Pink scored its most noteworthy "victory" by disguising the HMS *Kenya* (aka "The Pink Lady") in a commando raid off the coast of Norway. The Germans' pink marker dye, used to target shelling, matched the Pink Lady's hue so well, the Krauts wound up firing more at their own shells than at the ship.

PINK-AND-WHITE AUTOMOBILE:
An early forerunner of Mary Kay's fabled pink Cadillacs—see p. 17. Meanwhile, green cars carry an aura of bad luck for historical reasons—see p. 74.

PINK GLOBE:
Former British Commonwealth countries are still colored pink on many maps (p. 18), perhaps a testament to their many delightfully ball-busting queens. For Victoria's contributions to the color canon, see pp. 4-5 and 98.

POLITICS:
Whatever the politics involved, police the world over soak protesters with water cannons marked with purple dye. As to why, see p. 99.

MAUVE:
In 1856, a dabbling teenage scientist accidentally invented the first synthetic dye—launching twin crazes in fashion and industrial chemistry. See p. 98.

MATCH THE SKY:
Why is the sky blue, anyhow? See p. 86. Why are Earth's plants green—and was that their inevitable color? See p. 77.

ROY
G.
BIV

PINK

BEHEMOTH OF TRADE:
Another heavyweight of the color trade is the mighty, if diminutively sized, Mexican cochineal. See p. 28.

QUEEN'S POWER:
Queen Victoria wielded power in fashion, too—see her instigation of the "mauve measles" in 1860s England, p. 98, and setting the fashion for white wedding dresses, pp. 4-5. For a scruffier take on queenly power, read on about Isabella brown, pp. 55-56.

PASS THE
PETITS FOURS:
Napoleon's Reign of Terror landed the Great Little Man in exile on St. Helena, where—supposedly—he was poisoned to death by his green wallpaper. (See pp. 44-45.) Meanwhile, French aristos revived the post-Terror ballroom scene with gruesome *bals des victimes*—see p. 92.

WARRIORS' SOULS:
Scottish warriors smeared themselves in blue woad, which simultaneously frightened the bejesus out of their enemies while boosting their immunity to wounds—see p. 85.

Sadly, although perfectly hidden at dusk, once the sun actually rose above (or dipped below) the horizon, the ships became big pink targets. Mountbatten Pink lapsed into disuse in 1942.

THE BRITISH COMMONWEALTH

These fifty-four sovereign states, members of the former British Empire, are often colored pink on maps. In the empire's heyday, the pink countries represented a behemoth of trade, cultural ties, and a visible manifestation of the queen's power sweeping pinkly across the globe.

PINKO COMMIE!

A term coined in *Time* magazine in 1925, a pinko (or "parlor pink") will express fervent sympathy for the Soviet Red Revolution but rarely budge when urged toward stronger action. (Pass the petits fours.)

JAPANESE-NESS

CHERRY BLOSSOMS & DEAD WARRIORS

Since the Heian period (794–1191), the short life of sakura flowers (aka cherry blossoms) has made the perfect, elegiac symbol of life's transience. Just as sakura petals fall off all at once, so samurai die unquestioningly when duty calls. Kamikaze suicide units in World War II painted cherry blossoms on the sides of their planes, and folk wisdom suggested warriors' souls were reincarnated in the fragile blossoms.

YAMATO NADESHIKO

Femininity has a name in Japan: Yamato Nadeshiko, named for the willowy, pale-pink *nadeshiko* (frilled carnation, *Dianthus superbus*) flower native to the nation. Yamato is chaste, quiet, loving, obedient, but—per Japanese World War II propaganda featuring her image—will brandish her *takeyari* (bamboo spear) to kill if her family or chastity is threatened.

PINK FILMS

Soft-core erotic films popularized in Japan from the 1960s through the 1980s, pink films (*pinku eiga*) worked cleverly around Japanese censorship laws forbidding the display of pubic hair or the so-called "working parts" in a sex film. Classic pink films include *Go, Go, Second Time Virgin* (1969); *Inflatable Sex Doll of the Wastelands* (1967); and *Daydream* (1964).

VAGINA

SHOCKING PINK

Parisian couturier Elsa Schiaparelli coined the term "shocking pink" in 1937 as both the name of her signature perfume and the color of the pink box (shaped like Mae West's torso) the bottle came in. Schiap, as her friends called her, adored shock, especially when that shock involved a transgressive peek of pink: a giant lamb-chop-shaped hat, for example (a joint project with Salvador Dalí), or a dress with a pink, trompe-l'oeil breast stitched in fabric. Such outré behavior might explain how shocking pink became a slang term for female genitalia, although Schiap's motto hardly screams feminism to non-clotheshorses: "Never fit a dress to the body, but train the body to fit the dress."

WORLD WAR II PROPAGANDA: For the backstory on the Nazi brownshirts, see p. 55.

WASTELANDS: Scientists imagine a disaster scenario in which nano-sized robots replicate endlessly and gradually consume the planet. They call it "gray goo." See pp. 110-111.

LAMB-CHOP-SHAPED HAT: A sartorially adventurous Chinese man might wear this, provided it were not dyed green. See pp. 73-74.

SHOCKING PINK: Another color named after its inventor is International Klein Blue, named for its patent holder and agent provocateur Yves Klein (p. 86).

BOY-GHOST-ALSO-NAMED-SUE:
In another unintentional Johnny Cash homage, all-black knights in Arthurian legend tended to be secret good guys. See p. 123.

THEY TURN DEEP BLUE:
As to how the Hindu god Shiva got his nickname Neelkantha, "The One with the Blue Throat," see p. 91.

DIGITAL DEATH:
Other fanciful Deaths by Color include H.P. Lovecraft's story "The Colour out of Space"—see p. 128.

MILKS:
Across time and cultures, milk ranks as an everyday miracle. See p. 3.

SAFFRON:
For curious lore surrounding saffron, a costly yellow dye, see p. 65.

LIME:
It's possible to graft a lime, kumquat, lemon, and orange on the same citrus rootstock—and all will flourish from a single tree. For more curious facts about oranges, see pp. 38-40.

MS. PAC-MAN

Released in 1981 as a sequel to the monstro-successful Pac-Man, Ms. Pac-Man took game play to another level: Action quickened, ghosts got cagier, "warp tunnels" sucked fruit from side to side, and Ms. Pac-Man did it all with a floppy pink bow half-obscuring her eyes.

Another milestone of Ms. Pac-Man: the orange ghost Clyde was renamed Sue, likely the first (but surely not the last) transsexual video-game character. Clyde, the Boy-Ghost-Also-Named-Sue, operates in league with her brothers Blinky and Inky. Their goal: to eat Pac-Man and deduct one of his precious lives. However, when Ms. Pac-Man manages to down an energizer pellet herself, the tables are turned and hunter becomes prey. The ghosts are slowed down, they turn deep blue, they reverse direction, and if they're not lucky, they're eaten themselves. Their dead eyes, floating to home base at the center of the screen, represent one of the more heart-tugging instances of digital death.

IRANIAN-NESS

PERSIAN ROSEWATER

Persian desserts are rife with pink ingredients derived from rose petals, rose hips, and rose-tinted sugars, milks, and syrups. *Bastani-e Za'farāni*, Persian saffron-and-rosewater ice cream, is served between wafers, evidence of a fine tradition of ice cream in the desert. (Also delectable on a scorching-hot day: *faloodeh*, a rosewater-and-lime granita offset with sweet noodles and crushed pistachios.) By 400 B.C., Persians were already storing ice spirited down from the mountains and licking cones well into the summer months.

EATING ROSE HIPS

Rose hips—the dark pink or orange fruits of rose plants—are a minor miracle food. They ward off urinary infections, constipation, iron loss, and rheumatic arthritis pains in people. They also boost vitamin C production in pet chinchillas (who can't produce their own). The fine hairs inside a rose-hip bulb also make a nice itching powder.

GHOSTLINESS & SECRECY

PINK NOISE

Also known as "1/f" or "flicker" noise, pink noise is a signal with a frequency spectrum in which—ahem—"the power spectral density is proportional to the reciprocal of the frequency." So scientists define it. *New York Times* science columnist Natalie Angier put it this way: "Track the pulsings of a quasar, the beatings of a heart, the flow of the tides, the bunchings and thinnings of traffic, or the gyrations of the stock market, and the data points will graph out as pink noise. Much recent evidence from reaction-time experiments suggests that we think, focus and refocus our minds, all at the speed of pink."

Angier's article goes on to describe a 2010 study in *Psychological Science* that found that the pacing of Hollywood films—how scenes of different lengths are edited together—has evolved to resemble the patterns of pink noise. The pinkest film surveyed? *Back to the Future.* The least pink were two comedies from 1955: John Ford's *Mister Roberts* and Billy Wilder's *The Seven Year Itch.* (Yes, the one where Marilyn Monroe's dress flutters up over a subway grate, her pearl-pink thighs in full view.)

Fittingly, pink noise sits halfway between white and red noise (also known as Brownian noise).

CONSTIPATION:
A considerably more anarchic fix to this nagging problem could be found in the dread "brown note." See p. 57.

QUASAR:
Color terms help to differentiate between the infinitesimally small subatomic particles known as quarks (p. 138) and to pinpoint the age (and average color) of the known universe. See p. 135.

THE SEVEN YEAR ITCH:
Ah, jealousy is a multichromatic thing. For the Chinese red-eyed monster, see p. 32; for the Scandinavian "black socks" of envy, see p. 119. For a Gypsy charm to suss out cuckoldry, see p. 31. Finally, why do married Chinese men avoid wearing green hats? See pp. 73-74.

BROWNIAN NOISE:
As for its kissing cousin, Brownian motion: French physicist Jean Perrin applied Brownian motion to prove the existence of atoms in 1908. For his public demonstration, he elected to animate particles of gamboge, a poisonous but popular yellow paint pigment. See p. 66.

ROY G. BIV

PINK

SCENT RADIUS OF A SUSPENDED ROSE: Orange blossoms are laden with both scent and significance for blushing brides—see p. 40. For tales of an eccentric duke who assembles a garden of living yet unnatural-looking flowers, see p. 119.

SUB ROSA

A medieval plot hatched in secret blooms sub rosa—literally "under the rose," a flower suspended in actual or painterly guise from the room's ceiling. Pink roses emerged as reminders of secrecy in classical mythology: Cupid gave Harpocrates, the god of silence, a rose to bribe him not to betray Venus' confidence. Anything whispered within the scent radius of a suspended rose must remain inviolate.

SPEED

THE GIRO D'ITALIA

The winner of this long-distance cycling race throughout Italy scores the *maglia rosa* (pink jersey)—colored to remind bystanders of the pink pages of the sponsoring newspaper, *La Gazzetta dello Sport*. This unblushingly masculine event competes for sports lovers' attention with the Tour de France, in which the top cyclist takes a sunshine-yellow jersey home.

FOXHUNTING JACKETS

They're technically colored red, but they're functionally referred to as pinks, as in "donning your pinks" to hunt. As legend among the horsy classes goes, *pink* doesn't refer to red as it weathers and fades, but to a legendary hunting-garb tailor named Pink, Pinke, or even Pinque—a tale London clothier Thomas Pink is loath to dissuade its clients against.

PINK-SHEET STOCKS

Super-tiny, thinly traded, often-volatile stocks traded on what's known as the "over-the-counter" market. Pink sheets are <u>renegades</u>, unbound by most rules for disclosing financial information, and hence are pretty suspect. Before electronic quotes, quotes to these mad little puppies were printed on pink paper to alert all comers of the wild ride implicit therein.

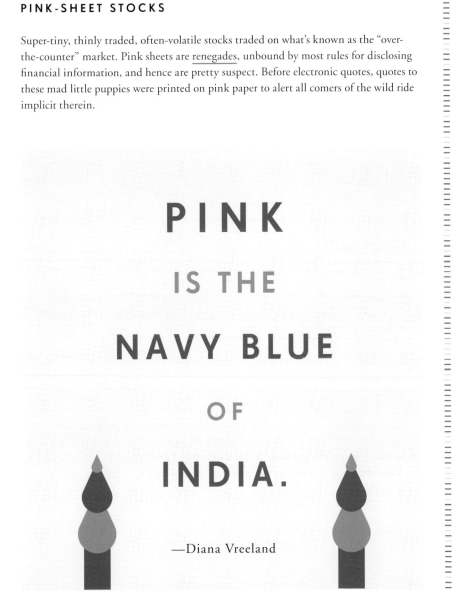

PINK

IS THE

NAVY BLUE

OF

INDIA.

—Diana Vreeland

RENEGADES:
Why do police the world over like to quell protesting crowds with cannons blasting purple-dyed water? It's a more cunning choice than one might imagine—see p. 99. For the sober yet virulent Protestant craze for black spanning three centuries, see pp. 120-121.

ROY
G.
BIV

PINK

BLOOD AND ELEMENTA

Red equals blood
(27)

Uncanny recurrence
(Germany)
(30)

FULL-BLOODEDNESS
AND ITS AFTERMATH

R

BUREAUCRACY
AND BINARIES

Why are barns red?
(33)

Minium
(29)

Why red = stop and
green = go

Red vs. Blue
(35)

(34)

brazilwood
(28)

The mighty Mexican
cochineal beetle

RED PAINTS/DYES

(27)

Red-eyed monsters
of China
(32)

Cuckolding test
(Gypsies)
(31)

JEALOUSY

Red-sewn chameleon
(Morocco)
(30)

ALL THE THINGS A
RED THREAD CAN MEAN

Red egg and ginger parties
(China)
(33)

ED

Chokers à la victime
(France)
(30)

BABIES

Red string of fate
(China, Japan)
(31)

The devil in redheads
(35)

Easily fooled
(Japan)
(33)

LOVE & MARRIAGE

RED, OF COURSE, IS THE
COLOR OF THE INTERIOR OF OUR BODIES.
IN A WAY IT'S INSIDE OUT, RED.

—Anish Kapoor

RED EQUALS BLOOD

First things first: Red is the color of blood. The dictionary even says so. (The color orange's association with the fruit is similarly chummy.) To that end, a few salient facts about that most vital avatar of red, blood:

Contrary to the fevered whisperings of know-it-alls, human blood isn't blue inside your veins before it hits the outside air. (That mistaken notion springs from color-coded diagrams of the circulatory system: red for veins, blue for arteries. Plus the vessels themselves look blue through your skin.) Human blood comes in two shades of red: a brightly oxygenated hue when pounding outward from the heart via the arteries, and a darker brick red when it returns to the heart, via the veins, deoxygenated. Plasma, the watery fluid in which blood cells are suspended, is straw yellow.

Blood's colors span the rainbow as one travels across the animal kingdom. Mollusks and arthropods have blue blood (from the copper-containing protein hemocyanin); the horseshoe crab's miraculous blood is also Smurfy blue. While hidden in the low-oxygen waters they prefer, the blood circulating inside these creatures hovers between gray-white and pale yellow. Sea squirts and sea cucumbers, thanks to proteins called vanabins, have mustard-yellow blood.

THE MIGHTY MEXICAN COCHINEAL

Once upon a time, a strong red dye for textiles was a rare and glorious thing. You had to make them primarily from insects, which varied in dye strengths and in some cases were very tough to capture. One such bug is *Porphyrophora polonica*, St. John's blood. It lives parasitically on the roots of the scleranth plant, found primarily in Poland, which had to be uprooted, cleaned, and stripped at harvest—all for a measly forty insects per rootstalk, a process that usually killed the plant in the process. Another color insect, the Armenian red scale (*Porphyrophora hameli*), clambers obligingly up from underground but is easily confused with insects with no dyeing power.

ORANGE'S ASSOCIATION WITH THE FRUIT: Oranges are, frankly, astonishing—and the tale of their global spread parallels the rise of civilization. See p. 41.

HORSESHOE CRAB'S MIRACULOUS BLOOD: High-tech modern medicine milks horseshoe crabs and puts their blood to powerful use. See p. 88.

INSECTS: Murex snails croaked by the trillions to empurple Roman emperors (see pp. 96-97). There is also that fictional color squant, detectable only by earthworms and their ilk (see p. 129)

BRAZIL:
Home to an eye-popping
one-hundred-plus races of
humans. For more, see pp.
53-54.

Enter the cochineal (genus *Dactylopius*), a tiny bruiser hailing from Mexico and points south. Benign parasites living off the prickly pear cactus, female Mexican cochineals could be simply brushed off their perch and dried to create a dyestuff packing an unrivalled chromatic punch. (The dyeing agent is carminic acid, a substance released by females that renders them unpalatable to predators.)

The market for cochineal reds was both bullish and durable. For two centuries the Spanish empire enriched itself to an eye-popping degree in cochineal dye exports, sustaining the color's mystique through complicated misinformation campaigns regarding the exact source of the dye. (The Spaniards kept alive a tantalizing old rumor of a "wormberry," a fabled creature shuttling constantly between animal and fruit.) The frenzy culminated in sweating Europeans plunging uninvited into the Mayan jungles, then smuggling out cactus nobs dusty-white with the insects. The cochineals, preening and apparently content with Spanish hegemony, tended to die en route home.

Think of all the heavy trade ships groaning across oceans in the sixteenth to eighteenth centuries—the prime imperial centuries—and consider the fact that those traders classified dyestuffs as a "spice." Mountainous piles of dried insects packed their hulls, densely crumby with maximized profit: Check your mental social studies textbook to weigh the economic wallop of *that*.

Even in the era of cheap synthetic dyes, real cochineal still stains many foods and drinks red. The lushly lipsticked mouth curving today over a sexy red lollipop: Both are, most likely, painted with the distilled essence of insects.

BRAZILWOOD

Another red dyestuff, brazilwood produced a flaming galaxy of orangey-pink, deep purple, and red dyes. Its downsides were several: Brazilwood-dyed fabric faded rapidly and tended to stiffen pricey cloth unattractively. Still, in an era of rare reds, it was so sought after that it infiltrated the distant land where it was harvested and gave that new sun-dappled country its name: Brazil.

MINIUM

Alchemy never was much good for making gold, but it wasn't without its handy by-products. By heating, macerating, precipitating, filtering, and shaking any raw ingredients that fell into their hands, alchemists accidentally invented many useful pigments and dyes.

Take red vermilion, also known as minium (and sometimes sandarach): a red lead paint that emerged with slow drama by simply heating white lead past a certain temperature. A hue redolent of blood oranges, minium burned so keenly in the minds of Persian and Indian Mughal artists that this reddish orange filled their canvases large and small to an enthusiastic degree. Later confusion of the paint's name with the Low Latin term

RUST-PROOF:
Rust fighting informed an iconic recipe for red paint on American (and Swedish) barns. See p. 33.

GOETHE:
A multitalented giant of the Enlightenment, Goethe himself was proudest of his book on color perception, iffy science and all. See p. xvii.

BRITISH MARINES:
For the backstory of Mountbatten pink, the Royal British Navy's military pink paint, see p. 17.

BATTLE:
Scottish warriors slathered themselves in blue wood dye before battle, frightening the bejesus out of their enemies while giving them a surprising medical advantage in combat. See p. 85.

minutum, meaning "a small portion," birthed a new word: *miniature*, a painting of any size painted gorgeously in minium.

Minium, which is naturally rust-proof, is now used to color and protect steel bridges.

ALL THE THINGS A RED THREAD CAN MEAN, #1: UNCANNY RECURRENCE

To the Germans, *der Rote Faden* connects the disparate dots of a buried, recurring theme in one's life or in a fictional story. (Say Cousin Billy accidentally broke your wrist, maimed your dog, got you your first job, married your first girlfriend, then washes up with you on a desert island. Like it or not, the Germans would call Cousin Billy's toothy, rueful apologies a *Rote Faden* of your life.)

The first *Rote Faden* appears in Goethe's 1809 novella *Elective Affinities*. Describing one character's discursive writing style, hopping from subject to subject but returning to certain themes, Goethe writes of "a curious practice of the British marines. The ropes of the royal navy's fleet, from the sturdiest to the thinnest, all have a red thread woven tightly into them, such that it cannot be removed without unraveling the whole, the smallest part of which announces these ropes belong to the Crown."

ALL THE THINGS A RED THREAD CAN MEAN, #2: THE STUFFED-CHAMELEON CHARM

Until the early twentieth century, Moroccan soldiers killed and gutted chameleons, embalmed them with coriander seeds, stitched their bodies closed with red silk thread, then slung their gory stuffed-animal friends over one shoulder before trudging into battle.

ALL THE THINGS A RED THREAD CAN MEAN, #3: CHOKERS *À LA VICTIME*

Certain questionable accounts of France's Reign of Terror chronicled the "victims' balls" thrown by rich young people seeking to revive the anemic post-Terror ballroom

scene. Only relatives of those who died by <u>guillotine</u> could attend. "Guests showed up with the nape of their neck shaved, as though prepared for the guillotine, and with a red thread around their throat," writes François Gendron in a 1993 account. "They greeted one another *à la victime* by imitating the sudden drop of the head as it is lopped off by the falling blade."

In a possibly related sartorial note, <u>"to wear the *bonnet rouge*"</u> indicates savagery in modern French.

ALL THE THINGS A RED THREAD CAN MEAN, #4: THE CUCKOLDING TEST

When ill, European Gypsies wrap their ring fingers with a red thread, preventing the fever from drawing out a sweat. Similarly, a Gypsy husband sweating out a suspected infidelity could apply the red-thread test to his wife. The charm-making recipe is deliciously strict: He must thread together three magpie skulls on three boxwood or rosemary twigs denuded of their leaves, tie the contraption together with a truth-invoking red thread, and slip it under his wife's bed. Faithful wives will sleep placidly; <u>cuckolding</u> ladies will toss and turn and spill the juicy details in their sleep.

ALL THE THINGS A RED THREAD CAN MEAN, #5: THE RED STRING OF FATE

Similar to the Western idea of finding one's "other half," the Chinese and Japanese share a belief in an invisible red string of fate that binds two people destined to get married. The Chinese tie their lovers together by the ankles, the Japanese often by their pinky fingers. In both cases, the lunar god of matchmakers Yuè Xià Lǎo (月下老) oversees the binding.

THE RED MARRIAGEABLE CHICKS OF THE NDEMBU

Spin the globe and plant your finger at random on any spot: Some red-soaked fertility ritual exists there. Usually a blood fest signaling the advent of passion and the familial constraints that must contain it, many of these rituals are balls-to-the-wall explicit and

GUILLOTINE:
Could Napoleon have been slowly poisoned to death by his penchant for steamy baths in a green-wallpapered room? Weigh the evidence on pp. 74–75.

"TO WEAR THE BONNET ROUGE": Foreign languages abound in quixotic color sayings, and the colors don't always line up with mental states as you'd suspect. See pp. 32, 60, and 97 for more examples.

CUCKOLDING:
Why do a half billion Chinese men never, ever wear green hats? See pp. 73–74.

ROY
G.
BIV

RED

JEALOUSY:
As for the Scandinavians, they don the black socks of envy (p. 119), while the Germans turn yellow (p. 60).

literal-minded. The Ndembu people of Zambia boast a surprisingly touching ritual in which young girls are given a baby chick reddened with ocher: a living embodiment of their newfound access to sex and childbirth. "Only after her first sexual union does the bride wash away the ritual red pigment," writes ethnologist Anne Varichon, "and the reddened water is kept in the house to promote the arrival of children. As for the chick, it is allowed to grow free in the courtyard."

THE RED-EYED MONSTER

Jealousy in Chinese colors your eyes red (yǎnhóng 眼红, red-eyed), a trick produced either by crying yourself red-rimmed over longing, or simply from the sanguinary force of your desire, filling you up to the eyelids.

A

THIMBLEFUL OF RED

IS REDDER

THAN A BUCKETFUL.

—Henri Matisse

RED-EGG-AND-GINGER PARTIES

The color of good fortune, red colors many Chinese rituals, including welcoming a new baby at a red-egg-and-ginger party. The ritual is called—with a whiff of officiousness—*pao-hsi*, "Reporting Happiness." One month after the baby's birth, parents welcome guests who bring the family eggs dyed in red ocher. The white ovals of eggs stained red look much like the babies' round faces, red and hollering: a great circle of renewal and diapers.

EASILY FOOLED

The Japanese also focus on a baby's red face as a synecdoche for the full package; their word for baby, *akachan*, translates loosely as "little red one." Along these lines, when Japanese steal candy from proverbial babies, they describe something all too easily accomplished as *akago no te o hineru* (赤子の手をひねる), "to twist a [red] baby's hand."

WHY ARE BARNS RED?

The answer springs not so much from hard fact as a network of plausible theories, like lazy flies circling a cow. In his book *American Barns and Covered Bridges*, Eric Sloane recounts how early American barns went unpainted until the late 1700s, when prosperous Virginians and Pennsylvania Dutch concocted a red paint of milk, lime, and rust flakes—a poison to fungi that trap moisture in wood, promoting rot—and started applying it to barns. Adding linseed oil gave the paint suppleness in drying.

From this factual starting point the explanatory lore spools outward. A pigment called Indian Red supposedly rivaled the rust-milk-lime varietal in some regions; it consisted of clay mixed with the whites of wild turkey eggs, with a dash of turkey blood staining it a mahogany shade. Adding blood to any folklore seals a visceral bargain of sorts; it makes a myth sing. The fresh milk of cows, the flaking rust of well-used tractors, the blood of Thanksgiving turkeys, and the clay earth underpinning them: What recipe could be more bountifully American?

Yet Americans fail to dominate the global barn-red myth market. Falu red—a mixture of water, rye flour, linseed oil, and residue from the copper mines of Falun in Dalarna, Sweden—is similarly iconic to the Scandinavians. So much so, in fact, that the Finnish

EGGS:
What makes some egg yolks orange and others yellow? The chicken's feed, of course. See p. 62.

LAZY FLIES CIRCLING A COW:
Cows fed exclusively on mango leaves get super-lethargic (and eventually die). But that cruelty does yield a knockout yellow pigment. See p. 66.

MILK:
Rabbis, mullahs, and moms agree: milk is indeed extraordinary. See p. 3.

ROY
G.
BIV

RED

DETROIT:
For the spectacular 1920 car crash that spooked Detroit against painting automobiles green, see p. 74.

RED-GREEN COLOR-BLIND MEN:
Color-blindness has an unusual obverse: tetrachromacy, or amped-up color vision in some women. See pp. 134-135.

A BILLION CHINESE:
Why do a half billion Chinese men never, ever wear green hats? Hint: It's a cuckolding thing. See pp. 73-74.

expression *punainen tupa ja perunamaa*, "a red house and a potato field," epitomizes a snug family homestead in the way our "house with a white picket fence" does. One is tempted to cobble together an IKEA-inflected national myth from Falu red's ingredients—is that rickety shelf actually made of pressed wood or stale rye crackers?—but a country's barn paint should, after all, be sacred.

WHY DOES GREEN MEAN GO AND RED MEAN STOP?

Transportation historians hardly ever get described as "maddeningly coy," but in the history of automotive traffic lights, it's a fair description. Their answer to this simple-seeming question evokes an endless series of Russian nesting-dolls: Traffic lights for cars borrowed the prevailing colors from railway switching signals. (Don't ask how railway switches got their color-coding.)

Whatever it lacks for other facts, the history of traffic lights is packed with whiz-bang noise. On December 9, 1868, the world's first traffic light rose near Westminster, London. Railway engineer John Peake Knight's premise was to treat main thoroughfares like large train arteries and smaller streets like spur lines. A policeman—no doubt dying for his next teatime—adjusted the signal's arms manually to dam or release the traffic flow of carriages, buggies, horse-drawn carts, and people sashaying about. At night, gas-powered lights cut through the fog: red for stop and green for go.

London's first traffic light was a cracking success—until it exploded from overloaded circuits a month after its debut. Americans hopped on the idea, introducing traffic "semaphores" in Cleveland, Detroit, and New York. Traffic lights gradually automated, first changing in response to a honk, then mercifully switching to a pressure sensor embedded in asphalt. Europeans got back on the bandwagon later, and traffic lights eventually twinkled across the globe, red-yellow-green.

Why red, why green? Nobody knows. The choice may seem questionable to millions of red-green color-blind men, but at least the order of colors is fixed worldwide. Deliciously, the Chinese Communists took a propagandist stab to the contrary, enforcing a red-means-go policy for a brief period. Eventually, however, they relented: an unusual instance of a billion Chinese actually being wrong.

RED VS. BLUE

Cognitive psychologists love pitting red against blue in experiments. For example, red rooms make people working in them more accurate and cautious, and blue turns them more creatively loose—so claims a 2009 study in the journal *Science*, not for the first time. Other findings: Teams in red Olympic uniforms enjoy a statistically significant edge over those clad in blue, while red test covers on IQ tests can make us antsy enough to drag down scores.

THE DEVIL IS REDHEADED

"*Rosso de pelo, cento diavoli per cavelo*," murmur older Venetians suspiciously as a carrot-top sails insouciantly by: "Redheaded, a hundred devils per hair." Flaming-red hair may raise eyebrows simply from its rarity: less than 1 percent of the global population sports a natural ginger top, and only 2 to 6 percent of Americans. (Scots trump all other countries for redheads at 11 percent.)

Ginger-headed folk have roundly taken abuse across times and cultures. To makers of potions and artists' pigments in less scientific times, a healthy redhead amounted to a collection of precious ingredients: Their blood, fat, urine, even whole undiseased carcasses were hotly in demand. Medieval European painters made Judas's evil unmistakable with a hideously specific palette: black skin with flaming red hair.

Modern science hasn't dropped the redhead-torturing impulse. Just a few years ago, two parallel studies came to near opposite conclusions on the question, Are redheads built to take extra pain—or are they actually morbidly sensitive? The Cleveland Clinic found that redheads do feel more pain and are more resistant to anesthetics. Simultaneously, researchers at McGill University poked and prodded both redheaded mice and humans, concluding contradictorily that redheads have a *higher* pain tolerance and greater sensitivity to painkillers. (The link stems from the melanocortin 1 receptor gene, responsible for both redheadedness and pain receptivity.)

The jury is out—for now. But the practice of singling out redheads for iffy, uncomfortable science continues.

WHOLE UNDISEASED CARCASSES:
Mommia is a brown artist's pigment made from Egyptian mummy remains. Yes, really. See p. 56.

FEEL MORE PAIN:
The science-fiction colors jale and ulfire are sensate: Jale is voluptuous, while ulfire is actively pained. See p. 128.

ROY
G.
BIV

RED

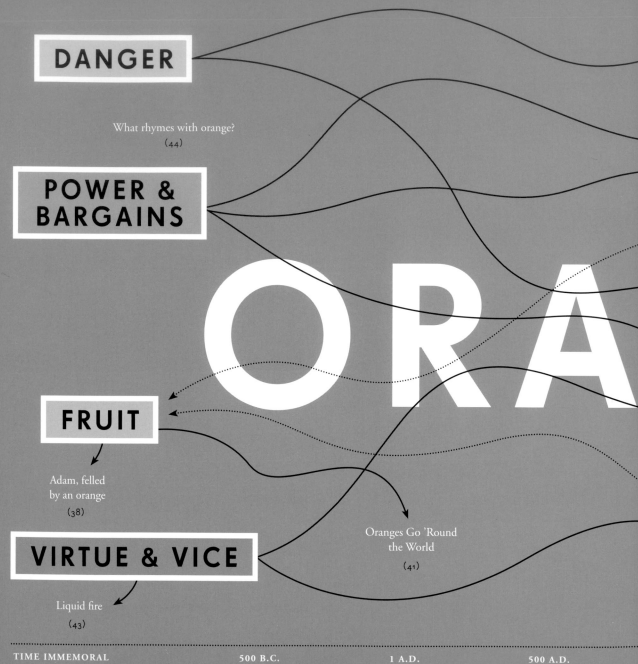

DANGER

What rhymes with orange?
(44)

POWER &
BARGAINS

ORA

FRUIT

Adam, felled
by an orange
(38)

Oranges Go 'Round
the World
(41)

VIRTUE & VICE

Liquid fire
(43)

TIME IMMEMORAL 500 B.C. 1 A.D. 500 A.D.

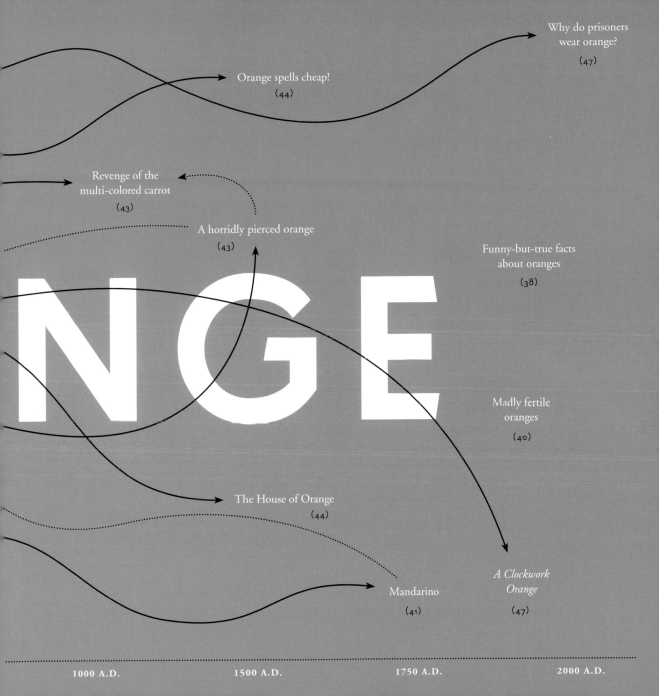

Why do prisoners
wear orange?
(47)

Orange spells cheap!
(44)

Revenge of the
multi-colored carrot
(43)

A horridly pierced orange
(43)

Funny-but-true facts
about oranges
(38)

NGE

Madly fertile
oranges
(40)

The House of Orange
(44)

Mandarino
(41)

*A Clockwork
Orange*
(47)

FRUITS:
For the deeply fertile black that reminds Iraqi Uruks of ripe fruit, see p. 119. For an introduction to the wormberry, a fabulous creature that shape-shifts between animal and plant states, see p. 28.

ORANGE

ADAM, FELLED BY AN ORANGE (OR A BANANA)

Was it really an apple that destroyed the garden of Eden? Rabbis squabble in the Talmud and Midrash over a wild range of fruits: Was it a fig? Or a grape? (A few dare to ask: Was it wine, *made* from grapes?) One rabbi suggests Adam and Eve could've been felled by wheat. The Koran's Tree of Knowledge apparently bore evil bananas. Pomegranate and quince each have their proponents, too.

In the Book of Enoch 31:4, the antediluvian prophet describes the tree of knowledge: "It was like a species of the tamarind tree, bearing fruit which resembled grapes extremely fine; and its fragrance extended to a considerable distance." The Hebrew word used in the Bible, *tapus*, and the Latinate *malum* both translate to "apple" in a generic, any-kind-of-fruit sense. (Think of the modern French word for potato, *pomme de terre*, which literally means "apple of the earth.")

Yet another tempting fruit grew lushly from trees in Asia Minor during Biblical times: the humble orange.

FUNNY BUT TRUE FACTS ABOUT ORANGES

In his lovely book *Oranges* (1967), John McPhee takes the Florida orange juice industry as a starting point to explore every succulent pip of the fruit's history and meaning. Among the fruit's quirks: Oranges acquire their color via exposure to cold air; an orange orange is not necessarily ripe but has certainly suffered a stiff chill. In tropical climates, however, temperatures may never dip low enough to turn the fruit from green to orange. As McPhee explains, "In Thailand, the orange is a green fruit, and traveling Thais often blink with wonder at the sight of oranges the color of flame."

Citrus trees grow like *Frankenstein*: The trunk (or "rootstock") is usually a Rough Lemon or Sour Orange plant, while the branches can be any citrus fruit, grafted onto the trunk after blossoming. A tree heavy with lemons, limes, oranges, grapefruit,

THE ORANGES OF THE ISLAND
ARE LIKE BLAZING FIRE
AMONGST THE EMERALD BOUGHS
AND THE LEMONS ARE LIKE
THE PALENESS OF A LOVER WHO
HAS SPENT THE NIGHT CRYING . . .

—Abdur-Rahman Ibn Muhammad Ibn Umar

SPONTANEOUS VIRGIN SELF-INSEMINATION: Other strange but true miracles of color: tetrachromacy, a genetic mutation that amplifies color vision (p. 134); how aeronautics engineers can temporarily overcome the human eye's limits to reveal "forbidden colors" to a lucky few (pp. 127-128); what synesthesia, a mostly harmless color hallucination, reveals about cognitive function (pp. 132-133).

VICTORIAN ENGLAND: Victoria authored several color crazes in her day. In a firmly romantic, minimalist move, she established the tradition of white wedding dresses (see p. 4). Then she fanned appetites for mauve by wearing it to her daughter's wedding in 1858—while coincidentally kick-starting the field of industrial chemistry. See p. 98.

tangerines, and kumquats all at once is entirely possible. Oranges are variously capable of reproducing sexually or asexually, incestuously or even by spontaneous virgin self-insemination. As one pomologist (orange scientist) observed to McPhee: "The sex life of citrus is something fantastic."

Oranges are sweeter if they grow near the top of the tree versus near the bottom, or on the south side of the tree versus the other directions. Pluck an orange precisely from the optimal zone, then sink your teeth into its blossom end for the sweetest bite of all.

THE MADLY FERTILE ORANGE

Orange blossoms offer a near-perfect symbol for brides: Pale white and delicate as flowers, they mature into heavy, fragrant fruits from trees that bear prolifically, year after year. Brides have clutched orange blossoms in the West since Muslims brought the custom from the Middle East to Europe—perhaps never so avidly as in Victorian England.

In a racier vein, tantric yoga teaches that orange is the color of the fertile sacral chakra, or Svadhistana, just below the navel and tantalizingly close to the genitals.

Despite all this sexiness, oranges convey a distinct freshness, too. Orange pomander balls once cut the stench of public places in the days before air-conditioning. Gaunt Dickensian figures (among them the sixteenth-century figure Thomas Cardinal Wolsey) clapped hollowed-out orange rinds to their noses before hitting the fetid-smelling streets.

Jamaicans slice oranges in half and scrub the floor with them; Mexican women relax after childbirth in baths of orange leaves. Orange-oil solvents also cut grease in eco-friendly cleaning products. Its active ingredient, d-limonene, can be used to kill fire ants: By disrupting their scent-pheromone trail, a smear of d-limonene foils their attempts to reinfest a destroyed mound.

ORANGES GO 'ROUND THE WORLD

Here's how the global migration of oranges resembles a Q*bert tournament final. Picture a bouncing orange over China that—twenty million years ago—springs across to the Malay Archipelago to India, then to the east coast of Africa. The orange hops to the Mediterranean (during sixth to seventh century A.D.), as Islamic armies conquered vast territories between India and Spain.

Bonus round! Thousands of little oranges sprout all over the Continent in fabulous indoor *orangeries*, reaching northward as far as Great Britain, until a few hardy oranges stow away in Christopher Columbus's ships to proliferate in a second jackpot across the equatorial belt of the New World. Pizarro brought them to Peru, Ponce de Léon brought them to Florida, and all those hairy-smocked Spanish missionaries brought more to California. Today oranges flow in giant international-trade-wave torrents from Brazil, Florida, and the orange's twin birthplaces, China and India.

MANDARINO

"What is it about orange that invites the antic?" writes Alexander Theroux in *The Secondary Colors*. He recounts a (possibly apocryphal) "game called Mandarino, orange tossing while quoting from memory alternate lines of Horace's *Odes* . . . [It's] a pastime ecclesiastics of the Catholic Church, mainly in Rome, I gather, often play." The mental image is itself delectable: Their rope rosaries swinging, negotiating their robes, the priests sing and catch, sing and catch as a summer evening darkens:

> "If you decant Massic wine under a flawless sky," sings one monk
> and pitches an orange to his brother.
> "Any cloudiness will be cleared by the night-time air," answers
> another, catching, then putting a little spin on the fruit in
> return. "The bouquet that sets the nerves on edge will fade,"
> chants number one, tossing it back underhand.
> "But its full flavor's lost if it's strained through linen," replies his
> comrade, lobbing the orange high into the sky.

Q*BERT:
Ms. Pac-Man represents a twin triumph: a madly successful video game with a Ginger Rogers–esque feminist hero at its center, the Lady Pac herself. For the game's history in miniature, see p. 20.

SECOND JACKPOT:
Another slam-dunk product of colonial Spanish trade: the cochineal insect, source of a brilliant red dye. See p. 28. An even hotter commodity among color traders was murex snails for purple dyes (pp. 96-97).

ROY
G.
BIV

ORANGE

THERE WAS NO RECORD OF ANYTHING ELSE, AMONG THE GUERMANTES, [SERVED] IN THESE [SUMMER] EVENINGS IN THE GARDEN, BUT ORANGEADE. IT HAD A SORT OF RITUAL MEANING. TO HAVE ADDED OTHER REFRESHMENTS WOULD HAVE SEEMED TO BE FALSIFYING THE TRADITION… FOR THIS FRUIT JUICE CAN NEVER BE PROVIDED IN SUFFICIENT QUANTITIES TO QUENCH ONE'S THIRST FOR IT. NOTHING IS LESS CLOYING THAN THESE TRANSPOSITIONS INTO FLAVOR OF THE COLOR OF THE FRUIT WHICH WHEN COOKED SEEMED TO HAVE TRAVELED BACKWARDS TO THE PAST SEASON OF ITS BLOSSOMING. BLUSHING LIKE AN ORCHARD IN SPRING, OR, IT MAY BE, COLORLESS AND COOL LIKE THE ZEPHYR BENEATH THE FRUIT TREES, THE JUICE LETS ITSELF BE BREATHED AND GAZED INTO DROP BY DROP.

—Marcel Proust, *In Search of Lost Time*

LIQUID FIRE

The bold-as-brass biblical trio—Shadrach, Meshach, and Abednego—perish in molten orange style in a furnace. Their crime: refusing to worship the towering golden god proffered by the Babylonian king Nebuchadnezzar. William T. Vollman retells this tale in *The Rainbow Stories:* "Liquid fire dripped from the ceiling as if a <u>million plastic party glasses had been set aflame</u> . . . It seemed to Meshach that the three of them wore the rare orange garments of kings."

A HORRIDLY PIERCED ORANGE

According to Italian folklore, here is what a Sicilian Ebeneezer Scrooge might do: tuck an orange or a lemon in his jacket pocket and carry it with him to Midnight Mass on Christmas Eve. At the propitious moment as the priest raises the Holy Sacrament, he'd tear a strip of the orange's peel away and pierce it grimly with pins while chanting, *"Tanti spilli infiggo in questlarancia, tanti mali ti calino addosso."* ("As many pins as I stick in this orange, may as many ills befall you.") Then he'd stomp home to a cold hearth, tossing the fruit into a well or cistern to complete the fatal charm. *Buon Natale* (Happy Christmas) to you!

REVENGE OF THE MULTICOLORED CARROT

All carrots are not created orange. Yellow and purple carrots date from 900 A.D. in <u>Afghanistan</u> and dominated markets from the Middle East to Europe until the Dutch popularized orange carrots in the sixteenth century, effectively extinguishing other varieties. As demand for all things artisanal and bespoke has increased, modern plant geneticists are now reviving purple carrots—previously sold only in odd pockets of Turkey for pigment or blended with turnips as a summertime drink. They similarly jumped enthusiastically on red carrots in New Delhi markets and yellow carrots from Syria, North Africa, and Beijing.

MILLION PLASTIC PARTY GLASSES HAD BEEN SET AFLAME: Creepy parties in color's history: the *bals de victimes* thrown after Napoleon's Reign of Terror (pp. 30-31); an all-black dinner commemorating the momentary loss of the host's libido (p. 119).

AFGHANISTAN: Chasteningly expensive ultramarine paint comes from lapis lazuli mined in Afghanistan; later, artist Yves Klein cashed in on ultramarine's appeal with his own patented International Klein Blue. See p. 86.

OPENING THE DIKES TO FLOOD OUT ENEMIES:
Cops the world over aim water cannons filled with purple dye at protesters, tagging the miscreants for later retribution. In the last fifteen years alone, protesters in South Africa, Indonesia, Hungary, Israel, and India have formed one purple-soaked mass, yearning to be free. See p. 99.

DECORATING SCHEMES:
Was Napoleon poisoned to death by his arsenic-laced green wallpaper? Science investigates on pp. 74–75.

PARLOR GAME AMONG POETS:
Every year the Bulwer-Lytton Fiction Contest awards what it proudly calls a "pittance" to the best writer of a stinkingly bad first line of an imaginary short story. See p. 101.

THE HOUSE OF ORANGE

In the sixteenth century, orange became the pennant color of William I of Orange, founder of the Dutch House of Orange-Nassau. "William the Silent" flung off Spanish rule of the Netherlands in a protracted battle from 1568 until he was assassinated in 1584. The resulting House of Orange was famed for rabid Protestantism, peasant solidarity, and a predilection for opening the dikes to flood out enemies.

A century later, William III of Orange was wed to the English throne, a move that prevented the Catholic heir apparent from taking the crown. Which in turn explains why so many American towns, founded by Scotch-Irish Protestants, named themselves "Orange"—not to mention explaining, if not excusing, the copycat decorating schemes of so many Irish bars.

ORANGE SPELLS CHEAP!

Brewer's Dictionary of Phrase and Fable calls orange "the ancient color appropriated to clerks and persons of inferior condition; it was also the color worn by the Jews." Which explains this zinger buried in Lord Francis Bacon's 1597 *Essays*: "Usurers should have orange-tawny bonnets, because they do Judaise."

WHAT RHYMES WITH ORANGE?

A favorite parlor game among poets is faking your way toward that all but impossible rhyme with the word orange.

"I can think of a lot of things that rhyme with orange," said rapper Eminem in a 2010 interview with Anderson Cooper for *60 Minutes*. He then spooled out a spontaneous rap about putting an "orange four-inch door hinge in storage" and having "porridge with Geo-rge."

Orange's other near rhymes include *lozenge, flange, Stonehenge,* or (unpleasantly) *sore minge.* A few proper names fit the bill: *Blorenge,* a hill in Wales; *Dorenge,* a town in France; or *Gorringe,* as in Commander Henry Honeychurch Gorringe, the American naval officer responsible for transporting the "Cleopatra's Needle" obelisk from Egypt to New York's Central Park in 1881.

There's also *sporange,* short for *sporangium,* a botanical term for a capsule containing spores.

SILVER:
What rhymes with silver?
Some odd, archaic words
that will be guaranteed
cocktail-chat fodder. Cash
in on the goods on p. 109.

PURPLE:
Do any words in English
rhyme with purple? Hirple
your way over to
pp. 101-102.

46

The hit parade of "Rhymes with Orange" poems is pleasantly scurrilous, epitomized in this anonymous Internet find:

> You can slit your wrists discreetly
> Whilst your family is drowsing,
> You can hear your neighbors breathing
> Through the walls of council housing
> You can be so odd,
> You don't find every inch of me arousing,
> But you'll never find a rhyme for orange.

Other allegedly unrhymeable words in English include silver, purple, month, bulb, jaguar, and film.

A CLOCKWORK ORANGE

Anthony Burgess's famed 1962 tale of ultraviolence takes its name from the Cockney expression "as queer as a clockwork orange"—roughly equivalent to our mistrust of a three-dollar bill. Drawing on his own experience working in the British Colonial Office in Malaysia, Burgess was also tickled by the fact that the phrase could punningly refer to a mechanically responsive (clockwork) human being (*orang*, Malay for man).

In the introduction to the 1986 edition of his novel, he remarked that a creature who can perform only good or evil is a clockwork orange, "meaning that he has the appearance of an organism lovely with color and juice, but is in fact only a clockwork toy to be wound up by God or the Devil . . . or the almighty state."

WHY DO PRISONERS WEAR ORANGE?

For visibility (particularly during perp walks) and a strong visual separation between those inside the cage and those outside of it. American jails switched state by state in the early twentieth century from prisoners in zebra-striped prison garb to solid orange jumpsuits; traditional black-and-white stripes were too shamefully associated with chain gangs and forced labor to persist in a modern, hopefully enlightened era.

More interesting are the institutional deviations away from the now-standard orange jumpsuits. As *Slate*'s Explainer column puts it: "New York State actually bans the color orange among prisoners: It issues uniforms that are 'hunter green,' and lets them wear their own T-shirts, as long as they're not blue (the color of prison-guard uniforms), black (too hard to see), gray (other officials wear it), or orange (the color worn by the Correctional Emergency Response Team, or riot control)." An alternate strategy by the Cleveland County prisons mixes high visibility with ludicrousness. Their prisoners wear pink shirts and yellow-and-white-striped pants, a combo Cleveland sheriffs think will deter escape. Call it Clown Suit Deterrence.

THREE-DOLLAR BILL:
How did the U.S. greenback take on its hue? See p. 78.

PRISON:
Yellow ribbons tied around trees once signaled that a prisoner was welcome back home on his release—see p. 68. Meanwhile, menacingly cheerful yellow wallpaper once symbolized the domestic prison of "hysterical" women. See p. 69.

ROY
G.
BIV

ORANGE

UBIQUITY

Brownie
(52)

Puce
(52)

All to astonish
the Browns!
(53)

BRO

The Browns
of Benin
(52)

Nazi Brownshirts
(55)

The Tintometer
(52)

THE BROWN
PRIMEVAL

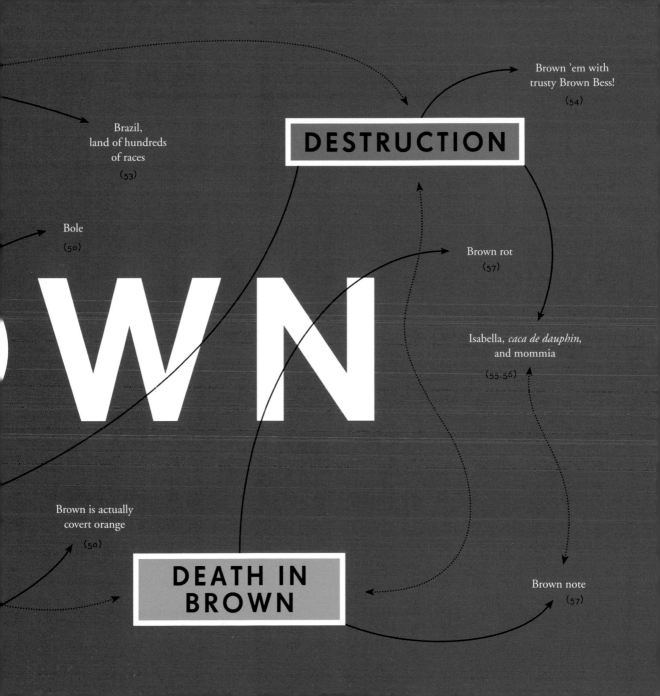

Brown 'em with
trusty Brown Bess!
(54)

Brazil,
land of hundreds
of races
(53)

DESTRUCTION

Bole
(50)

Brown rot
(57)

WN

Isabella, *caca de dauphin*,
and mommia
(55,56)

Brown is actually
covert orange
(50)

**DEATH IN
BROWN**

Brown note
(57)

CRASH COURSE IN BA-
SIC COLOR THEORY:
Hit more high points of
color theory on pp. xvii-xiv.

LINGUISTIC MUCK:
Color naming is a surpris-
ingly messy business:
Different languages split
the rainbow in various
ways. Yet also surprisingly,
there's an ironclad logic
underneath. See pp. xix-xx.

"THE LAND OF
COPULATION":
When Ndembu brides in
Zambia enter their new life
of licensed sex, they bring
a sweet red marriage chick
with them. See p. 32.

THE BROWN PRIMEVAL

BROWN IS ACTUALLY COVERT ORANGE

Where does brown fit in the rainbow? Answering that question requires a crash course in basic color theory. Color has three chief characteristics: its hue (the color itself), saturation (a color's purity, or how much black or white has been mixed in), and brightness (approximately what shade of gray a color generates in a black-and-white photocopy). Colors also interact with each other in two fundamentally different ways: *Additive* colors refer to colors built from actual light sources, while subtractive colors are reflected colors, those built from pigments that reflect (but don't generate) light.

Which brings us to brown. Hue-wise, it occupies the space between yellow and orange, but its brightness factor is significantly lower. (That low brightness factor also explains why coloring a traffic light brown wouldn't be very effective: A weakly orange light is technically possible, but its dim glow would barely register in a foggy nightscape.)

BOLE

A very old English word for brown, *bole* arose from the linguistic muck as early as 1275. In fact, it has three related meanings: a soft, fine, reddish-brown clay; a tree trunk; or the color of either of these.

The humble richness of English bole is much like the Chinese reverence for brown chestnut trees, whose hardy fruit remains nutritious throughout the winter. It also resembles the symbolism of a mud-dyeing technique for loincloths known as *bogolan* in the Bambara culture of West Africa. The mud pits where *bogolan* dye begins are called "the land of copulation," a gathering place where all the villages' unborn souls await their turn at life.

Picture it: a late winter afternoon, bare of all leaves, one bole sprouts quietly out of another. Brown comes from brown and returns to it.

GOD HAS
A BROWN
VOICE,
AS SOFT
AND
FULL AS
BEER.

—Anne Sexton

ENTIRE TREASURE OF COINS:
Yves Klein, artist and patent holder of the color International Klein Blue, once sold vacant lots he didn't own to patrons, then converted the proceeds into gold bricks that he tossed ceremoniously into the Seine. For more expensive chicanery, see p. 86.

BLOOD-FILLED FRENCH FLEA:
Bugs occupy a crowning position in the material history of color. Mexican cochineals yielded the most brilliant red dyes ever seen—see p. 28. Humble snails were crushed by the trillions to yield Phoenician purple dyes—see pp. 96-97. There is also that fictional color squant, detectable only by earthworms and underground animals (see p. 129).

FRIENDLY DAIRYMAIDS:
Overly friendly dairymaids sometimes caught a "green gown" from outdoor sexual romps—see p. 73.

LEXICON:
Other languages distinguish between animate and inanimate colors, whether the color is glossy or matte, or whether it's sophisticated or childishly simple. See p. 117.

THE TINTOMETER

Poor teenage Joseph Lovibond sallied forth to the gold mines of Australia in the late 1800s, secured his fortune there, and then boarded a ship home. Triumphant, he waved his gold-stuffed hat vigorously to friends on the dock and watched his entire treasure of coins spin out and fall into Sydney Harbor. He returned home, penniless, to Henley-on-Thames and joined his family's beer-brewing business.

Lovibond perked up, however, upon realizing that beer color was a reliable indicator of its quality—yet no graded scale existed to quantify its many shades. After toying with painted pigments on cards, which tended to fade, he hit upon an alternate solution after visiting Salisbury Cathedral: Amber-stained glass samples, backlit, provided the best means for measuring beer's orange-brown tints.

Behold the Lovibond Color Scale, later incorporated as Tintometer Ltd. Food scientists worldwide still measure beer colors in degrees Lovibond today.

PUCE

Possibly the most cringe-makingly ugly color name ever, puce is a purplish brown reminiscent of raw chicken meat, prunes sweating in hot water, or the blood-filled French flea for which it is named.

BROWNIE

A shaggy little house elf that tidies up Scottish homes and farms overnight. Brownies feed on stolen wort from beer, shots of fresh cream proffered by friendly dairymaids, or tiny stacks of corn left to charm them into service.

BROWNS OF BENIN

Among the tribes of Benin in West Africa, the lexicon is crowded with words for brown, each varying according to hue but also according to the speaker's age, gender, and social status. A rich Beninese older woman sits next to a poor young man and they

peer at the same brown together: two different names, two different browns.

UBIQUITY

ALL TO ASTONISH THE BROWNS!

So ubiquitous is the name Brown among the English that "the Browns" in this expression refers to two polar opposites of society: the elegant upper crust and the country-bumpkin cousins.

Fable has it that Anne Boleyn, Henry VIII's second wife, surrounded herself with her humble cousins the Browns at court, who obligingly oohed at her flouncy dresses and were bewildered by all the silverware. The snootier members of her entourage delighted in shocking these simple souls with outré pronouncements, "all to astonish the Browns."

Flash-forward three centuries to the publication of John Ashton's poem "All to Astonish the Browns," in which the frumpy Craggs try (and fail) to compete socially with their neighbor, the dashing Gentleman Brown. If you're struggling to keep up with the Joneses, Ashton has some timeless advice for you:

> In this you'll discover my moral,
> A moral worth mitres and crowns,
> If you would save silver and gold,
> You must always beware of the Browns.

BRAZIL, LAND OF HUNDREDS OF RACES

Arguably no country divides the human races with more baroque complexity than Brazil. The product of Portuguese, German, and Dutch immigrants who brought African slaves to the new continent and then subsequently mated (forcibly or not) with Amerin-

FLOUNCY DRESSES: A creepy form of dress-up took place in post–Reign of Terror France: the so-called "victims' balls." See pp. 30-31.

BRAZIL: Those Euro-immigrants came in search of a dyestuff, a fever that ultimately gave the country its current name. See p. 28.

ROY G. BIV

BROWN

HAIR COLOR:
Can natural redheads actually withstand more pain—or are they preternaturally more sensitive? For the science behind unpleasantly prodding redheads, see p. 35.

AMARELO (YELLOW):
Chinese folklore offers its own indelicate rebuttal to Eurocentric taunts of the twentieth century. See p. 62.

BATTLE:
Scottish warriors smeared themselves in blue wood dyes before battle, a scare tactic with a surprising side benefit—see p. 85. To learn about Mountbatten Pink, the British military pink paint used briefly in World War II, see p. 17. Last but not least, there's the fearsomely maternal Hindu goddess Kālī —see p. 122.

dians, plus a twentieth-century influx of Japanese and Arabs, Brazilians come in seemingly infinite racial varieties. Yet segregation persists there, and because race in Brazil stems not just from skin color but from hair color and texture, facial features, and body type, children with the same parents can easily be assigned to differing races—and reap the fruits or abuses of those assignations.

While the annual governmental census in Brazil counts only five major races, several scholars have parsed those numbers more finely, asking Brazilians to self-identify their race. The results are bewilderingly specific. A 1976 survey yielded 136 different racial identities; a 1998 survey found 143. Still, while 1 percent of respondents waxed verbose on their own race, 99 percent of respondents fell into ten main categories. This list reads like a brimming continuum of coffee cups, and the briskly caffeinated debates held while drinking them: *branco* (white), *moreno* (brown, i.e., dark-haired), *moreno-claro* (light brunette), *moreno-escuro* (dark brunette), *pardo* (split—literally by drawing a diagonal slash through the checkbox for race on a census form), *preto* (black, possibly politically unengaged), and *negro* (black, more black-movement-minded), *amarelo (yellow)*, *mulato* (mulatto), and simply *claro* (pale). One can only hope the Brazilian race conversation is moving toward how one survey respondent described himself: *cor-de-burro-quando-foge* (literally, "the color of a donkey when it runs away," a Portuguese saying for an undefined color).

DESTRUCTION

BROWN 'EM WITH TRUSTY BROWN BESS

To "burnish" your weapon, protecting it against encroaching rust, actually means to make it brown. A brownish stain of blood also spoke volumes about experience: It mellows and seals the sword much the way a chef seasons a wok with repeated use. This explains otherwise puzzling references in medieval ballads to "brown blades" or some hero's "shining brown brand." For instance, in chapter 36 of *Beowulf*, Wiglaf, Weohstan's son, seizes his newbie "linden-yellow" shield and rushes into battle while the poem floods with the cinematic backstory of Weohstan's own conquests of yester-

year—including nabbing the "old sword of Eotan . . . and brown-bright helmet" now wielded by Wiglaf.

This notion of "browning" a weapon also illuminates British soldiers' deep feeling for their colonial-era muskets, variously nicknamed "Brown Bill" or "Brown Bess." Of course, a giddy affection for Brown Bess does not quite excuse the faux pas of an overeager hunter who "browns": firing indiscriminately at the darkest spot in a covey of birds, usually hitting none and scattering all. That usually "browns off" your fellow sportsman, who stomps off, fed up.

NAZI BROWNSHIRTS

The Nazi *Sturmabteilung* (storm troopers) initially opted for brown shirts because of their cheap plenitude: The defunct Kaiser's government had ordered them to clothe the German army in its former African colonies. As many quipped at the time, most "brownshirts" resembled just-singed beefsteaks in their politics: brown on the outside, but red (Communist) at their cores.

Brown spread over maps, denoting Nazi stronghold neighborhoods, those who "voted brown." Nazi headquarters in Munich resided in the Brown House; the Nazi seizure of power in 1933 became known as the Brown Revolution. Perhaps most creepily, Adolf Hitler liked sleeping under a big brown quilt emblazoned with a swastika, wearing matching brown pajamas and a brown silk dressing gown.

THREE UNAPPEALING PIGMENTS

ISABELLA BROWN

The Austrian archduchess Isabella allegedly vowed not to change her underwear until the 1601 siege of Ostend reached a successful conclusion—a feat accomplished three

JUST-SINGED BEEFSTEAKS: The color red uncannily signals, first and foremost, blood. For more on blood's amazing qualities, see p. 27. To learn about the horseshoe crab's Smurfy blue blood (and its handy applications in the laboratory), see pp. 88-89.

RED HAIR'D:
For the contentious science of measuring redheads' tolerance for pain, see p. 35.

GARLIC AND AMMONIA:
Fabrics dyed purple with murex snails release a scent of garlicky spring onions when rubbed—even centuries later. See pp. 96-97. Urine's ammonia makes it an excellent reducing agent in pigment and dye making—to learn more, hold your nose and see p. 97.

years later, in 1604. It's also possible Isabella brown was named for the Spanish queen Isabella, she who pawned her jewels to fund Christopher Columbus's 1492 journey to America. In solidarity with her hometown, Castile, as it fended off a siege, lore suggests she too vowed not to change her bodice until the victory came off—which took only an itchy interlude lasting six months.

CACA DE DAUPHIN

This peculiarly unattractive shade enjoyed a short-lived craze in France in the final weeks of 1751. The yellowish-brown color celebrated the birth of Louis XV's first grandson and translates, appropriately enough, as "dauphin poop."

MOMMIA

This colorant consisted of crushed mummy remains—an ingredient that was by definition in extremely finite supply. Its first recorded reference dates to 1586, after which it circulated as an artist's pigment until as late as the nineteenth century. Attempting to rectify the pigment's scarcity, in 1691 British pharmacist William Salmon provided a recipe for making artificial mommia:

> Take the carcase of a young man (some say red hair'd) not dying of a Disease but killed; let it lie 24 hours in clear water in the air: cut the flesh in pieces, to which add Powder of Myrrh and a little Aloes, imbibe in 24 hours in the Spirit of Wine and Turpentine . . .

British colorman William Field described a delivery of "Mummy" pigment in 1809 with remarkable sangfroid. It arrived "in a mass, containing and permeating rib-bone etc.—of a strong smell resembling Garlic and Ammonia—grinds easily—works rather pasty—unaffected by damp or foul air."

DEATH IN BROWN

BROWN ROT

A plant disease attacking peach, plum, apricot, and cherry trees that wilts and browns the foliage and rots the fruits.

BROWN NOTE

An outrageous Internet rumor implicating brown: a low-frequency noise between 5 and 10 Hz, just below the threshold of human hearing, supposedly can induce nausea, vomiting, disorientation, and uncontrollable bowel movements.

Two weird-science TV shows—*Mythbusters* and *Brainiac: Science Abuse*—have tried and failed to reproduce the effects of the "brown note" with a series of "experiments." Yet reporter Jon Ronson in no less august a publication than the *Guardian* suggested it might be real—real enough to fund research on it, anyway. Author of *The Men Who Stare at Goats* (2005), which he describes as "a book about U.S. military craziness," Ronson stumbled on a leaked U.S. military report describing "non-lethal techniques" designed to disrupt the enemy.

Among them is the deadly brown note. As the report describes it, it's a "low-frequency infrasound" which "easily penetrates most buildings and vehicles" and creates "nausea, loss of bowel control, disorientation, vomiting, potential internal organ damage and death." Is the brown note truth or fiction? You decide.

PEACH, PLUM, APRICOT, AND CHERRY TREES: Which was the evil fruit used by Eve to tempt Adam? For religious scholarly debate, see p. 38.

SERIES OF "EXPERIMENTS": Another scientist horsing around with color experiments? That'd be Goethe, playing with beer bubbles, soap, and just-dead fish. See p. xvii.

ROY G. BIV

BROWN

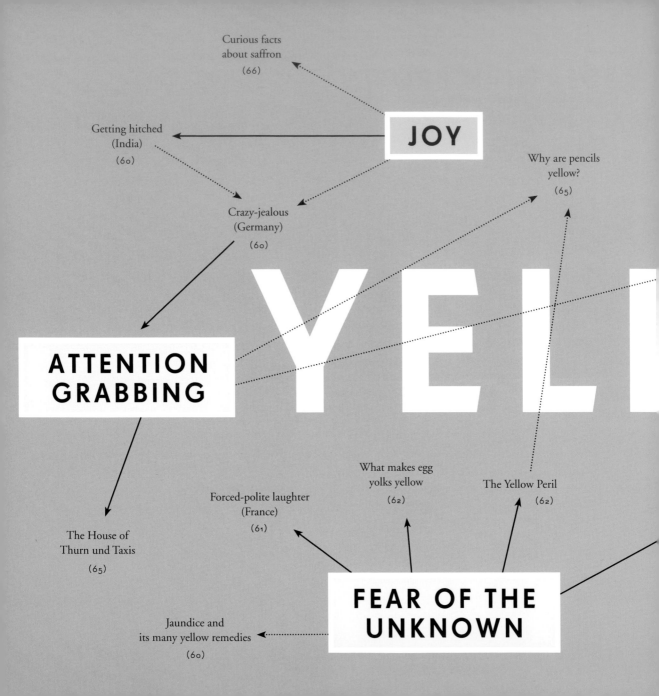

Curious facts
about saffron
(66)

Getting hitched
(India)
(60)

JOY

Why are pencils
yellow?
(65)

Crazy-jealous
(Germany)
(60)

YELL

ATTENTION
GRABBING

What makes egg
yolks yellow
(62)

The Yellow Peril
(62)

Forced-polite laughter
(France)
(61)

The House of
Thurn und Taxis
(65)

FEAR OF THE
UNKNOWN

Jaundice and
its many yellow remedies
(60)

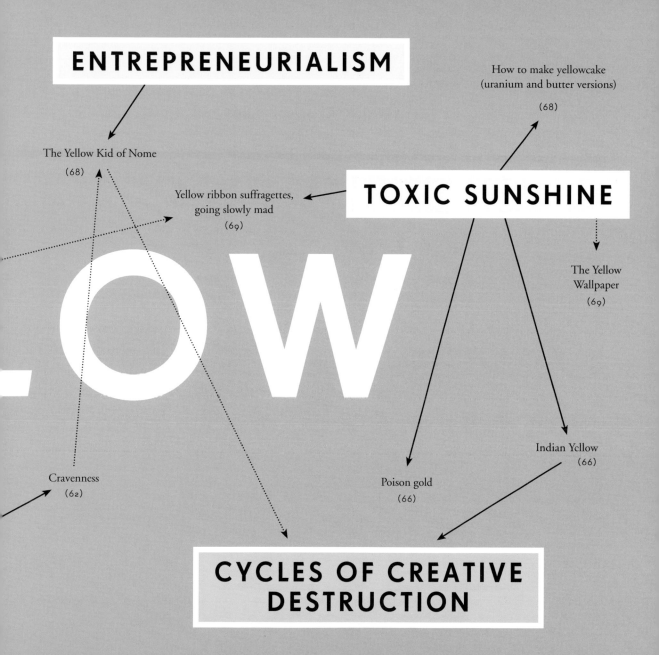

TIES THE KNOT:
Marriage brings out the buried traditionalist/color stylist in even the most reluctant among us. For more on unlucky green wedding dresses in Scotland, see p. 73. To plumb the fragrance of orange blossoms clinging to Victorian English weddings, see p. 40. For the history of our White Wedding Dress, see pp. 4-5.

PALE NEW INFANT:
Chinese babies are heralded with red-egg-and-ginger parties. See p. 33.

BUN FROM THE OVEN:
For a Chinese explanation of their golden-toasty skin color, see p. 62.

BLACK WITH RAGE:
The Scandinavians, by contrast, don the black socks of envy. See p. 119.

JOY

In 1947, novelist Vladimir Nabokov found a yellow vase with blue flowers deposited on his desk at Wellesley. A former student recalls how he strode to the blackboard and wrote, "Yellow blue vase." "That is almost 'I love you' in Russian," he remarked: *ya lyublu vas.* "That's probably the most important phrase I will teach you."

GETTING HITCHED

When a blushing Hindi girl ties the knot, she "gets her hands yellow" (*Haath peelay kar diya*), a reference to lavishly decorating the bride's hands in henna for a wedding. Similarly, the many aunts, cousins, and former babysitters attending the wedding each finger a turmeric-stained scrap of fabric, an everyday talisman carried for good luck.

Henna also burnishes many other nervous-making transitions among the Maghreb countries of northwest Africa. To protect a pale new infant? Smear the freshly baked bun from the oven in henna and olive oil. Moving house? Fill two bowls with milk and henna respectively to greet the household genies hospitably. Trouble conceiving? Wake the "sleeping baby" within by drinking a filtered concoction of henna that has been bathed overnight in (menstrually persuasive?) moonlight. You could call henna the all-purpose bless-maker of traditional Arab households.

CRAZY JEALOUS

The Germans undergo a curious color shift from English speakers for many of their emotional states: They go "yellow with envy" (*gelb vor Neid*), "black with rage" (*schwarz mit Ärger*), get as "blue drunk as a violet" *(blau wie ein Veilchen),* and "beat someone up green and yellow" (*jemanden grün und gelb schlagen*). Possibly in that order.

JAUNDICE AND ITS MANY YELLOW REMEDIES

In the long-persistent medical theory of the four humors, yellow bile (*chole*) was consid-

ered hot and dry; too much yellow bile caused an arid desert within the body, a heightened sense of ambition, and a marked irritability with anyone who preferred to think smaller. Hippocrates first theorized the system of four humors (or "temperaments") around 400 B.C., and the notion persists both in the arts and in myriad personality tests into the modern era.

Actual jaundice springs not from an excess of choleric sap but rather from excess levels of bilirubin in blood. Normally excreted in urine and bile, a bilirubin backup colors the skin and whites of the eyes an acid yellow. Never was an actual disease so strongly suggestive of the underlying "proof" of the theory of humors.

Early medicine men often treated jaundice with correspondingly yellow *pharmakon*. (The alternate approach was also popular: that is, a hot, dry, yellow disease like jaundice could be neutralized by some wet, cool, blue solution.) Burnished-yellow ochers could be fed to a jaundice sufferer as an astringent—a use proved legit by modern science. In his seminal first-century tome *The Natural History*, Pliny recommends that someone with jaundice gaze upon a male golden oriole, mystically transferring his disease to the bird, who dies in his stead. Another treatment recommended injecting juice from a wild cucumber directly into one's nostrils. A half millennium later, the yellow-fighting-yellow theory of medicine continued: Inaccurately, Galen liked yellow madder for treating jaundice and red hematite to help blood clot.

Some other odd cures for jaundice: Yellow spiders rolled in butter (England); turnips, gold coins, or saffron (Germany); gold beads (Russia).

FEAR OF THE UNKNOWN

FORCED-POLITE LAUGHTER

A thigh slapper about "freedom fries" that kills in Paris, Texas, will, in Paris, France, yield you only "yellow laughter" (*rire jaune*).

MYRIAD PERSONALITY TESTS: Spiritualists and quacks do like to use the rainbow as a nifty metaphor for diagnosing ills, plumbing the personality, and projecting possible futures. See p. 137.

BLOOD: The one inescapable red. For a firmer handle on blood's more surprising properties, see p. 27.

URINE: Pee looms largely, and sulfurously, as a key ingredient in dye-making tradition. Yes, likewise with number 2. See pp. 66 and 97.

61

ROY
G.
BIV

CUCKOLDED MAN:
European Gypsies suss cuckoldry out with a test involving red threads (p. 31), while Chinese married men nurse an irrational fear of green hats (pp. 73-74).

SUNSHINE:
Astronomers have calculated—twice—the average color of the universe, based on a huge cataloguing of stars and their respective colors. See pp. 135-136. Meanwhile, why is the sky blue? See pp. 86.

POINTED, IF EQUALLY RACIST, REBUTTAL:
Brazil is home to a hundred-plus races. See pp. 53-54.

THE COLOR OF CRAVENNESS

Cowardly Adam (in the Koranic version of the Garden of Eden) broke into a lemony-yellow sweat upon seeing the Angel of Death. In France, a cuckolded man is called *jaune cocu*, a "yellow deceived." Medieval Europe was riddled with treacherous yellows: In tenth-century France, the homes of thieves, traitors, and felons were daubed copiously in yellow paint, a medieval take on the investigative journalist's dictum that sunshine is the best disinfectant. Inquisition-era Spanish victims trudged to their deaths by *auto-da-fé* cloaked in gold *sanbenitos*, "Sacks of Benedict": garish yellow linen costumes bedecked with flames and crosses and devils. Until 1836 *dyvours*—Scottish code name for bankrupted people—wore a parti-color shirt stained yellow and brown designating their status. One suspects the color palette's hint of excrement was pretty much right on.

THE YELLOW PERIL

World War II propaganda films gave us such charming characterizations of the Asian "Yellow Peril" as *Slap the Jap Right Off the Map* and *When Those Little Yellow Bellies Meet the Cohens and the Kellys*. These were only the latest echo of a deep suspicion by the West of the Far East—or, as Carolus Linneaus's *Systema Naturae* in 1758 termed the peoples of Asia, "*Asiaticus: luridus, melancholicus, rigidus*" (yellow, sad, and inflexible).

An old Chinese adage offers a pointed, if equally racist, rebuttal to these prejudices: When God cooked up the human race like dumplings from an oven, the first batch came out pale and undercooked (Europeans), the second race burnt (Africans), but the third race golden brown and crisply perfect.

WHAT MAKES EGG YOLKS YELLOW?

In a word: feed. If hens eat feeds rich in carotenoids, their egg yolks pop out a carroty orange. The chicken-feed rainbow extends further: Alfafa meal and yellow corn yield a burnt-yellow yolk, wheat and barley a pale-straw shade, and white corn the faintest yellow of all.

[TO PAINT] FACES
OF YOUNG PEOPLE WITH
COOL FLESH COLOR...
[PAINTS] SHOULD BE TEMPERED...
WITH YOLK OF A TOWN HEN'S EGG,
BECAUSE THESE ARE WHITER YOLKS THAN
THE ONES WHICH COUNTRY OR FARM HENS
PRODUCE; THOSE ARE GOOD, BECAUSE
OF THEIR REDNESS, FOR TEMPERING FLESH
COLORS FOR AGED AND SWARTHY PERSONS.

—Cennino Cennini, *Il Libro dell'Arte*

I'M FRIGHTENED OF EGGS, WORSE THAN
FRIGHTENED; THEY REVOLT ME. THAT WHITE
ROUND THING WITHOUT ANY HOLES... BLOOD
IS JOLLY, RED. BUT EGG YOLK IS YELLOW,
REVOLTING. I'VE NEVER TASTED IT.

—Alfred Hitchcock

Dialogue between Karen Wright, arts reporter for Bloomberg, *and Jean-Claude, artist with partner* Christo:

Q: **WHY DID YOU CHOOSE ORANGE AS THE COLOR FOR THE GATES?**

A: **SAFFRON! SAFFRON! THEY ARE SAFFRON!**

ATTENTION GRABBING

THE HOUSE OF THURN UND TAXIS

A true fable of transportation: In fifteenth-century Italy, one Francesco Tasso surveyed the complicated system of "post" transit—an overlapping mass of way stations served by a constantly refreshed army of ponies—and breathed a single magic word: centralization. Tasso indeed managed to corral post travel into one integrated system, carrying both correspondence and travelers from the then-German states of northern Italy throughout Europe. Seeking to build brand unity across squabbling fiefdoms, Tasso colored his taxis yellow—a shade that sidestepped most political associations while offering high visibility. The emperor of Austria ennobled the family with a fancy new name, Torre e Tasso, which the family branch operating in the German-speaking realm transliterated as "Thurn und Taxis."

The House of Thurn und Taxis still embodies a living ideal of royal Eurotrash, enriching themselves through brewery investments and producing gawdy spawn like Gloria von Thurn und Taxis, whom *Vanity Fair* in 1985 styled as "Princess TNT, the dynamite socialite."

WHY ARE PENCILS YELLOW?

To imbue them with the dusty-golden aura of the Ch'ing dynasty (1644–1911), which made yellow the exclusive imperial color of China. While both the English and French had been mass-producing graphite pencils sheathed in wood since 1792, it was Jean-Pierre Alibert's 1847 discovery of an abundant graphite lode in Siberia that sealed the fate of the Chinese pencil. Yellow pencils flooded the world market, filling billions of school pencil cases with a slender, now-mute tribute to Emperor Huang Ti (2698–2598 B.C.), the so-called Yellow Emperor. Emperor Huang clothed himself in yellow to worship the sun and, as legend has it, invented for children and adults alike wooden carts, the bow and arrow, and writing.

ROYAL EUROTRASH:
Better-heeled Cambridge students looked down their ancestrally long noses at commoner students, calling them "empty champagne bottles." As to why, see p. 99.

SIBERIA:
One day, the endless steppes of Siberia were bisected by a mouse-gray flamingo dropping from the sky. But what in Sam Hill (or, as the Siberians might call him, САМУИЛ ХОЛМ) was it doing there? See p. 15.

As to why, see p. 99.

See p. 15.

ROY
G.
BIV

BITTERNESS IN
THE MOUTH:
The litmus test for purples
dyed with actual murex
snails: Even centuries later,
rubbing the fabric releases
a pungent scent of spring
onions. See p. 97.

URINE:
A golden shower could be
used to make more than
just yellow paint. For more
on traditional dye makers'
go-to reducing agent, see
p. 97.

CURIOUS FACTS ABOUT SAFFRON

Tibetan monks are too humble to dye their robes with actual saffron—they use the considerably cheaper turmeric. (Thai monks prefer another modest dye from the jackfruit, while the Burmese fill yellow with such humility that it's their traditional mourning color.) Saffron's deeply yellow dye comes from a purple, impossibly fragile flower originating in Iran. It's ruinously expensive because harvesting it is an infinitely finicky process: The stigma threads used for dyeing must be picked by hand, placed into straw baskets (not nylon or plastic, which curdles the herb on contact), then painstakingly dried. Saffron dealers' tricks to cheat buyers form their own unscrupulous lexicon: weighing down saffron with lumps of butter, onion skins, or corn stigmas; dyeing saffron's useless yellow stamens red to resemble the female stigmas used in dyeing. Rumorous Restoration-era medicine in Britain held that too much saffron could kill you with a fit of the murderous giggles. Tasted alone, saffron gives a fine, faintly crunchy filament of bitterness in the mouth.

TOXIC SUNSHINE

INDIAN YELLOW

Urine supplied a crucial ingredient of the painter's pigment Indian Yellow—specifically, the urine crystals of cows fed entirely on mango leaves, a diet that rendered cattle haggard (and farmers poor). Transported as foul-smelling balls of compacted powder, their greenish patina would crack open to reveal a strong, richly spreading yellow within. French, Dutch, and Persian painters alike ignored the protestations of their noses and ran delightedly amok with the buttery pigment until Indian Yellow's cruel secret was outed in 1883 (and supplanted by mercifully synthetic chrome yellow).

POISON GOLDS

Several of history's most celebrated yellow paints have vanished from use due to alarmingly high arsenic levels. Orpiment's glinting gold finish excited alchemists but painters

I LOVED DOWNERS, ALMOST ANY KIND.
LOVED THE COLORS OF THEM.
LOVED THEM YELLOW... I DID. I WOULD JUST HAVE
A BOUQUET IN MY HANDS AT NIGHT.

—Rosemary Clooney, *singer*

I TOLD MY DENTIST MY TEETH ARE GOING YELLOW.
HE TOLD ME TO WEAR A BROWN TIE.

—Rodney Dangerfield, *comedian*

MURDER WEAPON:
Scholars squabbled for decades over whether Napoleon died of arsenic poisoning, leached by frequent steamy baths from the green wallpaper of his suite. See pp. 74-75.

BROWNIAN MOTION:
An entirely different sort of brown motion, the dread "brown note," has seized the imaginations of both reality-TV writers and an elite counterintelligence force within the U.S. military. See p. 57.

DR. STRANGELOVE:
Other global endgames implicating color: For a revealing backstory of Anthony Burgess's *A Clockwork Orange*, see p. 47. For a glimpse of how gray-goo horror might ultimately consume us all, see pp. 110-111.

WEAPONS-GRADE POWER:
Burnishing one's sword with rusty-brown blood—an English literary tradition stemming back to Beowulf—explains the British nickname for their guns, Brown Bess. See pp. 54-55.

"BANKING" SOME GOLD POWDER:
"Gray queens" is the term designating discreetly homosexual bankers. See pp 108-109.

less so, as its poison tended to blacken nearby colors. The recipe for another arsenic-laced paint, the red realgar, starts by following where peahens nest for three years (they choose the spot, near the trees that produce realgar sap, because the arsenic-laden sap fends off snakes).

Gamboge, a corruption of the name Cambodia, is an organic yellow formulated from the hardened resin of the *Garcinia hanburyi* tree. Like orpiment, it's an extraordinarily effective diuretic; an excess dose of gamboge also served as the murder weapon in at least one Chinese murder mystery (it was injected into a peach). Gamboge played a peculiarly apposite role in chemistry's history: In 1908, it was the substance used in an early demonstration of Brownian motion, ultimately proving the existence of atoms.

HOW TO MAKE YELLOWCAKE (URANIUM AND BUTTER VERSIONS)

Here is a mashup of recipes for yellowcake by *Dr. Strangelove* and Betty Crocker. First mine some rich buttery uranium ore, also known as uranium oxide (U_3O_8). Surprisingly weak in weapons-grade power, the ore must be fastidiously milled to remove impurities and increase its concentration of viable uranium. As *Slate's* Explainer column describes it, "First, raw ore is passed through a series of industrial-sized crushers and grinders. The resulting 'pulped' ore is then bathed in sulphuric acid, a process which leaches out the uranium."

Much like its confectionary equivalent, yellowcake packs a punch only with further embellishment. Yellowcake must first be converted to uranium hexafluoride (UF_6) and made gaseous, floating like a stray party balloon, before enrichment into bombs and electricity can successfully happen.

THE YELLOW KID OF NOME

A legendary bartender during the Alaskan Gold Rush who poured syrup into his hair daily before work. Weighing out miners' gold dust—the currency of payment for their drinks—he ran his hands habitually through his hair, surreptitiously "banking" some gold powder each time. Pioneer ingenuity, what-ho!

YELLOW-RIBBON SUFFRAGETTES, GOING SLOWLY MAD

STRUGGLES
FOR LIBERTY:
In an oddly consistent
choice worldwide, police
quelling resistance move-
ments do so with water
cannons gushing purple
dye. See p. 99.

69

Tying yellow ribbons around tree trunks to remember fighting soldiers has a recent provenance. The practice began as early as 1917 with a military marching tune, "Round Her Neck She Wears a Yeller Ribbon (for Her Lover Who Is Far, Far Away)" and got topped up with a 1973 hit by Tony Orlando & Dawn.

Yellow ribbons became a symbol of women's rights in the late nineteenth century. In 1876, the year of the first U.S. centennial, women wore yellow ribbons to mark their own sex's struggles for liberty. A contemporary poem entitled "The Yellow Ribbon" by Marie LeBaron voiced, in grandiloquent purple prose, women's underappreciated role as guardians of the home front. And yet it wasn't all so forward-thinking: The yellow-ribboned women were lobbying not for new rights but to be recognized for protecting family and hearth.

GRANDILOQUENT
PURPLE PROSE:
For a heated defense
of purple prose (plus a
contemporary fiction con-
test for exuberantly bad
writing), see p. 101.

WALLPAPER:
Napoleon may have been
killed by it. See pp. 74-75.

THE YELLOW WALLPAPER

Another sunnily dystopic association of yellow with women's rights: yellow wallpaper as a motif in stories of repressed housewives. Its most iconic use occurs in Charlotte Perkins Gilman's 1892 story "The Yellow Wallpaper," in which a married woman is removed by her husband from the pressures of city life to a strictly imposed rest cure. Locked in a bedroom bedecked in yellow wallpaper, her swift descent from neurasthenia to psychosis is detailed in her laser focus on the room's cruelly cheerful yellow wallpaper. She finds the color greasy, like "old, foul yellow things," sees tortured women and unhappy children tangled in its "breakneck scrawling pattern," and strips the paper systematically off the walls. The story ends when the woman—circling the locked room, fingering the awful wallpaper—refuses entry to her husband. He unlocks the door from outside and faints dead away upon entry; she continues circling, cackling in full irony, "I've got out at last," while hugging close to her yellowy prison's walls.

ROY
G.
BIV

Give 'er a
green gown
(73)

Unlucky
Brits
(73)

Green hats
in China
(74)

French
thoughtlessness
(77)

GRI

Never drive
a green car
(74)

Alien plants
(77)

UNLUCK

Green magazine
covers
(74)

Napoleon's death
by wallpaper
(75)

*Die Schöne
Müllerin*
(76)

U.S. dollar bills
(78)

The color
of Islam
(78)

LUCK

Confucius says:
Jade is invaluable
(80)

Green queen
(76)

EEN

The
green room
(80)

Dirty old
Spaniards
(76)

Green Language
(81)

HE HAD THAT CURIOUS
LOVE OF GREEN, WHICH IN
INDIVIDUALS IS ALWAYS THE
SIGN OF A SUBTLE ARTISTIC
TEMPERAMENT, AND IN NATIONS
IS SAID TO DENOTE A LAXITY,
IF NOT A DECADENCE
OF MORALS.

—Oscar Wilde

UNLUCK

MAY THE UNLUCK OF THE BRITISH BE WITH YOU.

Part the lush shamrocks and witness the Riddle of Green: On the verdant British Isles, the color of life is considered unlucky. Folklore blames the fairies: Green is their magical color, and human use provokes their ire.

Some Brits avoid green more carefully than others—no hunter-green smoking chair, no apple-green cardigans, no battered green rain boots—but all residents of Albion fear a green wedding dress. As the saying goes: "Wear green, ashamed to be seen," reminiscent of the Scottish tradition of pinning green garters to an unmarried elder sister to shame her at her little sister's wedding.

Some even say wearing green is asking for death: "Wear green today, wear black tomorrow."

GIVE 'ER A GREEN GOWN

Brewer's Dictionary of Phrase and Fable (1898) defines this coyly: "A tousle in the new-mown hay. To 'give one a green gown' sometimes means to go beyond the bounds of innocent playfulness." Seventeenth-century poet Robert Herrick urges sexual frolic thusly in his poem "Corinna's Gone A-Maying": "Many a green-gown has been given/ Many a kiss, both odd and even . . . "

The practice jibes with a springtime game, "caught without green," detailed by writer François Rabelais. The rules were simple: Wear a green leaf tied into your ensemble every day in May. Infractions, of course, were punished: Pay a fine in pennies (or, one presumes, in dearer coin).

APPLE:
Did Eve tempt Adam with an apple—or was the fatal fruit an orange? Religious scholars debate the most classically evil fruit on p. 38.

"WEAR GREEN, ASHAMED TO BE SEEN":
For the history of the white wedding dress, see pp. 4-5.

SHAME:
Hebrew and Hindi speakers paint the metaphorical color of shame differently. See p. 8.

SEXUAL FROLIC:
Italians who fail to score "walk in white" (p. 5). For winners of the Bad Sex in Fiction literary contest, see p. 101.

A STOP SIGN:
Why does green mean go
and red mean stop? For
traffic-light history and
lore, see p. 34.

NEWSBOY BAWLING:
Other newsworthy
milestones in color history:
William Perkin invented the
first synthetic dye (mauve)
in 1856, jump-starting a
colossal fashion craze and
the field of industrial chem-
istry—see p. 98. In 2011,
scientists rediscovered
the recipe for a lost blue
used to dye Jewish prayer
shawls—see p. 87.

COLOR TABOOS:
For a list of big-picture
color questions answered,
whether factually or other-
wise, see p. 142.

74

WEARING A GREEN HAT IN CHINA

Amid the teeming billions of Chinese businessmen, rarely will you see one clutching a green hat—whether bowler or baseball cap—to his head. The phrase "wearing a green hat" in Chinese sounds uncannily like the word for "cuckold," so Chinese men steer clear.

NEVER DRIVE A GREEN CAR

Race drivers raised a stop sign to green cars, declaring them unlucky, after two early races ended in legendary crack-ups.

In 1911 in Syracuse, a green Knox Racer blew out a tire and plowed into the crowd, killing nine fans and injuring fourteen more. In 1920, Gaston Chevrolet's green Frontenac careened to victory in the Indy 500—but ended a smoldering wreck later that year at the Los Angeles Freeway, killing Chevrolet and two others.

Enter the newsboy bawling, tonsils a-wag: *Extra, extra! Green machines sure are mean!*

ARE GREEN MAGAZINE COVERS NEWSSTAND POISON?

It's one of the great color taboos: Predominantly green magazine covers supposedly kill newsstand sales.

A 2006 *Slate* article relates one journalism professor's guess: "He's heard some retailers speculate that the fluorescent bulbs in stores cast a yellow light that washes out newsstand greens and gives them a feeble, bluish cast." Lynn Staley of *Newsweek* blames the difficult business of printing greens accurately: "'Like brown, [green] can be tricky to control on press and either one can migrate in the baby poop direction if the printer isn't careful,'" Staley told *Slate*. Most tempting of all is to invoke the towering publishing figure Alexander Liberman, Condé Nast's editorial director from 1962 to 1994. Liberman infected a generation of young minions by repeating in booming, Ukrainian-accented tones, "Green is death on the newsstand!"

DEATH BY DECORATING?

Rumors hinted for years that Napoleon's death from stomach cancer may have actually been from arsenic poisoning. Doubts raised in 1961 swelled to high-toned Continental intrigue in 2001 when tests on Napoleon's hair found alarmingly high arsenic levels. A delicious near-decade ensued, in which historians swiveled a suspicious eye from one beribboned fellow to the next, attempting to finger the poisoner.

Perhaps the finest theory blames the decorator—plus evokes the suffocating quality of the emperor's final days. Hemmed in on the remote island of St. Helena, Napoleon's stomach pains galled him only slightly more than his smarmy captors and quack doctors. For relief, he passed hours roaming between a steamy bath and his bedroom, curtains drawn, the jungle-hot green interiors oddly resonant with the tropical outdoors. Humidity begat mold, converting the pigment in the wallpaper—Scheele's green—from copper arsenite to arsenic trimaythal, a vapor toxic enough to finish *le petit caporal* off.

Sadly, in 2008 Italian scientists armed with a nuclear reactor declared incontrovertibly that everyone in Napoleon's day was plumb full of arsenic compared to today's levels. Stomach cancer may win, but a sturdy little Napoleon cussing fate in the poisonous vapors of the bath still holds a certain allure.

ARSENIC POISONING:
The history of yellow pigments is also arsenic-laced. See p. 66.

QUACK DOCTORS:
Quite a few psychotherapists and spiritualists use color to measure personality, change your aura, or decode your fate. See p. 137.

> THEY'LL **SELL** YOU THOUSANDS OF GREENS. VERONESE **GREEN** AND **EMERALD** GREEN AND CADMIUM GREEN AND ANY SORT OF **GREEN** YOU LIKE; BUT **THAT** PARTICULAR GREEN, **NEVER.**
>
> —Pablo Picasso

ROY
G.
BIV

GREEN

GREEN MAID:
There's also the green of rough-and-tumble experience. See p. 73.

JEALOUS, IN ONLY ONE HUE:
That hue is green—although to modern Germans and Chinese, envy is otherwise colored. See pp. 60 and 32.

GREEN LEAVES:
On the non-inevitability of green plants, see p. 102. On the curiosities of color naming around the globe, see p. 97.

PINKU EIGA, "PINK PORN":
see p. 19.

DIRTY GREEN FILMS:
For a tour of blue's links to obscenity, see p. 87.

GAY:
"Gray queen" designates homosexual men who work, usually discreetly tucked in the closet, in financial services—see pp. 108-109. For various colors and their meanings in hanky code, see p. 76 and 91.

BETWEEN LUCK AND ITS OPPOSITE

SCHUBERT'S *DIE SCHÖNE MÜLLERIN*

Franz Schubert's 1824 song cycle *Die Schöne Müllerin* (*The Fair Maid of the Mill*) takes the cake for the most famous, most miserable, and most thoroughly green-addled artistic work going.

It opens on a green young man, in every sense of the word, who falls for the equally green maid amid sun-dappled verdure. She hesitates; he palpitates. His token of love to her: a sheaf of green ribbons. She bolts into another's arms, a hunter clad in green. Our hero is *jealous, in only one hue*. Things Go Badly. Love-crazed, he soliloquizes to cruel, unfeeling nature that blooms and drips with sap even as he longs for death. (Sample lyrics: "I'd like to pluck all the green leaves/From every branch and twig/I'd like to weep on all the green grass/Until it's pale as death.") Green ultimately fades to black: Mercifully, he drowns himself in a babbling green brook.

DIRTY OLD SPANIARDS

English speakers think of green as the color of fresh young things, but to Spanish speakers, green spreads a rusty patina over dirty old men (*viejos verdes*), dirty green jokes (*chistes verdes*), and dirty green films (*películas verdes*). The Japanese, by contrast, like their pornos anatomically correct, labeling them *pinku eiga, "pink porn."*

"GREEN QUEEN"

Illicit gay sex is dappled with green references, evoking the great and furtive outdoors, where many trysts occur. "Green queens" are so named because they delight in the danger of sex in public parks.

Latterly, Green Queen has taken on a new meaning. It's the name of a sweet bud of medical marijuana prized for its pain-busting effects and the powerful veil of sleep it draws over users.

FRENCH THOUGHTLESSNESS

A sharp and thoughtless remark in French earns the appellation *une verte réponse*—unripe, sour, plucked much too early from the brain's vine.

ARE PLANTS ON ALIEN PLANETS ALSO GREEN?

First off, why are Earth's plants green? Rewind 3.7 billion years: Earth's star was a hot G-type; our atmosphere reeked of methane and hydrogen. Early bacteria started photosynthesizing under protective cover of water, evolving into cyanobacteria and eventually becoming plants.

Earth's plants consume only red and blue light waves and reflect the more abundant green waves of our light spectrum. This seems wasteful, but it's surprisingly efficient: Long red wavelengths make up for their low energy levels with an enormous volume of protons, while shortwave blue light carries zippily energetic protons, if not too many of them. Chlorophyll in plants, therefore, gets maximal quality AND quantity from red-blue light photons, reflecting back the green we see.

So what about alien plants? It depends on the light of the stars illuminating them. Scientists figure only certain star types are long-lived enough to promote complex life forms. These are, from hottest to coldest, F, G, K, and M stars.

Hot, bright-blue F stars aren't too different from our own G sun: Plants lit by F or G stars could be green, orange, or yellow. Especially hot F stars might flood their planets with so many blue protons that plants could develop reflective surfaces, like paparazzi shades, to keep from getting scorched. Cool, dimming M stars—also known as red dwarfs—abound in outer space. Like Dickensian children huddled around a wan fire, plants lit by M stars are fighting to absorb every scrap of photon energy they can—clothing them, in all likelihood, in ultra-absorbent black.

GREEN QUEEN:
Pink traditionally designates countries of the British Commonwealth on maps—see p. 18. Meanwhile, among brown pigments is Isabella brown, the color of one stubborn and filthy Spanish queen. See pp. 55-56.

WHY ARE EARTH'S PLANTS GREEN?:
Some scientists hold to the Purple Earth Theory, in which the early planet was covered in purple proto-plants. See p. 102.

BLUE LIGHT WAVES:
What makes the sky blue? See p. 86.

DICKENSIAN CHILDREN:
Heartless Dickensian parsons clapped hollowed-out oranges to their noses to cut the stench of the London streets—see p. 40.

ROY
G.
BIV

GREEN

WHY ARE DOLLAR BILLS GREEN?

The U.S. greenback takes its signature green from a so-called "demand note" from the Civil War era, the first nationally used paper currency. Rather than lug your gold bars around, a "Demand Note" represented an amount you'd stockpiled in gold elsewhere, a handy virtual record that you could, upon demand, exchange for actual gold. Dollars were later backed by a collective gold reserve, and now by the country's Gross Domestic Product (GDP). The virtual qualities of money have steepened over the years—a trend goldbugs would love to reverse.

What's buried in apocrypha is why dollars were colored green in the first place. The Bureau of Engraving and Printing offers a wan answer: "No definite explanation can be made for the original choice; however . . . the color was relatively high in its resistance to chemical and physical changes, and green was psychologically identified with the strong and stable credit of the Government."

LUCK

THE COLOR OF ISLAM

The Koran's pages reveal a paradise in dewy curlicues of green. Believers of Allah stroll through Paradise wearing fine green silks; souls of the faithful fly to their reward as green birds. Muhammad himself wears a green turban and shields his four relatives under his green cloak—symbolized by the four pillars supporting the Ka'aba. Muhammad's prophet *al-Khidr*, "The Green One," protects all travelers, whether literally moving from town to town or figuratively traveling through the puzzle of life.

Dervishes and Sufis dressed in rags choose "the green death," the gentle renunciation of the material for the spiritual world. To them is revealed the brilliantly green emerald mountain carved with a celestial throne, invisible except for its reflected color filling the sky.

DIG A WELL, TWO GAZ DEEP, IN A MOIST PLACE.
HANG BROAD SWORDS MADE OF THIN COPPER
IN THE WELL. POUR VINEGAR ALL OVER THE
SOIL, AND COVER THE WELL FOR ONE
MONTH. ALL COPPER CONVERTS TO BEAUTIFUL
GREEN ZANGAR.

—Sadiqi Beg Afsha, *from a seventeenth-century recipe
for making verdigris (zangar), a green pigment*

FORTUNE-COOKING
SAYING:
Other surprising color
sayings across foreign lan-
guages: the Scandinavian
black socks of envy (p.
119), and the Germans
playing hooky with blue
(p. 88).

ACTING LORE:
Other high points of
creative energy in
color's history: Yves Klein
patented his supersatu-
rated ultramarine blue in
1961—see p. 86. Elsa
Schiaparelli exploded into
the fashion world of the
early twentieth century in
a cloud of shocking pink
(p. 19).

CONFUCIUS SAYS: JADE IS INVALUABLE!

Sixth-century B.C. philosopher Confucius saw ten virtues in jade. Its bright polish reflects purity; its hardness, intelligence; its angles, defined but not cuttingly sharp, akin to justice. Confucius peered into jade's limpidly milky flaws and saw sincerity and tapped jade to hear its pure music. He saw loyalty in its color and heaven in its iridescent sheen, grounded in an agreeable heaviness suggestive of earth. Beautiful even unadorned, it reminded him of chastity, and its universally high price represented truth. All of these virtues boil down to a fortune-cookie saying common among the Chinese: "Gold is valuable, jade is invaluable."

TO THE GREEN ROOM!

The *OED* defines the "green room" as "a room in a theatre provided for the accommodation of actors . . . when not required on the stage, probably . . . originally painted green."

Acting lore is rife with theories to explain the green room's color. For some it's evocative of Shakespeare's green, when actors strutted on the grass with the audience in bleachers.

JUICY,
MOLECULAR POP:
What are the character-
istics of a charmed green
quark? See p. 138.

81

Or was it a room filled with dripping plants, whose humidity soothed actors' throats? Blinded by limelights, actors may have stumbled into the green room to recover their sight, with slow green spots swimming before their eyes. Or, like starlets in mud masks, actors supposedly let wet stage makeup shade from a livid green to lovely dry pink there. A place of invention, of sprouting, in more ways than one.

THE GREEN LANGUAGE

When God talks, he speaks the green language. Mystics and alchemists through-out history awaited the instant of transformation when "the green language"—also known as the "language of the birds"—would finally become intelligible. Mythologi-cal figures across Eurasia all supposedly spoke green with the birds, from the Swedish king Dag the Wise and his house sparrow to the Talmudic version of Solomon and on to the French troubadours. In a sinister twist, in 1978 the U.S. Department of Defense developed its own Green Language (later renamed Ada), a programming language developed to manage avionics during battle.

From stars tumbling in the heavens to cells splitting with a juicy, molecular pop—all of nature's wheels within wheels are greased green; all of them speak green.

Does blue exist?
(84)

SACRED
VS. PROFANE

Indigo
vs. Woad
(85)

BL

SPIRITUAL
VS. REAL

Russian
homosexuals
(91)

MALE AND
FEMALE

Bluestockings
(92)

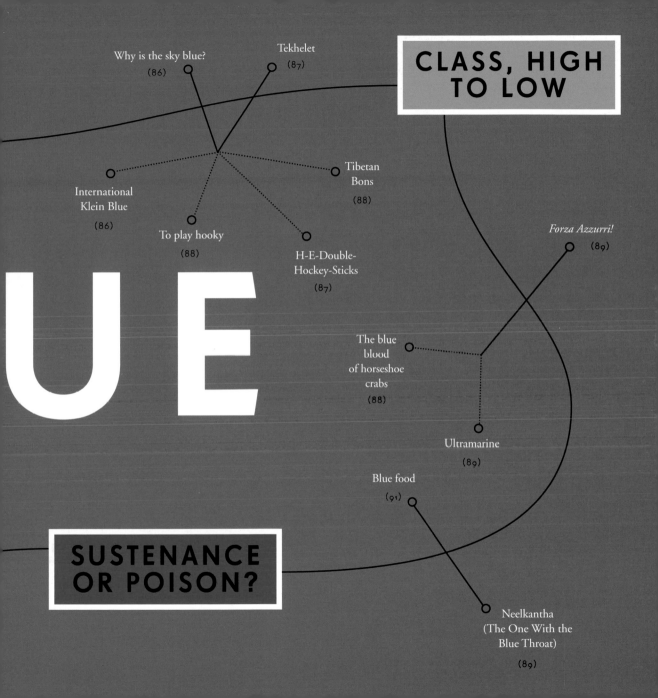

Why is the sky blue?
(86)

Tekhelet
(87)

CLASS, HIGH TO LOW

International
Klein Blue
(86)

Tibetan
Bons
(88)

To play hooky
(88)

H-E-Double-
Hockey-Sticks
(87)

Forza Azzurri!
(89)

U E

The blue
blood
of horseshoe
crabs
(88)

Ultramarine
(89)

Blue food
(91)

SUSTENANCE OR POISON?

Neelkantha
(The One With the
Blue Throat)
(89)

COLOR TERMS:
See p. xv.

MOURNING:
Queen Anne of Brittany, aka the Duchess in Clogs, introduced Europeans to black as a mourning color (see p. 7). Gypsy mourners trail a white-painted cart, tracing the dead person's life journey in reverse (p. 7), while the Burmese mourn wearing yellow (p. 65).

BLUES LIKE *GLAUKOS* AND *KYANEOS*:
Vietnamese, Zulu, Korean, Thai, and Kurdish are all languages that conflate green with blue. Japanese, Gaelic, and Chinese distinguish between living blues and artificial ones. Yes, it gets weirder. For more, see p. xx.

DOES BLUE EXIST?

Blue may be the Western world's favorite color (verified in a 2004 survey by global marketing group Cheskin Added Value), but historically blue is a stepchild color, considered either a paler shade of black or a variant on green.

In linguist Morris Swadesh's list of top one hundred basic words, one finds colors including "red, white, black, yellow, green"—but no blue. This jibes with the findings of linguists Brent Berlin and Paul Kay, whose 1969 book, *Basic Color Terms*, found that blue occupies the number-five spot among color terms. That is, a given language will see fit to distinguish between white, red, black, yellow (or green) before it will acknowledge blue with a separate color name.

Blue was nowhere on the Western radar until the eleventh century, when technical innovations in blue by glaziers and dye makers woke the world up to the sparkling potential of an as-yet-unsymbolized color. The stampede to symbolize blue began with depictions of the Virgin Mary, whose somber clothing (then a near-black blue of mourning) shifted to a shining blue emphasizing divine illumination. The blue-gold rush continued as French Capetian kings in the twelfth century seized on the blue-and-gold fleur-de-lis as their heraldic crest; for the ensuing two centuries, newly richified families designed their family seals with royal Marian blue.

As Michel Pastoureau recounts in *Blue: The History of a Color*, blue's prestige rarely flagged from the late Middle Ages to the present day. Even so, the ancient Greeks' and Romans' lack of awareness of the color has sparked heavy academic debate. Homer's "wine-dark sea" sounds more black than blue to us; ancient Greek words for blues like *glaukos* and *kyaneos* don't quite map to our *blue*, either. (Pastoureau writes: "During the classical era, *kyaneos* meant a dark color: deep blue, violet, brown and black . . . [as for *glaukos*], rather than denoting a particular color, it expresses the idea of a color's feebleness or weak concentration . . . [like] water, eyes, leaves, or honey.")

The puzzling truth, it seems, is this: Ancient Greeks could stand on a hilltop surrounded by Mediterranean sea and sky, arguing until they were green in the face—they saw no blue there.

INDIGO VS. WOAD

The tale of a smackdown between blues begins with woad (rhymes with *load*), a weed that—despite its habit of sucking soil dry of nutrients—became popular in Europe as a source of blue dye. Woad grew in England early as 55 B.C., when Julius Caesar described how Scottish warriors smeared themselves in a blue woad paste. Woad gave them a double advantage in war: Not only did they frighten the bejesus out of their enemy, but woad's natural antiseptic properties shielded them in advance from wounds.

Woad's popularity enriched merchants in England, Germany, and especially France, where pays de cocagne—"the land of woad balls"—became a byword for Easy Street.

Jenny Balfour-Paul's book *Indigo* details how the two blues, woad and indigo, duked it out for centuries before woad ceded the field to indigo's many superior points. This battle is surprisingly bloody, a story of tactical bans by the French against indigo imports from the British. England lost its American colonies and swiveled indigo production back to India, where British planters forced natives to jump in fly-infested vats of indigo leaves to beat out the colorant. When the Germans synthesized indigo in 1897, blue became yet another dye exclusively produced there. When World War I cut the British and French off from their synthetic-indigo supply, the British redoubled Indian indigo production, pushing the natives so relentlessly that indigo abuses paved the road to India's independence.

Balfour-Paul's book also details how woad and indigo flourished around the globe. Indigo was prone to "sulky vat" troubles when the fermentation process stalled; many superstitions claimed either to prevent or break the spell of a sulky vat. Indonesian and Irish dyers alike forbid pregnant women near the vats, as their potency might compete with the bubbling life of fermenting indigo; Sumatran and Thai dyers cover their vats at news of death. In the High Mountains of Morocco, Berber dyers tell outrageous lies—spreading blackness—to distract demons who might thwart fermentation.

SMACKDOWN BETWEEN BLUES: A showdown between red dyes yielded an unequivocal winner: Mexican cochineals. See p. 28.

PAYS DE COCAGNE: Richie colors through the centuries include Roman royal purples (p. 96), exclusively imperial Chinese yellow (p. 65), and lustrous Puritan blacks (pp. 120-121).

ROY G. BIV

BLUE

CONES IN OUR EYES:
For the complementary conditions of color blindness and tetrachromacy, see p. 134.

PURPLE RAIN:
Police forces the world over like to soak rioting crowds with water cannons shooting purple-dyed water. See p. 99.

GOLDBRICKER:
Why are U.S. dollar bills green? See p. 78. For poisonous yellow-gold pigments, see p. 66. For the spiritualist quackery around color-personality tests, see p. 137.

URINE:
Pee bestows a golden shower of benefits to natural dye makers. See p. 97.

THE SACRED TO THE PROFANE

WHY IS THE SKY BLUE?

As Earth's atmosphere thickened with oxygen and other gases, that atmospheric layer also refracted incoming light rays, slowly changing the color of the sky over time. Layers of nitrogen and oxygen atoms built up, colliding with the shortest wavelengths of our sun's light, the blue and violet ones. (That collision bears the jaunty name of Lord Rayleigh, who first described the phenomenon in the nineteenth century.) The cones in our eyes are more sensitive to blue than violet, punching up our impression of a blue sky rather than a purple one. *Voilà*! Why the Sky Is Blue, Why the Sky Used to Be Clear, and Why Only Prince Sees Purple Rain.

INTERNATIONAL KLEIN BLUE

International Klein Blue (IKB) is an eye-wateringly strong color teetering between blue and purple.

Enraged by the placid reception of his first exhibit of monochromes, Yves Klein doubled down on provocation by painting exclusively in one color: blue. In 1955 he teamed up with Parisian paint dealer Édouard Adam to patent International Klein Blue, synthesizing the color using a new technique that preserved the pigment's blue luminosity. The effect was startlingly modern, a cobalt phoenix of a color.

It's hard not to dismiss Yves Klein as a *goldbricker*—in a 1959–62 work *Zones of Immaterial Pictorial Sensibility*, he sold empty lots (that he didn't own) in exchange for bars of gold, which he then ceremoniously tossed into the Seine. At a later exhibit, Klein served cocktails of gin, Cointreau, and methylene blue, which—to his delight—stained everyone's *urine* blue. Trickster or not, his antics served a point: Art flings us into the void, and it ought (literally) to penetrate us thoroughly.

THE LOST BLUE OF *TEKHELET*

Blue spells heaven for practically every religion on earth. Catholics revere Marian blue; Sikhs wear blue turbans in the pursuit of limitless open-mindedness. Count the blue mosques in the Muslim world and grow dizzy with the fecundity of Allah. Turquoise prayer beads absorb the sins of Buddhists; their darkening with age parallels the dimming of our lives as death nears.

As for Orthodox Jews, staring at the blue fringes of their prayer shawls (*tekhelet*) draws them into deeper contemplation of God, surrounded by blue like a "pavement of sapphire, like the very sky for purity," according to the Book of Exodus. But which shade of blue, exactly? The sacred recipe for *tekhelet* blue, a closely guarded Jewish secret involving *Murex trunculus* snails, was irretrievably lost around 70 A.D. What seems a trivial question actually makes for hot religious debate. Two Jewish authorities disagree in a fundamental way. The Jewish scholar Maimonides thought the color resembled the sky on a sunny day; Rashi, another prominent medieval commentator, described the color variously as green, and elsewhere as resembling a darkening evening sky.

In 2011, Dr. Zvi C. Koren identified the first known physical sample of *tekhelet* blue dye, a two-thousand-year-old scrap of fabric recovered from Masada, King Herod's fortress in the Judean Desert. The verdict: *Tekhelet* should be a deep purplish blue. Dr. Koren explains to the *New York Times*: "'*Tekhelet* is the color of the sky . . . It's not the color of the sky as we know it; it's the color of sky at midnight.' He paused and added, 'It's when you are all alone at night that you reach out to God, and that is what *tekhelet* reminds you of.'"

H-E-DOUBLE HOCKEY STICKS

In his slender volume *On Being Blue*, author William Gass paints an azure world in which blue colors obscenity and vice—even as it vaults overhead as the innocent blue of the heavens. On the seedier side of blue, then: Blue pigs are stores selling liquor even when blue laws forbid it. Blueskins (thieves) and blue gowns (prostitutes) who star in blue movies (porn) will get nabbed by bluebellies (police) and burn together in the blue blazes of hell.

FECUNDITY OF ALLAH: As epitomized in the color of Islam, green. See p. 78.

MUREX TRUNCULUS SNAILS: Hardly kosher, those. For more on the hardest-working snails in the color business, see pp. 196-197.

BLUE GOWNS (PROSTITUTES): "Giving her a green gown" signals a different type of licentiousness. See p. 73.

ROY G. BIV

BLUE

"TO BE BLUE"
(*BLAU SEIN*):
More metaphorical colors
of excess on p. 97.

HORNY DINOSAUR-
LIKE BODIES:
What colors were the
dinosaurs? Scientists are
starting to figure that out.
See p. 136.

TO PLAY HOOKY

Germans ditch school or work with an industrious-sounding alibi: They're "making blue" (*blau machen*). Medieval printmakers and dye workers had to take the next day off when a big job called for blue. The blue dye oxidized during the extra day of drying, improving its durability. Perhaps not accidentally, "to be blue" (*blau sein*) refers to getting drunk.

THE BLUE TONGUES OF TIBETAN BONS

After invading Tibet in 1717, the Dzungar tribe rooted out insurrectionist practitioners of the Bon religion via tongue inspection. Constantly reciting mantras, as the shamanistic Bons were wont to do, bruised the tongue a bluish-black color. Sticking out one's tongue remains a respectful greeting among Tibetans today, akin to the Western practice of shaking hands to show one is not armed.

CLASS, HIGH TO LOW

THE BLUE BLOOD OF HORSESHOE CRABS

In counterpoint to aristocratic "bluebloods"—a term coined by Iberian Crusaders with pale skin and visible blue veins—we submit the miraculous blue blood of horseshoe crabs. Every year a half million horseshoe crabs are harvested along the East Coast and—their horny dinosaur-like bodies hooked to pumps in pristine white labs—milked of their sky-blue blood. As *National Geographic* explains: "For decades [horseshoe crab blood has] proved vital to biomedical companies that must screen vaccines, IV fluids, and medical devices for bacteria that can be fatal in our bloodstream. Thanks to proteins in cells that act like a primitive immune system, the crabs' blood coagulates instantly when it touches pathogens like *E. coli* and *Salmonella*. So sensitive is the test derived from the proteins that it can detect amounts as slight as one part per trillion. That's like one grain of sugar in an Olympic-size pool." After delivering their antiseptic bounty, the crabs are returned, living, to the sea.

ULTRAMARINE

"Ultramarine blue is a color illustrious, beautiful, and most perfect, beyond all other colors," writes Cennino Cennini in *Il Libro dell'Arte*, the best-practices guide of artists in fifteenth-century Florence. The traditional recipe for ultramarine begins with crushed lapis lazuli mined in Zambia, Chile, Siberia, or Afghanistan—hence the name *ultramarine*, "from beyond the seas." Three days minimum of kneading and extracting suffice to coax the gorgeous blue dye out.

Ultramarine's radiant quality matched its high price, explaining its <u>meteoric popularity</u> among Renaissance Italian patrons seeking a pricey homage to the Virgin Mary. Painting commissions from that era briskly describe the scene to be depicted and instead dwell on the ingredients list, specifying exactly which grade of pigments should be used where and in what quantity. Devious artists could be strung up in the courts for swapping in cruder blues like azurite or—heaven forfend—smalt. Such was the gravitas of true ultramarine, its luminous life-giving draw.

FORZA AZZURRI!

Picture the fans: a moaning, swaying, laughing swelter of teeth and limbs. With one throat, one voice, they lift their dark, curly-headed mops and cry: *Forza Azzurri!* Go Blue! To Italians the thrill of *patria* stirs not from their modern red-green-and-white flag but from cerulean sky blue, *Azzurri*, the color of the House of Savoy generally and Vittorio Emanuele II specifically, the first king of a united Italy.

SUSTENANCE AND POISON

NEELKANTHA (THE ONE WITH THE BLUE THROAT)

Here's how the Hindu god Shiva got his eternally blue throat. To score a nectar of immortality buried deep in the oceans, the gods cooperated (uneasily) with the demons

Other color fads of history: the mauve craze of the 1850s (p. 98); Puritans' super-holy lust for black (pp. 120-121).

IF ARTISTS DO SEE FIELDS BLUE THEY ARE DERANGED, AND SHOULD GO TO AN ASYLUM. IF THEY ONLY PRETEND TO SEE THEM BLUE, THEY ARE CRIMINALS AND SHOULD GO TO PRISON.

—Adolf Hitler

to retrieve it. Their method: lashing a monstrous serpent god to an equally monstrous mountain, like a spoon tied with yarn to a turbo-charged Mixmaster.

They churned the sea for a hundred years, yielding all kinds of fascinating booty from its depths—unfortunately all laced with venom spewing from the punch-drunk serpent. As the ratio of venom to treasure reached distressing proportions, the gods appealed to Shiva the Destroyer to save them from further annihilation. Shiva drank the world's poison down like it was a malted milkshake—but he did not swallow. The poison hangs like a tangle of malignant blue thread, stoppered forever in his throat.

BLUE FOOD

A meal composed of naturally blue foods would be odd, scanty, and far-flung geographically. For an appetizer: Scoop out the moldy veins of a Stilton cheese and pair them with Kadarka grapes from Hungary. Entrée: Take a flatbread of Indian blue cornmeal, dust it with blue pumpernickel seeds from Turkey, the Netherlands, or Tasmania, and then gently lay a Long Island Blue Point oyster on top. Dessert we all know: Good ol' blueberry pie, with an arctic sliver of vanilla ice cream.

MALE AND FEMALE

RUSSIAN HOMOSEXUALS

Urged, perhaps, toward finer distinctions between blues by the ubiquity of winter, Russians consider sky blue (голубой, *golubój*) and navy blue (синий, *sínij*) to be separate hues from each other, as English speakers distinguish red from orange. That distinction runs to sexual orientations in men, where "sky blue" is shorthand for gay men, in the same way that one can call a lesbian a "pink" (розовая, *rózovaya*).

POISON:
Pre-synthetic colors often packed a deadly punch, like white lead (p. 11), arsenic-laced yellows (p. 66), or the deadly Scheele's green wallpaper that allegedly killed Napoleon (pp. 74-75).

BLUE THREAD:
A simple red thread signifies all sorts of things in different cultures. See pp. 30–31.

MEAL COMPOSED OF NATURALLY BLUE FOODS:
The hero of decadent literary classic *À Rebours* once hosted an all-black dinner to mourn the loss of his libido. For more high-priced, color-tinged antics, see p. 65.

SEXUAL ORIENTATIONS IN MEN:
The rainbow of gay men's proclivities includes green queens (p. 76) and gray queens (pp. 108-109). As for how the rainbow flag came to symbolize the Pride movement (and rioting German peasant farmers), see pp. 136-137.

FURBELOWS:
We owe the invention of shocking pink to fashion designer Elsa Schiaparelli. Those so inclined can also thank her for lamb-chop-shaped hats. See p. 19.

HOW TO CUT A RUG:
A creepy vestige of France's Reign of Terror was the *bals de victimes*, dancing-society parties open to anyone whose family perished at the guillotine. See pp. 30-31.

BLUESTOCKINGS

The first circle of Bluestockings—ladies slightly too learned for men's comfort—was formed around 1750 by coal heiress and salonnière Elizabeth Montagu in London. The ladies favored intellectual chat over card games and simple dress over furbelows. The Bluestockings' nickname refers more to their mannish directness than to what they literally wore. These women spoke frankly, like male tradesmen, who favored blue worsted hosiery instead of gentlemen's black silk stockings.

Bookish or not, Mrs. Montagu knew how to cut a rug. She explained her nickname "Fidget" and her fondness for dancing as follows: "Why should a table that stands still require so many legs when I can fidget on two?"

RENO DAKOTA

THERE'S NOT AN IOTA

OF KINDNESS IN YOU.

YOU KNOW YOU ENTHRALL ME

AND YET YOU DON'T CALL ME,

IT'S MAKING ME BLUE.

PANTONE TWO-NINETY-TWO.

—The Magnetic Fields, "Reno Dakota"

ROYALTY

King Purple
(96)

Splurging
(97)

INDIG

VIO

Purple earth theory
(102)

You empty
champagne bottles!
(99)

Mauve
measles
(98)

The Purple
Shall Govern
(99)

Purple States
of America
(98)

PROLETARIAT

GO &

LET

What rhymes
with purple
(101)

O, deathless
purple prose!
(102)

RAINBOW:
What could the gay-pride rainbow have in common with grumbling German peasant farmers? Their symbolic flag. See pp. 136-137.

TINTS OF BLUE-BLACK:
As it happens, blue didn't rank as a primary color in the West until the eleventh century. Until then it mooched around on the sidelines as a pale variety of black or an alternate green. See p. 84.

CLOTTED BLOOD:
Blood is far and away the top color association worldwide with red, but also darned fascinating for its own properties. Enter the gory nimbus of blood trivia on p. 27.

ROMAN FASCES AND AXES:
Other tidbits of military color: Scottish warriors daubed in freaky woad-blue dye (p. 85), the Dutch House of Orange gleefully flooding out its enemies (p. 44), and Moroccan soldiers fashioning a grim stuffed-chameleon charm with red thread (p. 30).

ROY G. BIV OR ROY G. BP?

His science of color proved more accurate than Goethe's, but Isaac Newton still bowed to an extra laboratory pressure: To the Enlightenment-era mind, the colors of the rainbow needed to match Descartes's seven-tone musical scale. So while he observed the same rainbow colors that we do—red, orange, yellow, green, blue, and violet—Newton shoehorned "indigo" into the list to bring the number of spectral colors to seven.

This also made for a neater mnemonic for the rainbow—ROY G. BIV to Americans, "Richard of York Gave Battle in Vain" to most Britons—although Yorkies prefer the version that applauds a local sweet, Rowntree's Fruit Gums and Pastilles: Rowntree's of York Gave Best in Value. (Richard of York got thoroughly spanked at the Battle of Wakefield in 1460, and it's still a sore topic.)

ROYALTY

KING PURPLE

In his *Natural History*, Pliny described the fabled color imperial purple as one that wobbled between hues, red or purple with tints of blue-black. "The Tyrian color is most appreciated when it is the color of clotted blood," Pliny writes, "dark by reflected and brilliant by transmitted light." It is "that precious color which gleams with the hue of a dark rose . . . this is the purple for which the Roman fasces and axes clear a way . . . It brightens every garment and shares with gold the glory of the triumph. For these reasons we must pardon the mad desire for purple, but why the high prices for the conchylian color, a dye with an offensive smell and a hue which is dull and greenish, like an angry sea?"

Behind the creation of this lustrous color were mountains of poor little snails, genus *Murex*, milked from anus to snout in a single fatal swipe. Their magical gland, the

"flower" or "bloom," is located near the mollusk's neck and yields one quivering white drop per snail. (It took ten thousand snails to dye a toga and a quarter million snails to yield a single ounce of dye.) The secretion initially stains fabrics a fluorescent green that, when exposed to sunshine, deepens from green to yellow to purple. Phoenician dyers operated amid unholy stink at the edge of town, surrounded by pots of stale urine and the heavenly reek of imperial purple itself: a garlicky, spring-onion scent so pungent you can rub even centuries-old fabric and still release the scent.

SPLURGING

What's the color of excess? Germans and French speakers go blue when they get drunk, while English speakers who've indulged kneel at the porcelain throne and express a "Technicolor yawn." Spaniards who eat or drink too much go purple (*ponerse morado de hacer/comer algo*).

> # ALL THE AMERICAN WOMEN HAD PURPLE NOSES AND GRAY LIPS AND THEIR FACES WERE CHALK WHITE FROM TERRIBLE POWDER. I RECOGNIZED THAT THE UNITED STATES COULD BE MY LIFE'S WORK.
>
> —Helena Rubinstein, cosmetics magnate

URINE:
Behind a surprising number of scintillating bright dyes stands pee as a key ingredient. See p. 66.

GO BLUE:
Germans also like to "make blue"—that is, play hooky from school or work. See p. 88.

ROY G. BIV

PURPLE

SCIENCE STUFF:
Color and science tango in all sorts of marvelous ways. For instance, scientists have invented a new superblack (pp. 117-118), overcome our usual color-vision limitations (p. 128), and figured out the average color of the universe (pp. 135-136). Science-fiction writers are no slouches either—for a full panoply of fictional colors from their pages, see pp. 128–129.

CURES FOR DEVASTAT-ING DISEASES:
Natural and artificial dyes can cure all kinds of ills—for instance, saffron as an antidepressant (p. 66) or woad as an antiseptic (p. 85). For all the yellow jaundice cures, from fanciful to actual, see pp. 60-61. For the totally fanciful quackery of color spirituality, see p. 137.

PURPLE TO THE PROLETARIAT

MAUVE MEASLES

In his 2001 book *Mauve*, author Simon Garfield paints a scene of accidental, super-profitable purple. In 1856, British teen chemist William Perkin was busy swishing coal tars in test-tubes—you know, science stuff—when he stumbled on a brilliant, durable purple dye he dubbed mauveine. When Queen Victoria wore mauve to her daughter's wedding in 1858, "mauve measles" broke out all 'round London town. Charles Dickens devoted the September 1859 issue of his new weekly *All the Year Round* to "Perkins's [*sic*] Purple." His literary team misspelled the scientist's name but otherwise accurately rendered the street-level mania for the color:

> One would think that London was suffering from an election, and that those purple ribbons were synonymous with 'Perkins for hever!' and 'Perkins and the English Constitootion!' The Oxford-street windows are tapestried with running rolls of that luminous extract of coal-tar . . . O Mr. Perkins, thanks to thee for fishing out of the coal-hole those precious veins and stripes and bands of purple on summer gowns that, wafting gales of Frangipanni, charm us in the West-end streets, luring on foolish bachelors to sudden proposals and dreams of love and a cottage loaf.

Science writer Philip Ball describes the extraordinary by-products of industrial science, discoveries that all stem from synthetic dyes like mauve: "Out of bright purples and lustrous reds, shocking pinks and brilliant yellows emerged . . . cures for devastating diseases; cheap and lightweight materials, mustard gas and Zyklon B, enough explosives to fill two world wars and more, liquid crystals and ozone holes. The modern age, in other words."

PURPLE STATES OF AMERICA

The 2000 presidential election marked the start of a bitter political war in America,

the red states versus the blue states. Even though red signifies left-wing solidarity in the rest of the world, and blue free-market conservatism, Americans have stuck with their own inverted red-blue divide for over a decade. Deepening rancor after the 2000 elections suggested that division was stark—until Princeton professor Robert Vanderbei's electoral map revealed the mixed-bag quality of actual politics. Vanderbei's map color-coded each county's voting results in a shade between true red (100 percent Republican) and true blue (100 percent Democrat). *U.S. News and World Report* popularized Vanderbei's map during the 2004 presidential elections, and the hopeful—possibly Pollyanna-ish?—notion of a Purple America was born.

YOU EMPTY CHAMPAGNE BOTTLES!

A withering designation for non-royal, nouveau riche students at Cambridge whose academic dress was, as *Brewer's Dictionary of Phrase and Fable* puts it, "a gaudy purple and silver gown, resembling the silver foil round the neck of a champagne bottle. Very few of these wealthy magnates took honours." (One wonders how many of the titled gentry's spawn behaved similarly but escaped snarky comment.)

THE PURPLE SHALL GOVERN

Cops worldwide quell rioting mobs with water cannons enriched with purple dye; the semipermanent purple "tags" protesters for later retribution by the police. In the last twenty years, protesters in Hungary, Indonesia, India, Israel, and (most recently) Uganda have all been purple-soaked.

It seems a shrewd move by police, but as *Slate*'s Explainer column explains, the tactic can backfire. In 1989, a group of anti-apartheid protesters marching on Cape Town's Parliament were ordered to stop, then soaked in purple dye. A protester seized control of the purple-dye cannon and turned it on the reigning National Party headquarters and the historic, whitewashed Old Town House nearby. "What about the purple people?" implored a Cape Town editorial the day after the "Purple Rain Protest." Graffiti on the Old Town House provided an answer that became a rallying cry of the anti-apartheid movement: "The Purple Shall Govern."

RED-BLUE DIVIDE:
Psychologists like nothing better than framing a fresh study pitting blue against red—see p. 35. As for another age-old pair of oppositional colors, red and green, see p. 34.

GRAFFITI:
The Gray Ghost of New Orleans does battle with Banksy—and loses spectacularly. See p. 108.

WORKS WITH NOBLE BEGINNINGS AND GRAND PROMISES OFTEN HAVE ONE OR TWO PURPLE PATCHES SO STITCHED ON AS TO GLITTER FAR AND WIDE ... FOR SUCH [EMBELLISHMENTS] THERE IS A PLACE, BUT NOT JUST NOW. PERHAPS YOU, TOO, CAN DRAW A CYPRESS. BUT WHAT OF THAT, IF YOU ARE PAID TO PAINT A SAILOR SWIMMING FROM HIS WRECKED VESSEL IN DESPAIR? THAT WAS A WINE-JAR, WHEN THE MOULDING BEGAN: WHY, AS THE WHEEL RUNS ROUND, DOES IT TURN OUT A PITCHER? IN SHORT, BE THE WORK WHAT YOU WILL, LET IT AT LEAST BE SIMPLE AND UNIFORM.

—Horace, *Ars Poetica*, lines 14–23

LITERARIA

O, DEATHLESS PURPLE PROSE!

Purple prose finds perhaps its wittiest expression in the Bulwer-Lytton Fiction Contest. Sponsored by San Jose State University, the contest has awarded a "pittance" annually since 1982 to the worst opening line of an imaginary work of fiction. The contest's name is a nod to Edward George Bulwer-Lytton, whose 1830 novel *Paul Clifford* would be lost to history if not for its schmaltzy opening line: "It was a dark and stormy night." 2010's winning line was penned by Molly Ringle of Seattle: "For the first month of Ricardo and Felicity's affair, they greeted one another at every stolen rendezvous with a kiss—a lengthy, ravenous kiss, Ricardo lapping and sucking at Felicity's mouth as if she were a giant cage-mounted water bottle and he were the world's thirstiest gerbil."

The Bulwer-Lytton Fiction Contest has spawned several offshoots, including the Bad Sex in Fiction event (featuring cringe-worthy sex passages from real books) and the Lyttle Lytton Contest, with a Twitter-friendly word limit of twenty-five words. Standouts from Lyttle Lytton include:

"It clawed its way out of Katie, bit through the cord and started clearing." —Gunther Schmidl (winner, 2007)

"'I shouldn't be saying this, but I think I'll love you always, baby, always,' Adam cried into the email." —Shexmus Amud (winner, 2010)

"Emperor Wu liked cake, but not exploding cake!" —Bret Victor (third place [three-way tie], 2007)

WHAT RHYMES WITH PURPLE?

Some lump purple in with *orange* and *silver* as a word without a natural rhyme in English—but mavens know purple has two rhymes, *curple* and *hirple*. In his 1787 poem "Epistle to Mrs. Scott," Robert Burns uses the word *curple*, a curvily apt synonym for

WORLD'S THIRSTIEST GERBIL:
Unnervingly reminiscent of the vomiting serpent of Hindu myth, whose blue poison permeated the world until the god Shiva (aka Neelkantha) swallowed it: See p. 91. Other suggestive animals of color lore: Herman Melville's dreaded white whale (p. 6), Indian cows chewing poisonous mango leaves (p. 66), birds speaking the green language (p. 81), and two disheveled but living flamingos that actually dropped out of the Siberian sky (p. 15).

EXPLODING CAKE:
Other unexpected single-color meals: the fictional duc des Esseintes's all-black meal to mourn his flagging libido (p. 119) and the rarity of truly blue foods in nature (p. 91).

ORANGE:
See p. 44.

SILVER:
See p. 109.

ROY G. BIV

PURPLE

SCIENCE DELIVERS
ACCIDENTAL POETRY:
Other installments include
the colors of quarks
(p. 138), dinosaurs (p.
136), and the average
color of the universe (pp.
135-136).

PLENTIFUL GREEN
WAVELENGTHS:
For more on why plants
are green (but might well
be other colors on alien
planets), see p. 77.

the posterior. Here's Burns in nearly impenetrable Scottish brogue, describing how he'd rather wear the family tartan on his rump than royal robes any day:

> "I'd be mair vauntie o' my hap,
> Douce hingin owre my curple,
> Than ony ermine ever lap,
> Or proud imperial purple."

We also have Burns to thank for *hirple*'s fifteen seconds of fame; it means to "walk lamely or hobble, like a hare." Burns uses *hirple* in his poem "On the Birth of a Posthumous Child, born in peculiar circumstances of Family-Distress," written to honor his friend James Henri, whose death in 1790 predated his child's birth by months. Burns describes the impecunious mother in labor (who died herself shortly after): "November hirples o'er the lea, Chill on thy lovely form./And gane, alas! the shelt'ring tree,/Should shield thee frae the storm."

NATURE

PURPLE EARTH THEORY

In another installment of Science Delivers Accidental Poetry, "purple earth theory" suggests that primitive microbes may have used retinal instead of chlorophyll to extract energy from the sun, empurpling the seas with lavender proto-plant life. As a 2007 *LiveScience* article explains, "Chlorophyll, the main photosynthetic pigment of plants, absorbs mainly blue and red wavelengths from the Sun and reflects green ones, and it is this reflected light that gives plants their leafy color. This fact puzzles some biologists because the sun transmits most of its energy in the green part of the visible spectrum." Chlorophyll microbes elbowed their way in by feasting on the plentiful green wavelengths not already dominated by retinal eaters.

Chalk up another unlikely association for purple: the color of efficiency.

FORGIVENESS IS THE FRAGRANCE

THAT THE VIOLET SHEDS ON THE

HEEL THAT HAS CRUSHED IT.

—Mark Twain

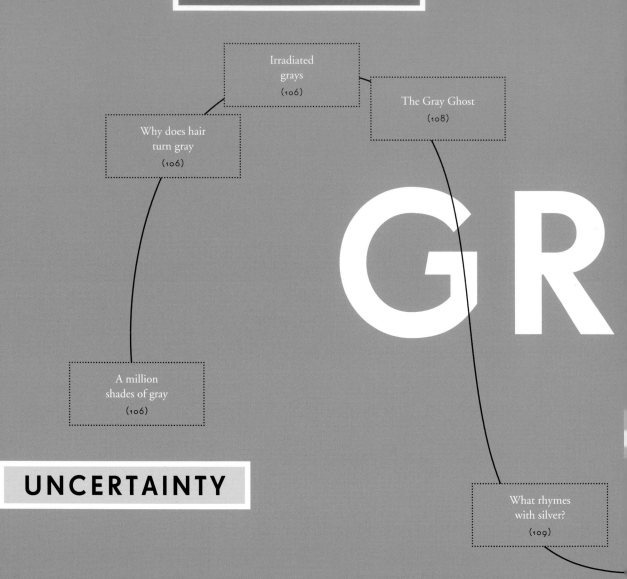

UNCERTAINTY

GR

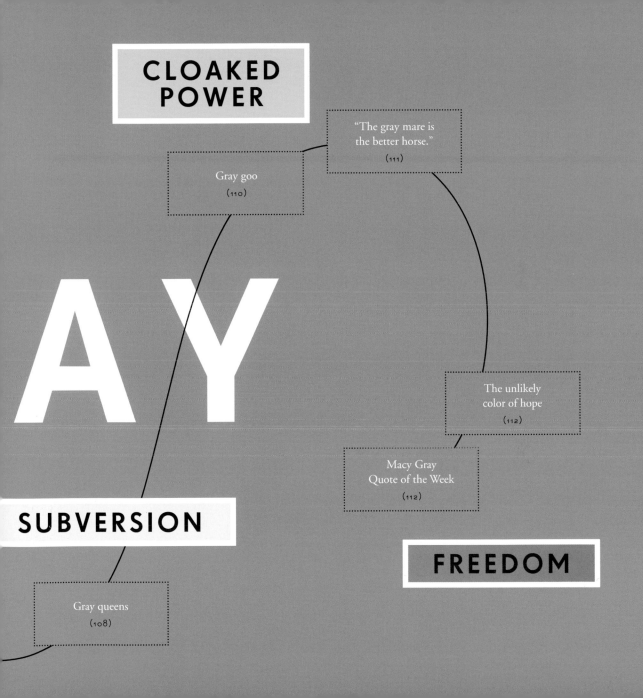

CLOAKED POWER

"The gray mare is
the better horse."
(111)

Gray goo
(110)

AY

The unlikely
color of hope
(112)

Macy Gray
Quote of the Week
(112)

SUBVERSION

FREEDOM

Gray queens
(108)

FROM THE MUD
TO THE STARS:
How did our sky become
blue? See p. 86. How
did Earth's plants become
green (after they were
mostly purple)? See p. 77.
What would the colors of
plants on alien planets
likely be? See p. 77. And
what's the average color of
the universe, anyway? See
pp. 135-136.

HAIR COLOR:
Natural redheads have at-
tracted more than their fair
share of scientific testing,
including two competing
claims about their ability
to withstand pain. To poke
and prod a ginger with
a team of blonde and
brunette scientists, see
p. 35.

KILLING UNITS:
For a scintillating list of
poisonous yellow pigments,
see p. 66. For the arsenic-
laced green wallpaper that
was thought to have killed
Napoleon, see pp. 74-75.
For crazed half-naked
Scottish warriors smeared
in blue wood dye, see
p. 85.

UNCERTAINTY

A MILLION SHADES OF GRAY

Roget's International Thesaurus sets the mood for gray's emotional range, one that stretches from the mud to the stars: Iron. Dun. Drab. Dingy. Leaden. Grizzled. Slate. Mousy. Ashen. Limy. Salt-and-pepper. Dove-colored. Silvery. Chiaroscuro. Grisaille. Pearlescent. Dappled.

EXHAUSTION

WHY DOES HAIR TURN GRAY?

"Not only blondes change their hair color with hydrogen peroxide," said Gerald Weissmann, MD, editor in chief of the *FASEB Journal*, published by the Federation of American Societies for Experimental Biology. "All of our hair cells make a tiny bit of hydrogen peroxide, but as we get older, this little bit becomes a lot. We bleach our hair pigment from within, and our hair turns gray and then white."

IRRADIATED GRAYS

Doses of radiation are measured in killing units called "grays" (Gy); each gray refers to the absorption of one joule of energy per kilogram of absorbing material. When that "absorbing material" happens to be a living person, experts talk instead in terms of a suitably sinister-sounding measurement, the "sievert." As the BBC explained after the 2011 Fukushima Daiichi nuclear disaster, "A sievert is a gray weighted by the effec- tiveness of a particular type of radiation at causing damage to tissues, and is used to measure lower levels of radiation and for assessing long-term risk."

THE COLOR OF TRUTH

IS GRAY.

—André Gide, French writer and 1947 Nobel Prize winner for literature

FOR A PAINTER

GRAY IS THE RICHEST COLOR,

THE ONE THAT MAKES ALL THE

OTHERS SPEAK.

—Paul Klee, Swiss-German painter

HEADACHES AND FEVER: Falling asleep under a walnut tree meant exposing oneself to nightmares, headaches, and visitations from the devil. So thought medieval Europeans, anyhow—see p. 120.

WALL STREET'S CANYONS: Why are U.S. dollars green? See p. 78.

Short-term, a dose of only one gray can provoke symptoms of radiation sickness: nausea and vomiting, diarrhea, headaches, and fever. Higher doses of gray can fry the internal organs to death, while a dose of three to four Gy will kill 50 percent of any given group of people.

SUBVERSION

THE GRAY GHOST

The Gray Ghost refers to one Fred Radtke, New Orleans's most virulent anti-graffiti activist, who has canvassed the city since 1997, covering graffiti with thick coats of gray paint. Radtke is so virulently famous in street-art circles that the shadowy graffiti kingpin Banksy came to the Big Easy in 2008 specifically to do battle with him. The two gray ghosts moved like smoke through the night, crossing paint cans like swords in innumerable alleys. An actuary could make himself dizzy calculating Radtke's net contributions to community wealth: What's the monetary value-add of an upstanding, graffiti-free street, compared to losing an authentic Banksy work on your building, which reportedly can up property values by $75,000 to $200,000?

Radtke got his comeuppance in 2009 with a mistake delectable to street-art fans: He covered up a graffiti-style mural legally commissioned by the wall's owner, Southern Coating and Waterproofing. Dripping gray paintbrush in hand, Radtke was remanded by National Guard Military Police to authorities, who slapped him with a summons for criminal damage to property; pleading no contest, he got off with a sixty-day suspended sentence and a warning: Don't gray out any graffiti without asking the building owner first.

GRAY QUEENS

In a slate-gray cubicle, one among millions lining Wall Street's canyons like a honeycomb, fingers flash over a cement-colored calculator. Another dour figure passes in gray

PALLOR OF SHAME:
Hindus and Hebrew
speakers see shame in
fundamentally opposing
colors—see p. 8. As to
how a white feather came
to symbolize cowardice,
see p. 8.

EWE LAMB:
Much like the sweet red-
dyed chick accompanying
Ndembu brides in Zambia
into marriage. See p. 32.

flannel, flicking a wrist in discreet greeting. In a world erupting with ugly secrets, can two gray queens —homosexuals who work in financial services— still cast the same pallor of shame?

WHAT RHYMES WITH SILVER?

English boasts more rhymes for *orange* and *purple* than you might suppose, but both are infinitely more rhymeable than *silver*.

In fact, despite lots of half- or near-rhymes (notably *salver*, *pilfer*, and the phrase *kill her*), silver's one true rhyme is *chilver*, an antiquated name for a ewe lamb.

For a thumping-good time on a winter's night, try to find rhymes for the other unrhymeable words in English: *angst*, *breadth*, *depth*, *gulf*, *mulcts* (plural of *mulct*, a penalty, tax or fine), *month*, *ninth*, *twelfth*, and *wolf*.

DOOMSDAY SCENARIO:
For the recipe for uranium yellowcake, the chief ingredient in nuclear weapons, see pp. 66-68.

LOOPY SCI-FI PLOT:
Science-fiction writers have gotten busy inventing new colors—see pp. 128–129. For an actual scientific study that momentarily overcomes the limits of color vision, see pp. 127-128.

CLOAKED POWER

GRAY GOO

Gray goo describes a theoretical doomsday scenario in which self-replicating robots go haywire and consume all the matter on Earth.

Far from a loopy sci-fi plot—although it's spawned plenty of those—gray goo has been a real worry for nanotechnologists and their frenemies. As an umbrella term, *nanotech* encompasses many concepts, including molecular manufacturing. Eric Drexler, author of the 1986 book *Engines of Creation*, first articulated molecular manufacturing's

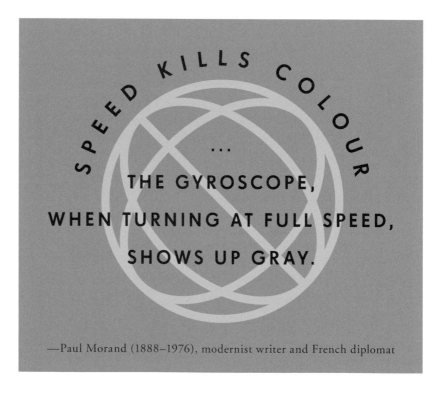

SPEED KILLS COLOUR

...

THE GYROSCOPE, WHEN TURNING AT FULL SPEED, SHOWS UP GRAY.

—Paul Morand (1888–1976), modernist writer and French diplomat

premise: Tiny "assembler" robots could someday be trained to "place atoms in almost any reasonable arrangement," thus allowing us to "build almost anything that the laws of nature allow to exist." Why raise your food or buy your car if assemblers can build products, atom by atom, for you? If assemblers could self-replicate, <u>teams of the little buggers</u> could multiply themselves to speed the work further. Any cancerous mutation in their activity, however—gray goo—could easily consume the planet.

How easily? A 2003 *New York Times* article reports Drexler's calculations: "In just 10 hours an unchecked, self-replicating auto-assembler would spawn 68 billion offspring; in less than two days the auto-assemblers would outweigh the earth."

Enter the horsemen of Revelations: In December 2008, a University of Pittsburgh research team tackled the potential problem of nanotube spills (<u>carbon nanotube molecules</u> are ideal raw material for the assemblers' bodies). Luddites and MacGyvers, taste your vindication: Pitt proposed fighting the gray-goo effect with—wait for it—horseradish.

"THE GRAY MARE IS THE BETTER HORSE"

This old saw describes a wife who dominates her husband, presumably the less spirited <u>horse</u> in a two-horse carriage's team. Alfred, Lord Tennyson (who married the exceedingly nice Emily Sellwood) conveys the gray mare's frustrated will—and some men's unholy fear of strong-willed women—in his 1846 proto-feminist comic poem "The Princess":

> Look you! the gray mare
> Is ill to live with, when her whinny shrills
> From tile to scullery, and her small goodman
> Shrinks in his arm-chair while the fires of Hell
> Mix with his hearth . . .

TEAMS OF THE LITTLE BUGGERS:
Insects are indeed the undersung heroes of color's material history. For the Mexican cochineal insects yielding an amazing red dye, see p. 28. For a paean to the billions of murex snails dying to make purple dye, see pp. 96-97.

CARBON NANOTUBE MOLECULES:
Another use for carbon nanotubes: to construct the world's blackest black. See pp. 117-118.

HORSE:
Arthurian knights in single-colored livery conveyed symbolic meanings to their readers. To crack the knight color code, see p. 123.

111

ROY
G.
BIV

GRAY

BLACK DYES:
Oak galls, cuttlefish,
walnuts, burnt bones, and
ashes all contributed their
bit to the advancement
of black dyes. See pp.
121-122.

FREEDOM

> EVERY ROOM HAS ITS GLOOM.
> THE GREAT THING IS TO FIND THE
> COLOR THAT WILL CUT THAT GLOOM.
> —Gertrude Stein

GRAY, THE UNLIKELY COLOR OF HOPE

Gray scored a promotion among colors in fifteenth-century Europe for several reasons, detailed by art historian Michel Pastoureau in his book *Black: The History of a Color*. Gray piggybacked on the technical advances in black dyes during that period; more deeply lustrous black textiles found their complement in more luminous grays. Furthermore, Gutenberg's printing press unleashed a stream of printed matter into society, promoting the color combo of black-and-white type and infinitely shaded *grisaille* etchings in gray.

As gray textiles moved from muddy to limpid, and in a historical context in which gray type epitomized future-forward technology, gray became symbolic of hope and joy. Pastoureau cites the songs of Charles d'Orléans, who was taken prisoner during the Battle of Agincourt of 1415 and exiled in England for twenty-five years. His hopefulness of one day returning to Mama France sings out in his gray clothes:

> He lives in good hope,
> Because he's dressed in gray,
> That he'll have
> Once more his heart's desire.

How long he is far from France
On this side of Mount Senis,
He lives in good hope
Because he's dressed in gray.

In another song Charles exhorts doubters back in France, who fear that his continued absence spells death, with these words:

Let no one wear black for me,
Gray cloth costs less,
Take it up, each of you, for all to see,
That the mouse still lives!

MACY GRAY QUOTE OF THE WEEK

For months in 2001, the alt-newspaper *Philadelphia Weekly* published the "Macy Gray Quote of the Week," an apparently inexhaustible supply of half-baked pronouncements by the R&B singer Ms. Gray. This daisy chain of found art offers perhaps the perfect Portrait of Gray: unintentionally ludicrous; studied yet naïve; doubly interesting for its gap between sound and sense.

Gray on her 2001 album *The Id*: "It's like if you were to take a Hershey's kiss and eat it while you're on a roller-coaster ride to the moon. While you're on the moon, you get your nails done, get your hair done and put on your best clothes. That's what my record's like."

Gray on herself as art: "I have a bronze statue of myself, naked. I have these really big curls and water comes out of every curl. It's hot."

Gray on stealing: "I do steal on occasion. I stole a painting from the last hotel I was in. But I'll probably be charged for it."

Gray on chicken: "Say you order roasted chicken and they serve it fried. That's not cool. You have to get it roasted like you want, or you leave. Satisfaction is crucial."

Gray on the freedom afforded by grayness: "Whatever your image is, it's probably not you, but it affords you the freedom to live up to it."

BLA

Sudanese
"black space"
(117)

THE VAST AND THE MINUTE

GODS AND MONSTERS

The new black
is very, very black
(117)

CK

Color-codes of
Arthurian knights
(123)

Ali and
the Ka'aba
(122)

BLACK IS A TRUE
SENSATION, EVEN
IF IT ARISES FROM
A TOTAL ABSENCE OF
LIGHT. WE PERCEIVE
THE SENSATION OF
BLACK AS DISTINCTLY
DIFFERENT FROM
THE LACK OF ALL
SENSATIONS.

—Hermann von Helmholtz

BLACK

SUDANESE "BLACK SPACE"

The Sudanese vocabulary of signs includes a motif for "black space." This refers to three realms of bodily darkness: an exhalation from the mouth, exhalation from the nose, and flatulence.

SHADES OF BLACK

Classical Latin recognized <u>two fundamental kinds of black</u>: *ater* and *niger*. The more commonly used term, *ater*, described neutral or matte blacks, taking on a negative connotation (it is the root word of atrocious) around the second century A.D. Meanwhile, niger described a glossy black, luminous with portentousness or life. Latin whites were similarly divided into *albus* (matte) and *candidus* (glossy). Although the former won out as the dominant name for white (think *albino*), candidus reserved a certain sparkle as the <u>color of togas worn by Roman politicians</u>, the *candidati*.

Niger swallowed *ater* at the beginning of the imperial period; however, the distinction persisted in Germanic languages until the late Middle Ages and even longer in isolated areas. German blacks *swarz* (matte) and *blach* (luminous) met their Old and Middle English cousins *swart* (dull) and *blaek* (shiny). Proto-Germanic posed glossy white (*blank*) and glossy black (*blach*) as complements, since both stemmed from a single root: *blik-an*, "to shine."

VERY, VERY BLACK IS THE NEW BLACK

In 2008 researchers at Rensselaer Polytechnic Institute invented a new black out of <u>carbon nanotubes</u>, sheets of carbon a single atom thick and rolled into cylinders. This new black sucks in light from all angles and all wavelengths with marvelous avidity, reflecting three times less light than previous "superblack" materials.

TWO FUNDAMENTAL KINDS OF BLACK:
The science of color naming gets infinitely weirder from here. For the seminal linguistic study, the Berlin-Kay color order, see p. xx. For how foreign languages divide the colors of the rainbow, see p. xix-xx. For truly unusual color nomenclature, see the browns of Benin, pp. 52–53.

COLOR OF TOGAS WORN BY ROMAN POLITICIANS:
Of course, once they secured an elected office, Romans flung off the white robes to suit up in maximally expensive purple togas. See pp. 52-53.

CARBON NANOTUBES.
On a less cheerful nanotech note, "gray goo" describes a doomsday scenario in which self-replicating nanorobots go haywire and consume all the matter on Earth. See pp. 110-111.

ROY
G.
BIV

BLACK

MILITARY STEALTH BOMBERS:
Anti-flash white, a super-powered white paint, supposedly protected nuclear bombers during the Cold War from the blasts they created. See p. 5.

Two years later, researchers at Purdue University fired back with an even more darkly successful meta-material. As the *Guardian* described it in 2010, the new-new black consists of "an intricately constructed array of tiny silver wires embedded in aluminium oxide, which does weird things to the light waves that hit it, bending them in odd ways and sending them in unnatural directions." Its potential uses? More efficient solar panels (by harvesting light more effectively); military stealth bombers, invisibility cloaks, or street wear for the ultimately disaffected.

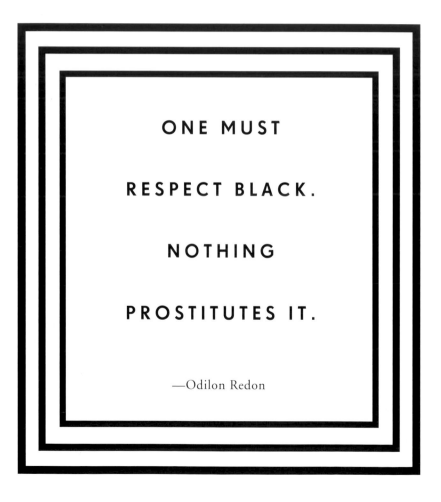

ONE MUST

RESPECT BLACK.

NOTHING

PROSTITUTES IT.

—Odilon Redon

EATING MELANCHOLY

À Rebours by Joris-Karl Huysmans (1884) is perhaps the most artistically decadent novel ever. It details an exhausted duke staging his every aesthetic fantasy down to all the fine details, including numerous minute observations on color. The book contains a gemstone-encrusted tortoise placed atop a particularly bright rug, a flower garden accented by flowers shaped like zinc stovepipes and pigs' tails, and other theatrically bizarre filigrees.

The darkest among these is le Duc's all-black dinner party commemorating, with lavish overreaction, the death of his libido (or, as it turns out, an inconvenient softness during lovemaking). Amid coal-lined garden paths and fountains spurting jet-black ink, the funereal eats include Russian caviar, bruised cherries, and game swimming in sauces "resembling liquorice water and boot-blacking," all served by "naked Negresses wearing shoes and stockings of cloth of silver besprinkled with tears." (One only hopes the waitresses exacted a colorless revenge of spitting into the soup behind kitchen doors.)

JEALOUSY

Swedes and Norwegians go "black-sick" (*svartsjuk*) with jealousy, which the Finnish call *mustankipeä*. When extreme jealousy curdles its way even to one's toes, the Finns describe that degree of envy as *mustasukkainen*, "with black socks."

FECUNDITY

In lands where rain is scarce, black takes on a character of maturity and ripeness. French ethnographer Anne Varichon writes, "The people of Uruk in present-day Iraq use the term 'black' to signify both very ripe fruit and arable land. In northwestern Africa, a young woman may don a black dress after seven days of marriage. The color of fertile soil, this garment bears witness to her transformation and her dreams."

Then again, ripeness tips all too quickly into rottenness. The Ndembu people of Zambia draw a black line running from navel to sacrum on anyone who dies without descendants. As Varichon puts it, "This mark signifies that the deceased must 'die forever.'" In a more paranoid vein, a jealous Indian lover uses a black thread to tie a rival's

ALL-BLACK DINNER PARTY: For the exceedingly short list of naturally blue foods, see p. 91.

JEALOUSY: If envy isn't itself a many-splendored thing, its metaphors do scintillate with colors. For the color shift among Germans that renders jealousy yellow, see p. 60. For a Gypsy charm designed to trick a cheating wife into confessing in her sleep, see p. 31. As to why married Chinese men shrink in horror from wearing green hats, see pp. 73–74.

BLACK DRESS: She may not have invented the little black dress, but fashion icon Elsa Schiaparelli did electrify *la mode* with her signature color, shocking pink. She also gave the world lamb-chop-shaped hats, for which it has been disgracefully unthankful. See p. 19. As to how black became the Western color of mourning, see p. 7.

BLACK THREAD: For all the things a red thread can mean around the globe, see pp. 30–31.

ROY
G.
BIV

BLACK

LOGWOOD:
For its Brazilian cousin, the rabidly successful brazilwood, see p. 28.

BLUE:
For blue's rise as a separate color to European eyes, see p. 84.

POISON COWS:
Dying cattle might augur a different kind of horror: infiltration by the deadly Color Out of Space. See pp. 128-129.

hair to three rings, buries the charm under rocks, and invokes the following incantation over it: "As from a tree they separate a liana, I separate from my rival her happiness and her radiance; like the immovable mountain, may she remain forever seated in her parents' home."

THE SLOWLY EXPANDING UNIVERSE OF BLACK DYES

Medieval European craftsmen had a problem: How do you turn a garment black? Many of the traditional dyeing methods, including using iron filings bathed in vinegar, produced dirty, not-black-enough results. Multiple dyeings in various colors could darken fabric to an acceptable matte black, but strict dyers-guild rules forbid too much mixing of dyes.

The standard low-cost recipe involved a bark called logwood, which blackened fabrics at least temporarily; predyeing in blue woad gave the black a solid "foot." Dyers typically left the corners of a "footed" black fabric woad blue as a sign of quality; lazy dyers skipped the woad bath and simply dipped the fabric's bare corners in blue. Consider a Puritan's outrage as his solid-black togs faded to a rusty Halloween orange within weeks.

Europeans could have easily turned to walnuts, a common tree growing in nearly everyone's backyard. However, toxic walnut roots' tendency to kill neighboring vegetation and even poison cows shrouded the walnut tree with ghastly, partly true superstitions. To fall sleep under a walnut tree, for example, was to the medieval mind to expose oneself to nightmares, headaches, even visitations from the devil. Dyers only overcame their suspicions of walnut trees in the fourteenth century, when rising demand for true blacks by merchants and princes gave black the glittering aura of cold, hard cash.

By the eighteenth century, dyemakers could produce a smoky continuum of blacks and grays with highly evocative names: silvery gray, thorn gray, and dying ape.

BLACK IS BACK (WITH A PURITAN VENGEANCE)

After Europe's Great Plague of 1346–50, some moral and economic housekeeping was called for. Enter the sumptuary laws initiated slightly before the plague but vastly

expanded afterward: a bewildering system of rules governing who could wear what clothes when (including specifications on cut, color, and cloth). In his book *Black: The History of a Color*, art historian Michel Pastoureau attributes the motivations for these laws to economic necessity (i.e., stimulating the local economy) as well as to limits imposed by what was perceived as immoral extravagance.

In these lean times, a good burgher could gussy himself up only by wearing one of few colors exempted from sumptuary law: black. Thus began the push for inventing deeper, more brilliant black dyes and a mania for wearing black that spanned Europe from the mid-fourteenth to seventeenth centuries.

Perhaps the poster boy for this era was Matthäus Schwarz, aka Herr Black, whose *Book of Costumes* (1520–60) depicts him, outfit by outfit, in a series of nearly exclusively black getups. Hoods, snoods, fur capes, cloaks, striped breeches, madly puffed-out sleeves: The Augsburg banker rocked them all.

One can index black's cachet at its peak across Europe with the following statistics: In Paris around 1700, a full 33 percent of noble clothing for men and women was colored black, while for officers black composed 44 percent of their wardrobes. In a clear signal that black had officially jumped the shark, by 1700 even domestics wore black 29 percent of the time.

THE CURIOUS SCIENCE OF INK

Love-letter inks in early China and Persia smelled as heavenly as the prose they conveyed. The lists of their ingredients read like all love's elements bottled: cloves, honey, olive oil, powdered pearl, rhinoceros horn, the smoke of pine trees burning in autumn. Scribes shaped the ink concentrate into little figures—animals, bells—breaking off a chunk and thinning it with water to write.

Burning tufts of oily wool in terra-cotta, Maghreb Muslims made a velvety black ink for Koran calligraphy, a small dose of which they ritually swallowed before copying out the holy word.

More prosaic sources of black ink include cuttlefish, oak galls (a growth formed on the tree trunk by invading worms), burnt bones, or lampblack ashes mixed with water.

WHO COULD WEAR WHAT CLOTHES WHEN: Fashion is cruel: No sooner does it liberate the fancies than it dictates what is gauche (and cinches its pronouncements with a tightly uncomfortable corset). For more on Elsa Schiaparelli, fashion icon and inventor of shocking pink, see p. 19. For the prohibition against green magazine covers, particularly for fashion rags, see p. 74. For the nineteenth-century craze for mauve, see p. 98.

ALL LOVE'S ELEMENTS BOTTLED: It's strong stuff. For various color superstitions to ward off cuckoldry, see pp. 31 and 74. For the origin of white wedding dresses, see pp. 4-5. Fertility rituals with color at their center also abound: see pp. 40 and 119 for starters.

BURNT BONES: A seventeenth-century recipe for mommia brown, an artist's pigment, calls for the crushed remains of ancient mummies. See p. 56.

ROY
G.
BIV

BLACK

DEEP REDDISH EYES:
To the Chinese, a classic
symbol of envy. See p. 32.

BLACK SKIN:
For more on Brazil's
puzzling notion of race,
see pp. 53-54.

MUHAMMAD:
Another favored color of
Islam (and Muhammad) is
green, the hue of paradise.
See p. 78.

Even inks of the bureaucracy can astonish. Modern British registrar's ink bites into paper so permanently as never to fade and is therefore a staple for signatures on legal documents. (Magistrates complain how a single ink splot can irretrievably ruin clothes.) Commercial ink batches around the world contain tracer chemicals that change from year to year, aiding future forensic efforts to date documents accurately.

BLACK GODS AND SAINTS: KĀLĪ

Kālī is the Hindu goddess of energy, time, blackness, and death. Closely associated with her equally black husband Krishna, Kālī likes collecting severed heads and dancing feverishly on her foes' graves—yet her monstrous power has a maternal edge, too. To take one example: While doing battle with the demon Raktabija, the more genteel goddess Durga was stumped by the demon's trick of self-replicating with every drop of blood spilled. Like a mother quashing a bully's attack on her child, Kālī emerged from Durga's forehead "very appalling owing to her emaciated flesh, with gaping mouth, fearful with her tongue lolling out, having deep reddish eyes, filling the regions of the sky with her roars . . . she devoured those hordes of foes." Thanks, Mom!

BLACK GODS AND SAINTS: SAINT MAURICE

Maurice, hailing from Thebes and named for his black skin (Mauritius in Latin), was so beloved by medieval Christians as to be dubbed the patron saint of knights and dyers' guilds: no minor role.

BLACK GODS AND SAINTS: ALI AND THE KA'ABA

Shiite Muslims wear black in honor of their assassinated leader, Ali, Muhammad's son-in-law and founder of the Shiite movement. The Abbasid dynasty (750–1258) seized black as a sign of fealty to both Abbasid caliphs and Ali's memory. The sacred black covering Shiite shrines and believers today binds all Shiites in this permanent memorial.

Shiites and Sunnis alike rally around one large black meteorite: the Ka'aba of Mecca.

Lore describes it falling from the sky in Adam's time, lily white at first but soiled by the sins of man. Subsequently destroyed by the Great Flood, the Ka'aba was reconstructed by Abraham and his son Isaac. The Koran dictates at least one trip to Mecca to behold the Ka'aba, to circle it reverently counterclockwise and to kiss its exposed corner (if possible—the crowds are usually crushingly large). Thirty days before Ramadan starts, the governor of Mecca invites religious leaders and dignitaries to an ultrasecret ritual to clean the stone. Using simple brooms, they wash it in water from the miraculously endless Zamzam Well, mixed with Persian rosewater.

COLOR CODES OF ARTHURIAN KNIGHTS

When an unknown knight strolls into a jousting tournament in Arthurian legend, clued-in readers know what kind of guy they're dealing with by the color of his kit. Knights clad in unbroken red are the worst troublemakers, hailing from the devil or some otherworldly locale. Less alarming are all-green knights, simply young and rash. White knights are predictably good, wise, avuncular. Black knights run counter to modern expectations: not necessarily evil (indeed, usually a very royal good guy in disguise), their color signals only a wish to remain incognito.

PERSIAN ROSEWATER: Copiously sprinkled on all kinds of Persian desserts. See p. 20.

123

ROY
G.
BIV

BLACK

BEY

TH

RAIN

OND

HE

BOW

**Color is like a closing eyelid, a
tiny fainting spell . . .**

—Roland Barthes, French philosopher
and cultural theorist

**Color is an illusion, but not
an unfounded illusion.**

—C.L. Hardin, author of *Color for
Philosophers: Unweaving the Rainbow*

IMAGINARY COLORS

However evocative to romantic poet types, "imaginary colors" is a scientific term. Each of your eye's cones carves out light wavelengths whose color you can see (red, green, or blue). The rest of the wavelengths, and the colors you can't see, are termed "imaginary," "non-physical," or "unrealizable" colors.

WITTGENSTEIN'S REDDISH GREEN

"Why can't we imagine a grey-hot?" asked philosopher and bigwig color thinker Ludwig Wittgenstein in his book *Remarks on Color* (written 1950–51 and published in 1977). His favorite conundrum color was the impossible reddish green. Like Kant, Hegel, Derrida, and other philosophers, Wittgenstein used color as a medium to explore the limits of sensation, the problem of other minds, the gap between language and its object, even the knowability of the world.

Stumped but clearly intrigued, Wittgenstein marveled at color's intractability the way one wrestler admires another's pin technique. He numbered all the impossible colors almost lovingly, depicting an obverse world from the one we live in: a place of black mirrors, brown traffic lights, clear milk.

FORBIDDEN COLORS

Wittgenstein's reddish green and yellowish blue were largely impossible for humans to see until 2001, when a team of researchers — Vincent A. Billock, Brian H. Tsou, and Lt. Col. Gerry Gleason — at Wright-Patterson Air Force Base made these so-called "forbidden colors" briefly visible.

In normal vision, color signals flood the cones in the retina in red, green, and blue wavelengths. Then other cells add and subtract the cones' outputs, producing two pairs of primary colors—red and green, yellow and blue. From there, Billock and Tsou wrote later in *Scientific American*, "It is as if the visual system is wired with two data channels for color: a red-minus-green channel (in which positive signals represent levels of redness, negative signals represent greenness and zero signal represents neither) and a similarly operating yellow-minus-blue channel." This hardwiring explains why we can't

ROMANTIC POET TYPES: For rhymes to the supposedly unrhymeable words orange, purple, and silver, see pp. 44, 101, and 109.

BROWN TRAFFIC LIGHTS: The Japanese call their green traffic lights aoi, or blue, even though their go signal is exactly as green as ours. For more on how foreigners' color terms don't always map to ours, see p. 84. Why does green mean go and red mean stop in traffic-light symbology? See p. 34.

ROY G. BIV

RAINBOW

THE COLOR OUT
OF SPACE:
If color depends on light,
what would the color of the
whole universe—with its
many, many suns—be? For
a tussle among astrono-
mers, see pp. 135-136.

MONSTROUS PLANTS:
What colors might alien
plants on other planets
be? See p. 77. Was
proto-Earth really cloaked
in purple plant life? The
Purple Earth Theory is
explained on p. 102.

KILLING COLOR:
Doses of radiation are
measured in killing units
called grays (Gy). See
p. 106.

POISON:
You can always recognize
the Hindu god Shiva in
paintings by the tangle of
blue poison, dimly visible
in his throat. For how
it got there, see p. 91.
For sunny yellow artists'
pigments laced in arsenic,
see p. 66. For all their
eco-friendliness, synthetic
green inks and pigments
are surprisingly toxic—see
p. 75.

see red and green simultaneously, a tenet of cognitive science known as Hering's law of color opponency.

Billock et al beat this law by pairing opponent shades—red and green or blue and yellow—of equal luminosity. They also retinally tracked the projected images, keeping the projections trained on an exact spot on the subjects' retinas, even though their eyes were moving.

Under these strict conditions, then, what subjects saw afterward was marvelous. For some subjects, borders between red and green dissolved, letting the opposing shades mix freely; others described a gradient field between red and green, crammed with every shade of reddish green and greenish red. Others saw green and red in the same field but at different depths, like colored waters mixing but each retaining its separate shade.

JALE AND ULFIRE

Some colors from science fiction operate on the Mini-Me principle: They are colors that are sensate or intelligent in their own right. Jale and ulfire are two unearthly colors on the sun Alppain in David Lindsay's 1920 novel *A Voyage to Arcturus*. "Just as blue is delicate and mysterious, yellow clear and unsubtle, and red sanguine and passionate," Lindsay writes, "so he felt ulfire to be wild and painful [and] jale [to be] dreamlike, feverish, and voluptuous."

THE COLOUR OUT OF SPACE

In H.P. Lovecraft's 1927 story "The Colour Out of Space," a Boston surveyor visits the town of Arkham to measure a reservoir site the natives call the "blasted heath." He soon learns the area's blight stems from a meteorite that once fell there; its core consisted of a lethal, alien color. "It was only by analogy that they called it colour at all," writes Lovecraft. "Its texture was glossy, and upon tapping it appeared to promise both brittleness and hollowness. One of the professors gave it a smart blow with a hammer, and it burst with a nervous little pop. Nothing was emitted, and all trace of the thing vanished with the puncturing."

Except: The Colour's unnatural spores spread, yielding monstrous plants, bucking horses, unnaturally quick-melting snow, and other horrors. By the story's end, the killing color has leached deep into the landscape. All over the farm, writes Lovecraft, "reigned that riot of luminous amorphousness, that alien and undimensioned rainbow of cryptic poison from the well—seething, feeling, lapping, reaching, scintillating, straining, and malignly bubbling in its cosmic and unrecognizable chromaticism."

HOOLOOVOO, GRUE, AND BLEEN

In Douglas Adams's smash series *The Hitchhiker's Guide to the Galaxy*, the Hooloovoo is a hyperintelligent shade of blue, using its nanorobot-like skills to construct the starship *Heart of Gold*.

Similarly brainiac in tenor, grue and bleen are hypothetical colors that morph from green to blue or vice versa over time. These switcheroo colors helped philosopher Nelson Goodman explore "the riddle of induction," the assumption that certain properties will persist because we've never observed them changing.

SQUANT, OCTARINE

Back in ScienceFictionLand, octarine is the color of magic, an animating force in the *Discworld* series by Terry Pratchett. A fluorescent, greenish-yellow purple, octarine can only be detected by wizards and cats.

Also delectable to animals is squant, the fourth primary color invented by the band Negativland. Writing as his alter ego Crosby Bendix in the radio program *Over the Edge*, band member Don Joyce describes squant as hovering between light blue and medium green. Its smell—"squanty"—holds "an irresistible attraction for anything that is blind, such as ants, earthworms, snails, cavern bats, and submarine life below ten thousand feet."

NANOROBOT-LIKE SKILLS:
"Gray goo" describes a doomsday scenario in which self-replicating nanorobots go haywire and consume all the matter on Earth. See pp. 110-111. In actual science, advances in carbon nanotubes have allowed scientists to make a new "superblack"—see pp. 117-118.

GRUE AND BLEEN:
Green and blue have a long history of hefty identity problems. See p. 84.

SNAILS:
On the backs of exhausted snails strode the Roman emperors, purple-dyed togas rippling in their wakes. For imperial purple's backstory, see p. 96.

SUBMARINE LIFE:
Horseshoe-crab blood— sky blue in color—turns out to have amazing antiseptic qualities. See p. 88.

THE NUMBER **1,**

FOR EXAMPLE, IS A BRILLIANT AND
BRIGHT WHITE, LIKE SOMEONE SHINING A
FLASHLIGHT INTO MY EYES.

FIVE

IS A CLAP OF THUNDER OR THE SOUND OF
WAVES CRASHING AGAINST ROCKS.

THIRTY-SEVEN

IS LUMPY LIKE PORRIDGE,

89

WHILE

REMINDS ME OF FALLING SNOW.

—David Tammet, math and language savant and author of *Born on a Blue Day*

GLOOMY DARK BLUE
WITH A STEELY SHINE:
Latin speakers used to
differentiate between
glossy and matte blacks,
a distinction that persisted
for centuries. See p. 117.

COLOR AND THE BRAIN

SYNESTHESIA

Synesthesia is a harmless brain condition that scrambles various senses. From child-hood, synesthetes "see" colors that aren't actually there, triggered by letters, numbers, or sounds; some synesthetes can even taste letters or sounds.

While baby brains usually "prune" themselves, separating brain regions with differing functions, pruning may be incomplete in synesthetes in the fusiform gyrus, where the regions responsible for colors and graphemes (letters and numbers) lie next to each other.

To a synesthete, A may look candy-apple red, according (uncannily) to just about everyone. F tastes like sherbet, according to James Wannerton, perhaps the most-studied "taster" synesthete. B major is a gloomy dark blue with a steely shine, according to Russian composer Nikolai Rimsky-Korsakov. But where do a synesthete's colors come from? Is there a universal color scheme to the alphabet that only these people know? Ask two synesthetes, and you probably won't get universal accord on which letter matches which color. But lock a few thousand synesthetes in with some cognitive psychologists, and you may catch some uncanny glimmers of agreement.

In 2005, a bunch of British psychologists ran an ambitious experiment testing synesthetes and non-synesthetes in England and Germany. First they culled genuine synesthetes from the fakers with confirmation tests. Then they split the non-synesthetes into two groups. "Free choicers" could associate colors with graphemes however they wished; "forced choicers" had to cough up colors for every grapheme. The scientists randomized the order of graphemes; they even controlled for language differences so that they could see how spelling *purple* (English) and *lila* (German) in each language might affect a letter's purplosity in subjects' minds.

Here's the bottom line: most subjects, synesthete or not, agreed on colors for a whop-ping ten of the twenty-six letters. Behold, the secret colors of the alphabet:

ABCDEFGHIJKLMNOPQRSTUVWXYZ

What factors could explain why these colors match so non-randomly with these letters? Top Good Guesses include the following:

- Something about a letter's shape influences its color

- The first letter of any color word will take on that color (*R* for *Red* or *Rot* in German, *B* for *Blue* or *Blau*)

- Colors "step up" progressively in shade, mirroring in some way the progression in alphabetical and numeric order.

There's a smidgen of evidence supporting each theory, but none explains the data conclusively. Synesthetes did pair the commonest letters with more ordinary colors, while oddball letters like Q or Z got paired with more exotic colors. Non-synesthetes, on the other hand, paired whatever graphemes they were given initially with common colors, then progressed to weirder colors.

Synesthesia is more than just a neat parlor trick. It's useful in aiding memory, math skills, and creativity. It's also drawn attention among cognitive scientists as a way to measure cognitive perception and visual processing. In other words, synesthesia lets us navigate the strange country of other people's thoughts.

RED, GREEN,
AND BLUE:
There are two sets of
primary colors, depending
on whether you're mixing
colored lights or pigments.
For a cheat sheet on color
theory, see pp. xvii-xix.

BEES, ZEBRA FISH,
MANTIS SHRIMP,
AND BIRDS:
For more on the "green
language" spoken
between lucky humans and
birds, see p. 81.

TETRACHROMACY

Humans are trichromats: The colors we see are produced by three cone sensors in the retina—red, green, and blue. (We get our near-colorblind night vision from another retinal sensor, the aerodynamic-sounding "rods," which pick up many fewer colors.)

Scientists estimate 2 to 3 percent of the world's women are tetrachromats. An extra fourth cone between the red and green cones boosts their color-vision range from one million to one hundred million shades. (Most cone development rides on the X chromosome, so to get the extra cone necessary for tetrachromacy you'd need to have two X chromosomes, as only women do. Similarly, color-blindness is more prevalent in men because they have only one X chromosome, so any lack in the usual number of cones will emerge on their single X.)

Tetrachromat ladies have serious Color Powers: Champions at sock-matching, they can also diagnose fever by the slightest flush of the skin, differentiate Dove White paint from Cloud, Pearl, Mayonnaise, and French Canvas, and challenge bees, zebra fish, mantis shrimp, and birds to a color-discrimination smackdown—although they can't mess with butterflies, which are pentachromatic.

COLOR-BLINDNESS

Color-blindness is the absence of either a red or a green cone cell, leaving people unable to distinguish between red and green or blue and yellow. Side effects are relatively minor but can be devastating when it comes to Christmas decor.

Color-blindness does have upsides. Recent studies show color-blind soldiers can pick out anomalies in aerial photographs much faster than those with normal vision. In his 1996 book *The Island of the Colorblind*, neurologist Oliver Sacks visits the Pingelap tribe in Micronesia, 10 percent of whose population is totally color-blind. Their world is drained of all color but rich in luminance, shadow, and texture.

Oddly, color-blind boys run a higher chance of having tetrachromat mothers. Find a boy with either two red or two green cones, and it's very possible his mother may also have an extra red or green cone, which converts for her into the tetrachromatic orange cone amping up her color vision. (Here, over the sartorial fights between color-rich

mother and color-poor son, we pass decorously in silence.)

THE AVERAGE COLOR OF THE UNIVERSE

In 2002, astronomers Ivan K. Baldry and Karl Glazebrook of Johns Hopkins University did a census of light from more than two hundred thousand galaxies. Galaxies with ongoing star formation emit more blue light, while galaxies where star formation has ended emit more red light, so their color is a tip-off of their age.

If you could strain the light from all the surveyed stars through an averaging prism— Baldry and Glazebrook explained at the 2002 American Astronomical Society—the resulting color would be . . . turquoise. That year's running, not-so-funny conference joke: "Have you seen the woman I was just talking to? She was wearing a turquoise dress, so I guess *she just blended into the universe.*"

Two months later, the plot thickened. Color scientist Mark Fairchild at the Rochester Institute of Technology confronted the astronomers with what amounted to a cosmic calculation error: The universe, he contended, is actually beige.

> # HAVING A FAVOURITE COLOR IS
>
> # LIKE HAVING A FAVOURITE LUNG.
>
> —Sara Genn

RUNNING, NOT-SO-FUNNY CONFERENCE JOKE: More groaners aplenty in the Bulwer-Lytton Fiction Contest, gathering the worst examples of purple prose imaginable. See p. 101.

ROY
G.
BIV

RAINBOW

FEATHERS:
Scientists have identified
fifteen different ways in
which something can be
colored. Structural color—
as in iridescent feathers
and seashells—is one
intriguing example. See
pp. 112–113.

As Fairchild put it, the astronomers' computer program had incorrectly set the "white point," the point at which light appears white to the human eye under different kinds of illumination. If you could peer at the universe in a box under an overcast sky (white point D65), the universe would look reddish. Take your universe box indoors, under Illuminant A lighting, and it'd look more blue. Illuminant E—what white looks like under dark conditions—probably makes the most sense in this context, yielding a universe whose average color is biscuity white.

Having resolved the matter, the scientists signaled their renewed amity with a contest to name the shade. Entries ranged from Big Bang Buff, to Univeige, Astronomer Green, and Primordial Clam Chowder. The ultimate winner? Cosmic Latte.

WHAT COLORS WERE THE DINOSAURS?

In 2010 a team of evolutionary biologists led by Yale's Richard O. Prum hit upon a way to determine the colors of dinosaurs. (You might think you know thoe colors already, but many dinosaurs are thought to have been covered in feathers. And what color were those?) Dr. Prum and team examined the feathers' pigment-loaded sacs, melanosomes, which can be preserved for millions of years. As the *New York Times* explains: "The shape and arrangement of melanosomes help produce the color of feathers, so the scientists were able to get clues about the color of fossil feathers from their melanosomes alone."

Working with Chinese paleontologists, the team turned to Dr. Matthew Sharkey, a University of Akron biologist who's accurately predicted the colors of modern birds based solely on melanosomes. The first dinosaur to emerge in Technicolor is 150-million-year-old *Anchiornis huxleyi*. Anchiornis was crowned with reddish feathers surrounding dark gray ones, with a red-and-black spotted face, a dark gray body, and white limb feathers tipped in black feathers. Now scientists are on the hunt for eumelanin, trace metals imparting color to fossils' feathers and skin. Prospects are exciting, although the prehistoric rainbow of nonfeathered dinosaurs is still limited to dun brown and black.

WHAT DOES THE RAINBOW-COLORED FLAG MEAN?

The rainbow flag, now best known as a gay-pride symbol, was designed by artist Gilbert Baker in 1978. The symbol that helped commemorate the Stonewall riots in New York City also riled sixteenth-century German peasant farmers against their overlords,

Incans against invading Spaniards, the Jewish territory of Far East Russia against its encroaching non-Jewish neighbors, and the antinuke movement against *button pushers everywhere*. Nearly all of these movements hearkened back to the biblical rainbow, God's covenant with Noah never to destroy humanity again. The rainbow's colors are all-inclusive—up to a point.

WHICH COLOR ARE YOU? COLOR PERSONALITY TESTS

Psychologists, spiritualists, and marketers alike have used color to diagnose mental, spiritual, or shopping-oriented ills. (Warning: a whiff of quackery lies heavy in the air.)

Exhibit A is Swiss psychologist Max Lüscher, inventor of the Lüscher Color Test. Designed to help therapists debrief new patients, it works like this: You lay out the Lüscher cards, shading your most to least favorite colors from left to right. You do this twice, then translate your choices into numbers via Lüscher's accompanying book, which also explains how various number combos reveal your "existing situation," "stress sources," "restrained characteristics," "desired objective," and "actual problem," presumably your reason for seeking a therapist in the first place.

Along similar lines, Professor Robert Plutchik issued his Plutchik Emotion Complex in 1980, using a color wheel to sort the tangled interplay between human emotions. And a color consultant named Faber Birren advised mid-twentieth-century marketers in what he called "color forecasting," finding the perfect color palette for luring shoppers for a given product.

At the nuttier end of this continuum is Mary Weddell's *Creative Color: An Analysis and Synthesis of Useful Color Knowledge*, a guide to changing one's aura by meditating on color. Especially felicitous is the Quick Color Remedies section: You can cool a fever by meditating on ice blue, alternating with dusty rose, or fix a sewing mistake with lemon yellow. A poisonous snake bite calls for "silvery ice blue, blue lavender and get medical attention fast. Do not use green for it will increase the pain."

BUTTON PUSHERS EVERYWHERE: For the recipe for uranium yellowcake, see pp. 66-67.

WHIFF OF QUACKERY: In preindustrial times, alchemists were unwitting pioneers in creating new artists' pigments—see p. 29. Meanwhile, pre-Enlightenment healers matched colored solutions to colored ailments, like yellow madder for curing jaundice. See pp. 60-61.

COLOR THEORY:
For a crash course, see
pp. xvii-xix.

QUANTUM CHROMODYNAMICS

Once considered the smallest units of matter, atoms have been known to be made out of other, smaller, particles for over a century. The electrons are—to the best of any physicist's knowledge today—fundamental particles that can't be split, but the protons and neutrons in the central nucleus can in fact be further subdivided into quarks. Protons and neutrons are just two examples of a whole slew of subatomic particles called hadrons that can be built out of quarks.

But how to organize this zippily anarchic subatomic world? Midcentury physicists at first spun out name after futuristic name for varieties of quark: kaon, pion, rho meson. But the various species of this "particle zoo" proliferated quickly and, by the early 1960s, it became entirely too confusing.

In 1964, physicists Murray Gell-Mann and George Zweig independently arrived at the so-called quark model, an organized system of classification that borrows from color theory to explain the particles' interrelationships. (Incidentally, Gell-Mann took the name quark from James Joyce's *Finnegans Wake*, specifically from a dream sequence in a bar in which publican Humphrey Chimpden Earwicker murmurs drowsily: "Three quarks for Muster Mark!")

Quarks are now known to come in six "flavors"—up, down, strange, charm, bottom (or beauty), and top. Quarks have two kinds of charge: a fractional electrical charge and a new kind of force physicists metaphorically dubbed "color." In the same way that stable atoms are electrically neutral, a hadron must be color-neutral. (A quark can exist in a stable condition without a complementary electrical charge; color charges, however, must always be evenly balanced out.) Unlike the electric field, which has just positive and negative charges, the color charge comes in three different types—red, green, or blue—so you can get a color-neutral particle with three quarks if you combine a red, green, and blue quark, much the way RGB light gels combine to form white light. You can also get color-neutral combinations of quarks by combining red and "anti-red" (or blue and "anti-blue," and so on).

For example, a green "up" quark may or may not seek to alter its flavor charge, but it will become a complementary color charge. That means it will become either an anti-green particle (resulting in a color-charged quark known as a pion), or it will seek to combine with red and blue quarks to make white.

Like waltzers vying to split their dance cards between partners, quarks unite for a brief spin and splinter off, decaying and rebuilding new hadrons, balancing colors with each new dance.

WALTZERS:
A creepy form of merriment in post–Reign of Terror France: *bals de victimes*. See pp. 30-31.

ROY
G.
BIV

RAINBOW

A Black, E white, I red, U green, O blue : vowels,

Someday I shall tell of your mysterious births:

A, black velvety corset of dazzling flies

Buzzing around cruel smells,

Gulfs of shadow; E, white innocence of vapors and of tents,

Spears of proud glaciers, white kings, shivers of Queen Anne's lace;

, purples, spitting blood, smile of beautiful lips

In anger or in drunken penitence;

U, waves, divine shudderings of green seas,

The calm of pastures dotted with animals, the peace of furrows

Which alchemy prints on wide, studious foreheads;

O, sublime Bugle full of strange piercing sound,

Silences crossed by Worlds and by Angels:

— the Omega, the violet ray of her Eyes!

—Arthur Rimbaud, *"Vowels"*

BIG-PICTURE COLOR QUESTIONS, ANSWERED

Why do brides (usually) wear white? See pp. 4-5.

Why is pink for girls and blue for boys? See p. 16.

What makes flamingos pink? See p. 15.

What are all the things a red thread might mean? See pp. 30-31.

Why are barns red? See pp. 33-34.

Why do prisoners wear orange? See p. 47.

What rhymes with orange, purple, or silver? See pp. 44, 101, and 109.

Why isn't brown in the rainbow? See p. 50.

Why are pencils yellow? See p. 65.

How did taxis become yellow? See pp. 62, 65.

What makes egg yolks yellow? See p. 62.

In traffic lights, why does green mean go and red mean stop? See p. 34.

Are green magazine covers really newsstand poison? See p. 74.

Why are plants green (and why were they once, very likely, purple)? See pp. 77 and 102.

Why are dollar bills green? See p. 78.

What explains the color of theater's "green room"? See pp. 80-81.

Why is the sky blue? See p. 86.

What colors were the dinosaurs? See p. 136.

What's the average color of the universe? See pp. 135-136.

THANKS TO . . .

This book owes its life to several color fans who helped me immensely. When I approached Tom Biederbeck about writing a visually driven column on color for *STEP Inside Design* (where he was editor in chief), he said yes—and gave me full creative license. That experience hatched the idea to think bigger about this topic.

Chrish Klose and Christine Gundelach, formerly of Studio Grau in Berlin, nudged me to conceptualize the book and partnered with me in its initial realization. I might have never gotten off the dime without their fearless, smart encouragement—and I know their gorgeous visual examples helped sell the concept.

Speaking of selling, my agent Jennifer Carlson (with Yishai Seidman) gave excellent counsel and had the guts to give this book a try. They connected me with Ben Adams at Bloomsbury USA, whose outsize intelligence matches his ample sense of humor. All the folks at Bloomsbury, especially Rachel Mannheimer, Patti Ratchford, and our design partner, Oliver Munday, shared a vision of this book I'm proud you're experiencing today.

Writing a book on such a big topic requires tapping experts. Color fans should run, not walk, to buy several of the books in my selected bibliography, especially those by Philip Ball, David Batchelor, Victoria Finlay, Simon Garfield, Derek Jarman, Michel Pastoureau, and Anne Varichon. I got invaluable fact-checking help from Vincent A. Billock of Wright-Patterson Air Force Base, Thomas Bosket of Parsons School of Design, Mark Changizi, Director of Human Cognition at 2AI, Brett Dion of the New York Transit Museum archive, Annegret Falkner of Columbia University, and Richard Easther of the University of Auckland (who, rather amazingly, corrected my faulty text on quarks from a beach in Pauanui, New Zealand). I also thank Professor Keith Knapp, chair of the history department at the Citadel, Jason Mattingley of The University of Queensland, Marvin Weinstein of Stanford's SLAC National Accelerator Laboratory, and science writer Carl Zimmer. The following folks also deserve much thanks: Rahul Agarwal, Alex Beecroft, Anders Bettum and Heather Campbell, Tina Boesch, Justin Caulley, Bianca Charamsa, Anne Dunlop, Heidi Enzian, Eckhart Frahm and Katherine Slanski, Ehren Fordyce, Carolyn Frantz and Eriks Smidchens, Irene Griffin, Juho Härkönen, Hiba Hafiz and Ilya Kliger, Heiko Hoffman, Kate Holland and Ivan Fernandez, Matej Hušek, Ronen Kadushin, Seth and Jules Kim-Cohen, Alice Heegaard Klynge, Dace Krejere, Esther Alba López, Karin Melnick, Alex Neratoff, Dagmar Novotná, Jonas Nyström, Ève Poudrier and Remi Castonguay, Thomas Richter, Lena Siyanko, Thomas Trummer, and Johanna Westeson. Not only do these people collectively speak twenty-five-plus languages, they nearly all have Ph.D.'s (and lent their expertise and advice accordingly), and they're bright and charming and thoughtful. What's not to like?

Writing is a solo affair, but with luck the experience can be informed by marvelous community. I have benefited from the help of my writer-friend cohort including Kimberly Bradley, Niki Dietrich, Sven Ehmann, Jack Hitt, Darra Goldstein, Emily Gordon, Cliff Kuang, Lina Kunimoto, Suzanne LaBarre, Andrew Leland, Adrienne Miller, Andi Mudd, Mark Oppenheimer, Todd Pruzan, and Hanna Rosin. James Gaddy, Aaron Kenedi, Jessica Kuhn, Gary Lynch, Megan Patrick, and Sarah Whitman of *Print* provided a great outlet for my color research in magazine, blog, and conference forms. I reserve special thanks for my co-curators of the Ordinary Evening Reading Series in New Haven: Lucile Bruce, Ann Leamon, and Alice Mat-

tison. Those fine ladies read my texts with care, helped me navigate the publishing process, and shared enthusiasms and frustrations equally. No circle of writers can beat them for sheer awesomeness. If I've forgotten anyone in this list, and I surely have, I will pick up our next drinks tab.

Friends are key, too. My shout-out of thanks resounds from Chicago, Illinois, to Berlin, Germany, and points in between. In addition to my dear friends in the list above, I thank Gavin Chuck, Milette Gaifman, Joy Goodwin, Adrienne and Brian Kane, Gundula Kreuzer, Ian Quinn, Josh and Jen Rutner, Stephen Decatur Smith, and Robert Wood. (Again, free drinks can be obtained from me by raising your hand as an omission.) A wonderful writer herself, Joy Goodwin may be the closest thing to a sister I'll find in life—and a smashingly marvelous one at that. Josh Rutner is a miraculous engine of color finds, a dogged supporter, a fantastic saxophonist, and a dear friend. All these great people urged me forward and cheered me up in the meantime. I'm so glad I know all of you.

Last but never least is family. My in-laws, Brodskys and Krugliaks alike, are remarkable people: canny, avid readers, witty, and loyal. Likewise, my parents Mary Jude and Michael Stewart gave me my life—and lent it considerable sparkle by their love and presence. My brother Andrew Stewart, his wife Danielle, and the Two Amazing Stewart Girls, Emily and Maggie, make me want to shout in happiness every time I see them. (As Andrew knows, I'll actually shout, too.) My extended family of Weickels and Stewarts encouraged my writing since childhood; they also trained my eye for color by example, as their collective skills in that department are acute. As for my husband, Seth Brodsky, the Beeb rocks. He helped in every single step of this book's genesis including wrapping me in a cocoon of delectable encouragement, constructive critique, boundless humor, and equally boundless love. This book is dedicated to him.

ACKNOWLEDGMENTS & SELECTED BIBLIOGRAPHY

I extend special thanks to the following people for permission to reprint copyrighted material:

Pedro Cabrita Reis extended his kind permission to reprint his quote in the book's introduction.

Quotes from Philip Ball's *Bright Earth* appear in "Color: A Pointillistic History and User's Guide" and in this book's final chapter with permission from Farrar, Straus & Giroux.

In the Blue chapter, lyrics of "Reno Dakota," written by Stephin Merritt and performed by the Magnetic Fields, are © 1999 Stephin Merritt and reprinted with permission from the author. The *National Geographic* quote about blue horseshoe crab blood is also reprinted with their kind permission.

In the Gray chapter, Dr. Weissmann's quote was reprinted with permission of the *FASEB Journal*, published by the Federation of American Societies for Experimental Biology.

In "Beyond the Rainbow," Daniel Tammet's quote about synesthesia appears with his kind permission.

MATERIAL HISTORIES OF COLOR, PIGMENTS, AND DYES

Balfour-Paul, Jenny. *Indigo*. British Museum Press, 2000.

Ball, Philip. *Bright Earth: Art and the Invention of Color*. The University of Chicago Press, 2003.

Böhmer, Harald. *Koekboya: Natural Dyes and Textiles*, trans. Lawrence E. Fogelberg. REMHÖB-Verlag, 2002.

Brunello, Franco. *The Art of Dyeing in the History of Mankind*, trans. Bernard Hickey. Nero Pozza Editore, 1973.

Chenciner, Robert. *Madder Red: A History of Luxury and Trade*. Routledge, 2000.

Delamare, François and Bernard Guineau. *Colour: Making and Using Dyes and Pigments*, trans. Sophie Hawkes. Thames & Hudson (UK), 2000.

Feller, Robert, ed. *Artists' Pigments: A Handbook of their History and Characteristics, vol 1*. National Gallery of Art, 1986.

Finlay, Victoria. *Color: A Natural History of the Palette*. Random House, 2004.

Fitzhugh, Elizabeth West, ed. *Artists' Pigments: A Handbook of their History and Characteristics, vol 3*. National Gallery of Art, 1997.

Garfield, Simon. *Mauve: How One Man Invented a Color That Changed the World*. W.W. Norton & Co., Inc., 2002.

Greenfield, Amy Butler. *A Perfect Red: Empire, Espionage, and the Quest for the Color of Desire*. Harper Perennial, 2006.

McKinley, Catherine E. *Indigo: In Search of the Color that Seduced the World*. Bloomsbury USA, 2011.

Pliny the Elder, *The Natural History*, trans. John Bostock and H.T. Riley. Taylor and Francis, 1855. Complete text online at www.perseus.tufts.edu/hopper/text?doc=Perseus%3Atext%3A1999.02.0137%3Abook%3D35%3Achapter%3D13.

Roy, Ashok, ed. *Artists' Pigments: A Handbook of their History and Characteristics, vol 2*. National Gallery of Art, 1993.

COLOR THEORY AND SCIENCE OF COLOR

Albers, Josef. *Interaction of Color*. Yale University Press, 2006.

Brusatin, Manlio. *A History of Colors*, trans. Robert H. Hopcke and Paul Schwartz. Shambhala Publications, 1991.

Hoeppe, Götz. *Why the Sky Is Blue: Discovering the Color of Life*, trans. John Stewart. Princeton University Press, 2007.

Itten, Johannes. *The Elements of Color*, trans. Ernst van Hagen. Van Nostrand Reinhold Company, 1970.

Lowengard, Sarah. *The Creation of Color in Eighteenth Century Europe*. Columbia University Press, 2008. Full text online at http://www.gutenberg-e.org/lowengard/.

Nassau, Kurt. *The Physics and Chemistry of Color: The Fifteen Causes of Color*. John Wiley and Sons, Inc., 1983.

Newton, Isaac. *Opticks, or, a Treatise of the Reflections, Refractions, Inflexions and Colours of Light*. General Books, 2010.

Rossotti, Hazel. *Colour: Why the World Isn't Grey*. Princeton University Press, 1985.

MEANINGS OF COLOR: ESSAYS & HISTORIES

Batchelor, David, ed. *Colour*. Whitechapel and the MIT Press, 2008.

Boccardi, Luciana. *Colors: Symbols, History, Correlations*, trans. Huw Evans. Marsilio Editori s.p.a., 2009.

Gage, John. *Color and Meaning: Art, Science and Symbolism*. University of California Press, 1999.

Gass, William H. *On Being Blue: A Philosophical Inquiry*. David R. Godine, 1997.

Jarman, Derek. *Chroma: A Book of Color*. The Overlook Press, 1995.

Marcos, Subcomadante Insurgente, and Domitila Domín-guez illus. *The Story of Colors*, trans. Anne Bar Din. Cinco Puntos Press, 1999.

Paoletti, Jo B. *Pink and Blue: Telling the Boys from the Girls in America*. Indiana University Press, 2012.

Pastoureau, Michel. *Blue: The History of a Color*, trans. Markus I. Cruse. Princeton University Press, 2001.

Pastoureau, Michel. *Black: The History of a Color*, trans. Joyce Gladding. Princeton University Press, 2009.

Theroux, Alexander. *The Primary Colors: Three Essays*. Henry Holt and Company, 1994.

Theroux, Alexander. *The Secondary Colors: Three Essays*. Henry Holt and Company, 1996.

Varichon, Anne. *Colors: What They Mean and How to Make Them*, trans. Toula Ballas. Harry N. Abrams, 2006.

ART HISTORY AND PRACTICE

Cennini, Cennino d'Andrea. *The Craftsman's Handbook/"Il Libro dell'Arte,"* trans. Daniel V. Thompson Jr. Dover Publications, 1954.

Color Chart: Reinventing Color, 1950 to Today. The Museum of Modern Art, 2008.

Gage, John. *Color and Culture: Practice and Meaning from Antiquity to Abstraction*. University of California Press, 1999.

Hebborn, Eric. *The Art Forger's Handbook*. The Overlook Press/Octopus Publishing Ltd., 1997.

Lévy, Dominique and Robert Mnuchin. *Yves Klein: A Career Survey*. L&M Arts, Inc. 2005.

Mayer, Ralph. *The Artist's Handbook of Materials and Techniques*, ed. Edwin Smith. Faber and Faber, 1951.

Smith, Cyril Stanley and John G. Hawthorne, eds. *Mappae Clavicula: A Little Key to the World of Medieval Techniques*. The American Philosophical Society, 1974.

Theophilus. *On Divers Arts*, trans. John G. Hawthorne and Cyril Stanley Smith. Dover Publications, 1979.

Berlin, Brent and Paul Kay. *Basic Color Terms: Their Universality and Evolution.* University of California Press, 1969.

Birren, Faber. *Selling Color to People.* University Books, 1956.

Eiseman, Leatrice and Keith Recker. *PANTONE: The 20th Century in Color.* Chronicle Books, 2011.

von Goethe, Johann Wolfgang. *Theory of Colours*, trans. Charles Lock Eastlake. MIT Press, 1970.

Heller, Eva. *Wie Farben Wirken: Sonderausgabe. Farbpsychologie.* Farbsymbolik. Kreative Farbgestaltung. Rowohlt, 2002.

Lüscher, Max. *The Lüscher Color Test*, ed. and trans. Ian Scott. Random House, 1969.

Riley II, Charles A. *Color Codes: Modern Theories of Color in Philosophy, Painting and Architecture, Literature, Music and Psychology.* University Press of New England, 1995.

Wittgenstein, Ludwig. *Remarks on Colour*, ed. G.E.M. Anscombe and trans. Linda L. McAlister and Margarete Schättle. University of California Press, 2007.

NOTES

All page citations in endnotes refer to the editions listed in the preceding bibliography.

COLOR: A POINTILLISTIC HISTORY AND USER'S GUIDE

xiii ...perverse charm: Ball, 27–29, 34; Kurt Nassau, *The Physics and Chemistry of Color: The Fifteen Causes of Color*. About iridescence specifically: Guineau and Delamare (hereafter G&D), 121; http://blogs.discovery.com/news_animal/2009/08/40millionyearold-iridescent-feather-found-with-color-preserved.html and http://www.world-science.net/othernews/090410_foam.htm.

xiii "...disregarded linoleum": Huxley, *The Doors of Perception* includes Heaven & Hell, Fontal Lobe Publishing, (2011), 59.

xiv "Gentlemen: I sent you...": John Ruskin quote is from Joyce Townsend, *Turner's Painting Techniques*, Tate Publications (1999).

xiv "In the chalky world of Dulux...": Jarman, 49.

xv ...all 'round London-town: Garfield's *Mauve*.

xv "Pigments are pure colors in powder form...": G&D, 16.

xv "...mordant to make them fast": G&D, 18, 101; Balfour-Paul, 115. Note: Balfour-Paul emphasizes indigo's unique advantage among dyes in *not* requiring a mordant.

xv ...clear, spreadable liquid: Ball, 65–66; G&D, 29.

xv "...wrecked by fatigue.": Brunello, 41.

xvi ...urine vats handy for donors: Balfour-Paul, 124–125; Finlay, 336.

xvi ...to aerate their smells: Finlay, 369–370. See also Gage, *Colour and Culture*, 25–27; Ball, 199.

xvi ...urine, and excrement: Varichon, 171.

xvi ...chief ingredient in Indian yellow: Ball, 138–139. Finlay investigates the lore at the source and can't quite prove Indian yellow's ills weren't exaggerated—see 205–217.

xvi ...white lead pigments: Finlay, 110; Ball, 64.

xvi ...allowing the mixture to rot: *Albert moderne, ou Nouveaux Secrets éprouvés et licites* (The Modern Albert, or New Tried and True Secrets), 18th century.

xvi ...smeared with rainbows: Ball, 178–179.

xvi ...gassed the Jews: Garfield gives the fullest account of how Germany's stranglehold on synthetic color turned into an advantage in pharmaceuticals, warmaking, and industrial chemistry generally: Garfield, 146, 154, 161, 166–167.

xvi ...the big drama of history: A sub-B-plot to synthetic color's story is the evolution of artificial food dyes. See http://www.slate.com/id/2161806/ and http://www.washingtonpost.com/opinions/the-rainbow-of-food-dyes-in-our-grocery-aisles-has-a-dark-side/2011/03/21/AFyIwaYB_story.html?hpid=z3.

xvii ...and have gotten them: For an expanded tour through this history, see my posts for *Print* magazine: http://imprint.printmag.com/color/the-wondrous-color-wheel-part-1/, http://imprint.printmag.com/color/wonderful-color-wheel-part-2/, and http://imprint.printmag.com/color/the-wonderful-color-wheel-part-3/. *The Creation of Color in Eighteenth Century Europe* by Sarah Lowengard provides detail on many of the figures mentioned here. Goethe's theory of color is nicely summarized in Riley, 21–23; Gage, 201–204. About the CIE curve and the Munsell system: Gage, 247 and Ball, 48–49; the latter also explains why there's no brown in the rainbow. For summaries about Albers: Riley, 154–157; Gage, 264–266.

xix ...hexidecimal color value: The number of primary colors, Maxwell's contributions, and additive-subtractive mixing are covered in Ball, 36–42. About CMYK printing's invention: J.C. Le Blon (1725), *Coloritto*, Van Nostrand Reinhold (1980). I learned much about Pantone's role in color management from interviewing their executives; see http://www.printmag.com/Article/Pantone-Merchants-of-Color, http://www.fastcompany.com/1649699/pantone-licensing-hotel, and http://imprint.printmag.com/color/pantone-capsure-match-the-color-of-anything. I also thank Thomas Bosket, who teaches color theory at Parsons, the New School's School of Art, Media and Technology, for verifying my facts.

xx "...cucumbers...[and] rye bread": Russian words for blue confirmed by native Russian speakers Ilya Kliger and Elena Siyanko and fluent Russian speakers Kate Holland and Ian Quinn. Batchelor's *Chromophobia*, Chapter 4, provides many of the examples mentioned here—see esp. 87–92 and Umberto Eco's essay "How Culture Conditions the Color We See," in *On Signs*, ed. Marshall Blonsky, Basil Blackwell (1985), 157–160; 167–171.

xx ...hasn't been disproved in forty years: Barbara Saunders disputes some of Berlin-Kay's underlying assumptions in this 1998 article: http://human-nature.com/science-as-culture/saunders.html. Another disputer: Stephen C. Levinson in "Yélî Dnye and the theory of basic color terms," *Journal of Linguistic Anthropology* (2000) 10(1):3–55. Still, when a body of scholarship develops specifically around refuting your claim, that fact alone suggests you're the gorilla in the room.

xxi "Color is like sex...": http://www.huffingtonpost.com/stephen-drucker/color-is-like-sex_b_165047.html.

WHITE

2 "White has a tendency...": As quoted in PBS interview http://www.pbs.org/art21/artists/ryman/clip2.html.

3 to describe a lovely day: Varichon, 21; see also Koran quote in different translation here: http://quod.lib.umich.edu/cgi/k/koran/koran-idx?type=DIV0&byte=797085"[47.15].

4 ...sweet milk and nuts: Confirmed by native Danish speaker Alice Heegaard Klynge. See also http://oaks.nvg.org/danetales9-10.html.

4 ...shone in pure white: http://www.royalcollection.org.uk/default.asp?action=article&ID=405.

5 ...Chinese closeted gays: http://www.slate.com/articles/news_and_politics/dispatches/2011/02/gay_marriage_with_chinese_characteristics.html.

5 ...in love or sex: French "white weddings": Varichon, 27. *Andare al bianco*: Boccardi, 30.

5 ...the plane and its occupants: http://www.vulcantothesky.org/history/the-558-story.html.

7 ...Duchess in Clogs...: Anne-Sophie Sylvestre. *Duchesse en sabots*. Père Castor Flammarion (2005).

8 "...the person who receives it": *English Standard Version*, 2001. As found here: http://bible.cc/revelation/2-17.htm

8 "...known only to himself": http://www.bartleby.com/81/17444.html.

8 bastards who gave them to you: Gamecock association with white feathers: http://www.thefreedictionary.com/white+feather. *The Four Feathers* full text: http://www.gutenberg.org/ebooks/18883.

8 *..Muh kaala kar deeya*: Confirmed by native Hebrew speakers Milette Gaifman and Ronen Kadushin.

9 "Happiness writes in white ink…": "*Le bonheur écrit à l'encre blanche sur des pages blanches.*" (Don Juan II, IV, 1048)

11 "…from lead acetate to lead carbonate": Finlay, 110.

11 "philosopher's wool": Ball, 152; Finlay, 414–415, note 25.

PINK

15 brazilwood dye: Ball, 140. Yellow-pink fell into disuse as a term by the eighteenth century, and brown-pink hung around until the nineteenth century. Somewhere in between, "pink" shifted from a term of manufacture to a specific color, the light-red shade of rose-pink.

15 …already digested spirulina: Bill McLain, *What Makes Flamingos Pink?: A Colorful Collection of Q & A's for the Unquenchably Curious*, Harper Paperbacks (2002), 18.

15 …the second, Phima: Ian Frazier, *Travels in Siberia*, Farrar, Straus & Giroux (2010), 380–382.

17 …the color can imply: This entry originally appeared (in longer version) on *Slate*: http://www.slate.com/articles/double_x/doublex/2010/02/pink_is_for_battleships.html. I thank Prof. Jo Paoletti for much of this entry's content. Also interesting: a 2007 cross-cultural study of British and Chinese children's attempts to explain why girls prefer pink and boys like blue: http://www.time.com/time/health/article/0,8599,1654371,00.html.

18 …into disuse in 1942: Cecil Earnest Lucas Phillips, *The Greatest Raid of All*, Little, Brown & Co. (1960), 77.

18 Pass the petits fours: Joseph J. Firebaugh, "The Vocabulary of 'Time' Magazine," *American Speech* (October 1940), 15, 3.

18 …the fragile blossoms: "Hagoromo Society of Kamikaze Divine Thunderbolt Corps Survivors," *The Cherry Blossom Squadrons: Born to Die*, ed. Andrew Adams and trans. Nobuo Asahi and the Japan Tech Co., Ohara Publications (1973).

19 …chastity is threatened: Kenkü sha's *New Japanese-English Dictionary* (5th edition, 2003), translates *Yamato-nadeshiko*: "a Japanese woman (with all the traditional graces); an ideal Japanese woman."

19 *Daydream* (1964): Harritz, Pia D., "Consuming the Female Body: Pinku Eiga and the case of Sagawa Issei," *Årgang* 1, No. 2, at http://web.archive.org/web/20070702120500/http://www.medievidenskab-odense.dk/index.php?id=57. See also: Roland Domenig, "Vital Flesh: The Mysterious World of Pink Eiga" in *Less Buzz, More Box Office: Japanese Cinema in 2001*, http://theninjadojo89233.yuku.com/topic/856/Vital-flesh-the-mysterious-world-of-Pink-Eiga.

19 "…the body to fit the dress": http://www.telegraph.co.uk/culture/art/3605196/Chic-value.html. See also Philadelphia Museum of Art exhibition catalogue *Shocking! The Art and Fashion of Elsa Schiaparelli*, Yale University Press (2004).

20 …instances of digital death: "The Top 200 Games of All Time," *Game Informer*, No. 200 (December 2009), 44–79.

21 …a nice itching powder: Albert MR, Novelty shop "itching powder," *Australasian Journal of Dermatology*, Vol. 39, No. 3 (August 1998), 188–189. Other pharmacological uses for rose hips documented here: http://www.drugs.com/npp/rose-hips.html and http://news.bbc.co.uk/2/hi/health/6763017.stm. As treats for chinchillas: http://www.chinworld.com/sitemap/prods/CW140004.html.

21 Brownian noise: Scientific definition of pink noise: http://www.nslij-genetics.org/wli/1fnoise. See also http://www.nytimes.com/2010/03/02/science/02angi.html.

22 …must remain inviolate: http://dictionary.reference.com/wordoftheday/archive/2003/02/17.html.

22 …to dissuade its clients against: Theroux I, 251. As to whether there could actually have been an apocryphal Tailor Pink(que), see http://www.dtc.umn.edu/~reedsj/pink.html.

23 …wild ride implicit therein: http://www.investopedia.com/terms/p/pinksheets.asp#axzz1anORMP7O.

RED

27 Smurfy blue: http://ngm.nationalgeographic.com/2011/08/visions-now-next#/next or http://www.wired.com/magazine/2011/06/st_process-crab.

27 …killed the plant in the process: Brunello, 97, 153. See also R.A. Donkin, "The Insect Dyes of Western and West-Central Asia." *Anthropos* 72 (1977), 847–868; Böhmer, 205–214.

28 cochineal dye exports: Amy Butler Greenfield's *A Perfect Red: Empire Espionage and the Quest for the Color of Desire* is a rollicking, well-researched read on the cochineal trade. See also: John Gage, *Color and Meaning: Art, Science and Symbolism*. University of California Press (1999), 111.

28 distilled essence of insects: As late as the 1990s, the FDA didn't require manufacturers to break out cochineal insects in its lists of ingredients. However, thanks to the combined outrage of Muslims, Jews, vegetarians, and the extremely allergic, cochineals now must be listed specifically. See http://www.sciencenews.org/view/feature/id/333204/title/The_color_of_controversy_ and http://www.fda.gov/ForIndustry/ColorAdditives/ColorAdditiveInventories/ucm115641.htm.

28 Brazil: Brunello, 25; Böhmer, 180–183. See also: H. Wescher, "Dyeing in France before Colbert." Ciba Review 18 (February 1939): 622.

30 …painted gorgeously in minium: Finlay, 163; G&D. 56.

30 …*a Rote Faden* of your life: Varichon, 100.

30 "…ropes belong to the Crown": Johann Wolfgang von Goethe, *Die Wahlverwandtschaften (Elective Affinities)* (1809), my translation.

30 …trudging into battle: Varichon, 101.

31 …in a 1993 account: François Gendron, *The Gilded Youth of Thermidor*, McGill-Queen's Press (1993), 32.

31 …savagery in modern French: Theroux I, 213.

31 …juicy details in their sleep: Varichon, 101.

31 …oversees the binding: Professor Keith Knapp, chair of the history department at the Citadel, confirms the details as follows: "The story is called 'The Inn of Betrothal'. It was published in a book called the *Xu Xuanguai* lu that was written by Li Fuyan. That book no longer survives, but this story was reproduced in a 10th century encyclopedia called *Wide-ranging Records of the Taiping Era*. Li Fuyan . . . lived during the Tang (618-907), so this concept is at least 1,100 years old."

32 "…grow free in the courtyard": Varichon, 89–90.

32 …filling you up to the eyelids: Theroux I, 213.

33 "Reporting Happiness": Theroux I, 160.

33 "to twist a [red] baby's hand": See http://japanese. about.com/od/japaneseculturn1/a/Japanese-Conception-Of-Red.htm.

34 …be sacred: http://www.sweden.se/eng/Home/ Lifestyle/Art-architecture/Reading/Home-Swedes-Home. Thanks to Jonas Nyström and his coworkers at Clasohlson.se for confirming my facts.

34 …a billion Chinese actually being wrong: History of traffic lights: http://www.techtransfer. berkeley.edu/newsletter/07-4/traffic_signals.php and http://www.bbc.co.uk/nottingham/content/ articles/2009/07/16/john_peake_knight_traffic_ lights_feature.shtml. For the Communist Chinese trying to make red mean go: http://www.nytimes. com/2000/09/28/garden/design-notebook-it-s-the-icon-challenge.html?src=pm. New York Transit Museum Archive Technician Brett Dion shared two sources about the colors used in early traffic lights. *Railway Locomotives & Cars* 27 (1854): 148 describes a "circular signal disc," colored white on one side and red on the other; red meant "stop" and white meant "don't stop." An even earlier account (Thomas Roscoe and Peter Lecount, *The London and Birmingham railway, with the home and country scenes on each side of the line*, 120), explains the color signaling this way: "a white light when the line was clear; a green one when it is necessary to use caution, and the speed of the train be diminished; and a red light, to intimate the necessity of immediately stopping."

35 …drag down scores: http://www.nytimes. com/2009/02/06/science/06color.html.

35 "…a hundred devils per hair": Boccardi, 161.

35 …redheads at 11 percent: http://www.washington-post.com/ac2/wp-dyn?pagename=article&node= &contentId=A47332-2002Mar18.

35 blood: Theophilus gives a recipe for making gold from copper using the blood of a redheaded young man.

35 fat: Thomas Middleton, *The Witch*, Act V, Scene ii.

35 …black skin with flaming red hair: Pastoureau, *Black*, 79.

35 …more resistant to anesthetics: http://well.blogs. nytimes.com/2009/08/06/the-pain-of-being-a-redhead.

35 …sensitivity to painkillers: http://healthland.time. com/2009/08/12/do-redheads-really-feel-more-pain-the-jurys-still-out/#ixzz1XJEYjVev.

ORANGE

38 …"apple of the earth": Rabbis in the Talmud: Berachos, 40a; Sanhedrin, 70a. In the Midrash: Bereishis Rabah 15:7, 19:5. Evidence for quince: James Strong and John McClintock, *Cyclopaedia of Biblical, theological, and ecclesiastical literature* 1. Harper (1867), 325. See also Charles Panati, *Sacred Origins of Profound Things: The Stories Behind the Rites and Rituals of the World's Religions*. Penguin Books (1996), 393–395.

40 …the sweetest bite of all: John McPhee, *Oranges*, Farrar, Straus & Giroux (1983). 8–10, 34, 22.

40 …a destroyed mound: http://www.bartleby. com/81/12483.html; McPhee, 4, 62. Orange oil as pesticide: Bastiaan M. Drees, "A Review of 'Organic' and Other Alternative Methods for Fire Ant Control." Texas Fire Ant Research and Management Project, Texas A&M University (2002). http://fireant.tamu.edu/materials/factsheets_pubs/ pdf/FAPFS012.2002rev.pdf.

41 …orange's twin birthplaces, China and India: Historical reprise from McPhee, 62–70, 89. Top orange-producing countries as of 2009 can be found here: http://faostat.fao.org/site/339/ default.aspx.

41 …high into the sky: Horace, *Odes*, trans. A.S. Kline. Published online (2005). BkIISatIV:40-69 "Tricks of the trade": http://www.poetryintransla-tion.com/PITBR/Latin/HoraceSatiresBkIISatIV. htm.

42 "There was no record…": Marcel Proust, *Remembrance of Things Past*, trans. Scott Moncrieff, Henry Holt and Company (1922), 1082–1083.

43 Nebuchadnezzar: Daniel 3: 19–23.

43 …orange garments of kings: William T. Vollman, *The Rainbow Stories*, Penguin Books (1989), 184, 187.

43 *Buon Natale* (Happy Christmas) to you!: http:// www.italiansrus.com/articles/subs/folkmagic_ part11.htm.

44 "…they do Judaise": Francis Bacon, *Essays, Civil and Moral*, Vol. III, Part 1. The Harvard Classics, P.F. Collier & Son (1909–1914); Bartleby.com (2001). www.bartleby.com/3/1/.

44 "porridge with Geo-rge": http://latimesblogs. latimes.com/music_blog/2010/10/eminem-finds-five-words-that-rhyme-with-orange-on-60-minutes. html.

47 …Clown Suit Deterrence: http://www.slate.com/ articles/news_and_politics/explainer/2010/12/ orange_alert.html and http://www.tulsaworld. com/news/article.aspx?subjectid=12&article id=20100601_12_0_NORMAN923123.

BROWN

50 …await their turn at life: Boccardi, 85; Varichon, 266.

52 …degrees Lovibond today: http://colour.tintom-eter.com//default.aspx and http://www.lovibonds. com/johnlovibond.php.

52 …charm them into service: John Gregorson Campbell, *Superstitions of the Highlands and Islands of Scotland*, James MacLehose and Sons (1900), 194.

53 …two different browns: http://www.worldcat.org/ title/voir-et-nommer-les-couleurs-resultats-de-re-cherches-collectives/oclc/7742278 from Pastoureau Blue, 175.

53 "…You must always beware of the Browns": http:// www.bartleby.com/81/2564.html. Ashton's full poem can be read here: http://www.staggernation. com/msb/all_to_astonish_the_browns.php.

54 …self-identify their race: Edward Eric Telles, *Race in Another America: The Significance of Skin Color in Brazil*, Princeton University Press, 81–84.

54 …136 different racial identities: As reported here (in Portuguese): http://www.google.com.br/url?sa=t&source=web&ct=res&cd=10&ved=0CEIQFjAJ&url=http%3A%2F%2Falmanaque.folha.uol.com.br%2Fracismo05.pdf&ei=hP9_S4zjLMmQuAf3sKCQBw&usg=AFQjCNE5pgeArLsxrlvUjZ_G75pdqncpTw&sig2=8GXCQq1ImhvCCccP4Qaoww.

54 …a 1998 survey found 143: José Luiz Petrucelli, "A Cor Denominada: estudos sobre a classificação étnico-racial," *LPP/Uerj* (2007), 18.

55 …now wielded by Wiglaf: *Beowulf*, trans. Francis B. Gummere, Vol. XLIX, Part 1. The Harvard Classics. P.F. Collier & Son (1909–1914); Bartleby.com (2001). www.bartleby.com/49/1/.

55 German army in its former African colonies: John Toland, *Adolf Hitler*, Doubleday & Company (1976), 220. See also *The Swastika: Symbol Beyond Redemption?* by Steve Heller, 114.

55 …a brown silk dressing gown: Glenn B. Infield, *Eva and Adolf*, Grosset and Dunlap (1974), 142.

56 "dauphin poop": Pastoureau, *Black*, 160.

56 "…unaffected by damp or foul air": Finlay, 104–106; see also Salmon, *The New London Dispensatory*, 1691.

57 …truth or fiction? You decide: http://mythbustersresults.com/episode25, Clip of *Brainiac: Science Abuse* segment on brown noise: http://www.youtube.com/watch?v=a73p6EORPyY. *South Park* episode: http://www.southparkstudios.com/full-episodes/s03e17-world-wide-recorder-concert. See also http://www.guardian.co.uk/world/2007/jun/18/gayrights.usa.

YELLOW

60 "…the most important phrase I will teach you": Brian Boyd, *Vladimir Nabokov: The American Years*, Princeton University Press (1993), 122.

60 …henna for a wedding: Confirmed by native Hindi speaker Rahul Agarwal.

60 …talisman carried for good luck: Varichon, 61.

60 …(menstrually persuasive) moonlight: Varichon, 129–130.

61 …myriad personality tests into the modern era: http://www.bbc.co.uk/programmes/b008h5dz.

61 …"proof" of the theory of humors: http://www.ncbi.nlm.nih.gov/pubmedhealth/PMH0001259.

61 …who dies in his stead: Theroux I, 140; as well as Peter Lutz, *The Rise of Experimental Biology: An Illustrated History*, Humana Press (2002): http://books.google.de/books?id=KmKQMjlyhSwC&pg=PA42&lpg=PA42&dq=pliny+%22golden+oriole%22+jaundice&source=bl&ots=OCICoXaM4b&sig=Wzecs9vC72F3kslT40EVtgliIlU&hl=en&ei=UDBzTsDXD8WXOpDvoKgM&sa=X&oi=book_result&ct=result&resnum=5&ved=0CDUQ6AEwBA#v=onepage&q=pliny%20%22golden%20oriole%22%20jaundice&f=false.000 …directly into one's nostrils: Pliny, *The Natural History*, Book XX, chapter 4.

61 …to help blood clot: D&G, 32.

61 …gold beads (Russia): Theroux I, 106–107.

62 …the Angel of Death: Varichon, 74.

62 …a "yellow deceived": Boccardi, 78.

62 …pretty much right on: Theroux I, 128–129.

62 …golden brown and crisply perfect: Theroux I, 113.

62 …the faintest yellow of all: http://www.chow.com/food-news/55099/does-the-color-of-an-egg-yolk-indicate-how-nutritious-it-is.

63 "[To paint] faces of young people…": Cennini, Chapter 47; 94.

65 …"Princess TNT, the dynamite socialite": Boccardi, 64; http://www.vanityfair.com/culture/features/2006/06/princesstnt200606.

65 …the bow and arrow, and writing: Finlay, 89; Henry Petroski, *The Pencil: A History of Design and Circumstance*, Alfred A. Knopf (1989). Dave Bridge, "Wad" in *Beneath the Lakeland Fells, Cumbria's Mining Heritage,* Red Earth Publications (1992). David Nunes Carvalho, *Forty Centuries of Ink, or A chronological narrative concerning ink and its background*, Bank Law Publishing Co. (1904).

66 …bitterness in the mouth: Finlay, 222–242; Varichon, 59–60, also John Humphries, *The Essential Saffron Companion*, Grub Street (1996).

66 …mercifully synthetic chrome yellow: Colormaker George Field (of modern-day paint manufacturer Winsor & Newton) thought Indian yellow derived not from urine directly, but from the urine-soaked dirt of cows after eating mango leaves.

68 …proving the existence of atoms: Robert Van Gulik, *The Chinese Maze Murders*, Michael Joseph (1962). Ball, 139; Finlay, 218–222.

68 …electricity can successfully happen: http://www.slate.com/id/2085848.

68 Pioneer ingenuity, what-ho!: Theroux I, 78.

69 …her yellowy prison's walls: Theroux I, 96,134.

GREEN

73 "Wear green today, wear black tomorrow": John Hutchings,"Folklore and Symbolism of Green" in *Folklore* 108 (1997).

73 …in dearer coin: E. Cobham Brewer, "Green Gown," *Brewer's Dictionary of Phrase and Fable*, Henry Altemus (1898); Bartleby.com, 2000. www.bartleby.com/81/. "Corinna's Gone A-Maying" (c. 1901): Sir Arthur Thomas Quiller-Couch, *The Oxford Book of English Verse*, Clarendon (1919), Bartleby.com (1999). www.bartleby.com/101/. "Caught without green" game: Varichon, 208.

74 …Chinese men steer clear: http://www.nytimes.com/2002/04/30/business/business-travel-beware-of-green-hats-in-china-and-other-cross-cultural-faux-pas.html?pagewanted=all&src=pm and http://www.languagetrainers.co.uk/blog/2009/02/03/green-hats-and-adultery.

74 "Green is death on the newsstand!": http://www.slate.com/articles/arts/culturebox/2006/11/it_aint_easy_being_green.single.html

75 …still holds a certain allure: These two articles debunk previous theories regarding Napoleon's death by arsenic poisoning: http://dsc.discovery.com/news/2008/02/11/napoleon-arsenic-death.html and http://www.livescience.com/2292-napoleon-death-arsenic-poisoning-ruled.html.

76 …in a babbling green brook: *Die Schöne Müllerin* lyrics can be found in German here: http://cla.calpoly.edu/~smarx/courses/253/schoene.html; I have translated them from the German. Quotation comes from Song 17, "The Hateful Color."

76 *películas verdes*: Confirmed by native Spanish speaker Esther Alba López.

76 …sex in public parks: Theroux 2, 260. Read on for more on "green discharge" from the navy and "greenhouses" as outdoor sex destinations.

77 …from the brain's vine: Confirmed by native French speaker Aurore Labenheim (friend of Emily Gordon).

77 …ultra-absorbent black: http://www.sciam.com/article.cfm?id=the-shocking-colors-of-alien-plants&sc=rss and http://www.sciam.com/article.cfm?id=local-color-plants-under-alien-suns-come-in-variety-of-hues.

78 "…stable credit of the Government": "Why is green ink used to print U.S. currency?" http://www.moneyfactory.gov/faqlibrary.html.

78 …reflected color filling the sky: Green cloak and al-Khidr: Boccardi, 171–172. Muslim everyday rituals involving green: Varichon, 203–204; Theroux 2, 279–280. See also http://www.slate.com/articles/news_and_politics/explainer/2009/06/islamic_greenwashing.html

79 "Dig a well, two gaz deep…": Qanoon-al-sovar. Malek National Library no. 6325 and Tehran University Central Library no. 7395 (microfilm). Found here: http://related.springerprotocols.com/lp/de-gruyter/ph-stability-of-saffron-used-in-verdi-gris-as-an-inhibitor-in-persian-Y0cW2TrhrW.

80 "…jade is invaluable": http://chinaculture.about.com/cs/history/a/JadeCulture.htm.

81 …in more ways than one: Brewer, Bartleby.com (2000). www.bartleby.com/81/.

81 …avionics during battle: Dag the Wise: "Laing's translation at the Internet Sacred Text Archive," sacred-texts.com. http://www.sacred-texts.com/neu/heim/02ynglga.htm. Solomon: Louis Ginzberg, Legends of the Jews (1909). History of Ada: Fuegi and J. Francis, "Lovelace & Babbage and the creation of the 1843 'notes,'" Annals of the History of Computing 25 #4 (October–December 2003), 16–26.

BLUE

84 …Cheskin Added Value: http://www.cheskin.com/cms/files/i/articles/9__report-2004_Global_Color.pdf. See also: Birren, Heller.

84 …but no blue: Morris Swadesh, "Lexicostatistic dating of prehistoric ethnic contacts," American Philosophical Society Proceedings 96 (1952), 452–463.

84 "…eyes, leaves, or honey": Hoeppe, 13–14; Pastoureau, Blue, 23–25, 32, 50–55, 60, 63–64, 123–124.

85 …demons who might thwart fermentation: Indigo by Jenny Balfour-Paul is the fantastic resource from which I gathered most of the facts for this entry. See also Julius Caesar, Commentarii de bello Gallico, Liber V, XIV (2). Indian ritual to counteract indigo's taint: Varichon, 171–172.

86 …Why Only Prince Sees Purple Rain: http://www.livescience.com/environment/070410_purple_earth.html and http://www.livescience.com/320-blue-skies-eye-beholder.html. See also Hoeppe, 169–202.

86 …penetrate us thoroughly: From http://calendar.walkerart.org/canopy.wac?id=4489. Also fun: International-Klein-Blue.com and http://www.yveskleinjeans.com.

87 …the Book of Exodus: Exodus 24:10.

87 "…what tekhelet reminds you of": http://www.nytimes.com/2011/02/28/world/middleeast/28blue.html?_r=3. The scholarly debate on tekhelet's color, plus other arcana, is debated on http://tekhelet.com, home of P'til Tekhelet: The Association for the Promotion and Distribution of Tekhelet.

88 …getting drunk: Courtesy of the many native German speakers with whom I've "made blue," especially Heidi Enzian and Thomas Richter. See also http://www.farbimpulse.de/Am-Blauen-Montag-waren-viele-Faerber-blau.123.0.html (in German).

88 …one is not armed: Namkhai Norbu, "Bon and Bonpos," Tibetan Review (December 1980), 8.

89 …returned, living, to the sea: Spanish aristocrats: Robert Lacey, Aristocrats, Little, Brown and Company (1983), 6. Horseshoe crab blood: http://ngm.nationalgeographic.com/2011/08/visions-now-next#/next.

91 …stoppered forever in his throat: http://library.thinkquest.org/C0118142/orient/shiva.php.

91 (, rózovaya): Confirmed by Russian speakers Kate Holland, Ian Quinn, and Ilya Kliger.

92 "…I can fidget on two?": Ward & Trent et al., The Cambridge History of English and American Literature, G.P. Putnam's Sons (1907–1921); Bartleby.com (2000). http://www.bartleby.com/cambridge. See also http://www.janeausten.co.uk/elizabeth-montague-queen-of-the-bluestockings.

INDIGO & VIOLET

96 …number of spectral colors to seven: Gage, Color and Culture, 171.

96 "…like an angry sea?": Pliny, 9:36.

97 …still release the scent: Balfour-Paul, 14; Finlay, 369–374, 381–384. See also: Aristotle. Historia animalium, trans. D.W. Thompson, Book V, Clarendon Press (1910).

97 …(ponerse morado de hacer/comer algo): Spanish saying confirmed by native speaker Esther Alba López. Chinese saying from Theroux 2, 112.

98 "The modern age, in other words": This entry owes its sparkle to the excellently researched story told in Simon Garfield, Mauve: How One Man Invented a Color That Changed the World. See also: Ball, 211–215, 222–223.

99 …Purple America was born: The backstory: http://www.dailyprincetonian.com/2005/11/10/13728/. The actual Purple America map: http://www.princeton.edu/~rvdb/JAVA/election2000/. See also Philip Klinkner and other poli-sci folks' response to Vanderbei's data collection and the media response it generated: http://www.bepress.com/forum/vol2/iss2/art2.

99 …escaped snarky comment: Brewer, Bartleby.com (2000). www.bartleby.com/81/.

99 "The Purple Shall Govern": http://www.slate.com/articles/news_and_politics/explainer/2008/06/purple_water_cannons.html.

100 "Works with noble beginnings…": Horace, Satires, Epistles and Ars poetica, trans. H. Rushton Fairclough, Harvard University Press (1936).

101 …the world's thirstiest gerbil: History of the contest: http://www.bulwer-lytton.com/lyttony.htm. List of winners: http://www.bulwer-lytton.com/lyttony.htm.

101 "…not exploding cake!": http://adamcadre.ac/11lyttle.html.

102 "Or proud imperial purple": http://www.robert-burns.org/works/154.shtml.

102 "…shield thee frae the storm": http://www.bbc.co.uk/robertburns/works/on_the_birth_of_a_posthumous_child_born_in_peculiar_circumstances_of_family_distress.

102 …purple: the color of efficiency: http://www.livescience.com/environment/070410_purple_earth.html.

GRAY

106 ...Pearlescent. Dappled: C.O. Sylvester Mawson, ed., *Roget's International Thesaurus of English Words and Phrases*, Thomas Y. Crowell (1922); Bartleby. com (2000). www.bartleby.com/110.

106 "...hair turns gray and then white": http://www. sciencedaily.com/releases/2009/02/090223131123. htm and http://www.scientificamerican.com/ article.cfm?id=why-does-hair-turn-gray.

108 ...any given group of people: http://www.bbc. co.uk/news/health-12722435.

108 ...by $75,000 to $200,000?: http://weburbanist. com/2010/09/11/banksy-vs-the-gray-ghost-in-new-orleans.

108 ...without asking the building owner first: http:// blog.nola.com/dougmaccash/2009/03/gray_ ghost_pleads_no_contest_t.html.

109 ...pallor of shame?: Bruce Rodgers, *Gay Talk (The Queen's Vernacular): A Dictionary of Gay Slang*, Paragon Books (1972), 99.

109 ...a ewe lamb: http://www.merriam-webster.com/ dictionary/chilver. For a list of words without rhymes in English, see http://painintheenglish. com/case/813.

110 History of nanotech: http://www.thenewatlantis. com/publications/the-nanotechnology-revolution *The New York Times* describes gray goo and Drexler's calculations: http://query.nytimes.com/ gst/fullpage.html?res=9C06E4DF163CF937A25 751C1A9659C8B63 BoingBoing summarizes the Pitt team's findings: http://gadgets.boingboing. net/2008/12/16/scientists-kill-gray.html. *Discover* debunks gray goo as unlikely: http://blogs.discovermagazine.com/sciencenotfiction/2009/05/18/ codex-futurius-why-gray-goo-is-a-great-dud/

111 "...Mix with his hearth": Quote from Tennyson's "The Princess": http://www.gutenberg.org/ebooks/791. This 1881 *New York Times* article relates a fable explaining the saying: http://query.nytimes. com/gst/abstract.html?res=F30D14FD3C541B7A 93C5AB1789D85F458884F9.

113 "...the mouse still lives!": *Charles d'Orléans, Poésies*, ed. J. Marie Guichard, (1842), my translation from this original text in French: http://www. gutenberg.org/files/14343/14343-h/14343-h. htm#p141.

113 "...the freedom to live up to it": Examples of the Macy Gray Quote of the Week: http://www. philadelphiaweekly.com/music/rpms-38351494. html, http://www.philadelphiaweekly.com/music/ rpms-38351349.html, and http://www.philadelphiaweekly.com/music/rpm-38343024.html. *Salon* article about the MGQotW phenomenon: http:// www.salon.com/2001/10/16/macy_2. You can find other wacky (uncorroborated) Macy Gray quotes here: http://www.icelebz.com/quotes/macy_gray.

BLACK

117 ...flatulence: Varichon, 219.

117 ...*blik-an*, "to shine": Jacques André, *Études sur les termes de couleurs dans la langue latine*, Librairie C. Klincksieck (1949), 43–63.

118 ...street wear for the ultimately disaffected: http:// news.bbc.co.uk/2/hi/science/nature/7190107.stm and http://www.guardian.co.uk/science/2010/ jun/13/scientists-invent-a-new-black.

119 "...with black socks": Confirmed by native speakers of Finnish (Juho Härkönen), Swedish (Johanna Westeson), and Norwegian (Anders Bettum).

119 "...her transformation and her dreams": Varichon, 222.

120 "...in her parents' home": Varichon, 223.

120 ...dying ape: Pastoureau, *Black* 90–92; Varichon, 248; Hebborn, 20–23.

121 ...29 percent of the time: Pastoureau, *Black*, 95–100,134–135.

121 ...pine trees burning in autumn: Finlay, 90–92.

121 ...the holy word: Finlay, 242–243.

122 ...to date documents accurately: Legal ink is actually pretty high-tech. See Finlay note 17, 411.

122 "...she devoured those hordes of foes": Bocccardi, 111. Quote: *Devi Mahatmyam (Glory of the Divine Mother): 700 Mantras on Sri Durga*. Jagadiswarananda Swami, Swami Jagadiswarananda, trans. Sri Ramakrishna Math (1953).

122 ...no minor role: Suckale-Redlefsen, Gude and Bugner, Ladislas. *Mauritus: der heilige Mohr*, Schnell und Steiner (1987).

123 ...Persian rosewater: Varichon, 232–233. See also: Karen Armstrong, *Islam: A Short History*, Modern Library (2002), 10–23.

123 ...to remain incognito: Gerard J. Brault, *Early Blazon: Heraldic Terminology in the Twelfth and Thirteenth Centuries with Special Reference to Arthurian Heraldry*, Broydell & Brewer (1997), 31–35.

BEYOND THE RAINBOW

127 "Why can't we imagine a grey-hot?": Proposition 216. Other mentions of reddish-green: propositions 52, 94, and 129. Brown traffic lights are discussed in proposition 65.

128 ...retaining its separate shade: Vincent A. Billock, Gerald A. Gleason and Brian H. Tsou, "Perception of forbidden colors in retinally stabilized equiluminant images: An indication of softwired cortical color opponency? "Journal of the Optical Society of America" A 18 (2001), 2398-2403. Published for popular readers later as Vincent A. Billock and Brian H. Tsou, "Seeing Forbidden Colors," *Scientific American* (February 2010). http://www. scientificamerican.com/article.cfm?id=seeing-forbidden-colors. Dr. Billock notes that Crane and Piantanida made forbidden colors visible in 1983, but the effect was variable among subjects and therefore disbelieved.

129 "...cosmic and unrecognizable chromaticism": Read the whole story at http://www.hplovecraft. com/writings/texts/fiction/cs.asp.

129 "...never observed them changing": Nelson Goodman, *Fact, Fiction, and Forecast*. Harvard University Press, 1983.

129 "...below ten thousand feet": Octarine appears in the first Discworld book, *The Color of Magic*. On squant, see http://www.negativland.com/squant/ story.html.

132 ...lie next to each other: Neuroscientist Vilayanur Ramachandran explains synesthesia at the 2007 TED conference, along with other fascinating cognition errata. Skip to 17:00: http://www.ted.com/ talks/vilayanur_ramachandran_on_your_mind. html.

154

133 …the strange country of other people's thoughts: Jamie Ward and Jason B. Mattingley, "Synaesthesia: an Overview of Contemporary Findings and Controversies," *Cortex* Vol. 42, Issue 2, (2006) 129–136. Mattingley ran a similarly ambitious Australia-wide study of synesthetes and non-synesthetes with his colleage A.N. Rich in 2005: "A systematic, large-scale study of synaesthesia: implications for the role of early experience in lexical-colour associations," *Cognition*, 98, 53–84. A 2013 study links synesthesia to the predominant colors used in alphabet magnets. See http://body odd.nbcnews.com/_news/2013/01/13/16759046-b-is-for-orange-synesthesia-linked-to-alphabet-magnets-in-small-study. Also interesting: the Channel Four documentary on Daniel Tammet, a savant who uses synesthesia to perform extraordinary memory feats. See http://video.google.com/video play?docid=4913196365903075662.

136 …Cosmic Latte: The scientists' tussle is summarized in these two articles: http://www.abc.net.au/science/news/stories/s456194.htm and http://www.abc.net.au/science/news/stories/s499599.htm. Baldry and Glazebrook, with Fairchild, explain the scientific concepts at play here: http://www.pha.jhu.edu/~kgb/cosspec.

136 "…dun brown and black": http://www.nytimes.com/2010/02/05/science/05dino.html and http://io9.com/5816767/discovering-the-colors-of-fossils.

137 …all-inclusive — up to a point: About the LGBT rainbow flag: http://6thfloor.blogs.nytimes.com/2011/06/29/who-made-that-rainbow-flag and http://www.wnyc.org/slideshows2/gayflag. About the Battle of Frankenhausen in 1525 (in German): http://www.farbimpulse.de/artikel/titel/Kampf_im_Zeichen_der_Regenbogenflagge/488.html and http://www.gameo.org/encyclopedia/contents/M858.html (in English). See also http://backspace.com/notes/2006/06/the-wiphala.php and http://www.flags-of-the-world.net/flags/ru-yev.html.

137 "…it will increase the pain": Robert Plutchik and Henry Kellerman, *Emotion: Theory, Research, and Experience: Vol. 1, Theories of Emotion*, Academic Press (1980).

139 …with each new dance: Thanks to Richard Easther of the University of Auckland and Marvin Weinstein of Stanford's SLAC National Accelerator Laboratory for helping me with this entry. Gell-Mann explains the origins of the name quark here: M. Gell-Mann, *The Quark and the Jaguar: Adventures in the Simple and the Complex*, Henry Holt and Co. (1995), 180.

A NOTE ON THE AUTHOR

Jude Stewart writes about design and culture for *Slate*, the *Believer*, *Fast Company*, *GOOD*, *Gastronomica*, *I.D.,* and other publications. She also writes a blog about color for *Print*. She lives in Chicago.

Her website is www.judestewart.com.